TOP 100

Simplified®

TIPS & TRICKS

D1533376

Photoshop®
Elements 11

by Rob Sheppard

Visual

WILEY

Photoshop® Elements 11
Top 100 Simplified® Tips & Tricks

Published by
John Wiley & Sons, Inc.
10475 Crosspoint Boulevard
Indianapolis, IN 46256
www.wiley.com

Published simultaneously in Canada

Copyright © 2013 by John Wiley & Sons, Inc., Indianapolis,
Indiana

Library of Congress Control Number: 2012948922

ISBN: 978-1-118-38085-7

Manufactured in the United States of America

10 9 8 7 6 5 4 3 2 1

Wiley publishes in a variety of print and electronic formats and
by print-on-demand. Some material included with standard
print versions of this book may not be included in e-books or in
print-on-demand. If this book refers to media such as a CD or
DVD that is not included in the version you purchased, you may
download this material at http://booksupport.wiley.com. For
more information about Wiley products, visit www.wiley.com.

Trademark Acknowledgments

Contact Us

For general information on our other products and services
contact our Customer Care Department within the U.S. at
877-762-2974, outside the U.S. at 317-572-3993 or fax
317-572-4002.

For technical support please visit www.wiley.com/techsupport.

WILEY

John Wiley & Sons, Inc.

U.S. Sales

Contact Wiley at
(877) 762-2974 or
fax (317) 572-4002.

CREDITS

Senior Acquisitions Editor
Stephanie McComb

Project Editor
Terri Edwards

Technical Editor
Dennis Cohen

Copy Editor
Scott Tullis

Editorial Director
Robyn Siesky

Business Manager
Amy Knies

Senior Marketing Manager
Sandy Smith

Vice President and Executive Group Publisher
Richard Swadley

Vice President and Executive Publisher
Barry Pruett

Project Coordinator
Katie Crocker

Graphics and Production Specialists
Carrie A. Cesavice
Jennifer Henry
Andrea Hornberger

Quality Control Technician
Rebecca Denoncour

Proofreading
Sossity R. Smith

Indexing
Potomac Indexing, LLC

ABOUT THE AUTHOR

Rob Sheppard is an author, photographer, and videographer who says his favorite location is the one he is in at any time. He is the author/photographer of over 40 books, as well as a well-known speaker and workshop leader, and a Fellow with the North American Nature Photography Association. He was the long-time editor of the prestigious *Outdoor Photographer* magazine and helped start *PCPhoto* (*Digital Photo*). Presently he is editor-at-large for *Outdoor Photographer*. As author/photographer, Sheppard has written hundreds of articles about photography and nature besides his books. His website is at www.robsheppardphoto.com; his blog is at www.natureandphotography.com.

ACKNOWLEDGMENTS

Putting together a book is always a group project, so I appreciate all of the hard work done by the Wiley editors to make this book work well for the reader. I also thank my workshop participants who give me a direct connection to photographers and what they need to know. And I thank my wife, Vicky, for all of her support during the times I am working weekends and evenings because deadlines loom.

HOW TO USE THIS BOOK

Who This Book Is For

This book is for readers who know the basics and want to expand their knowledge of this particular technology or software application.

The Conventions in This Book

① Steps

This book uses a step-by-step format to guide you easily through each task. Numbered steps are actions you must do; bulleted steps clarify a point, step, or optional feature; and indented steps give you the result.

② Notes

Notes give additional information — special conditions that may occur during an operation, a situation that you want to avoid, or a cross reference to a related area of the book.

③ Icons and Buttons

Icons and buttons show you exactly what you need to click to perform a step.

④ Tips

Tips offer additional information, including warnings and shortcuts.

⑤ Bold

Bold type shows text or numbers you must type.

⑥ Italics

Italic type introduces and defines a new term.

⑦ Difficulty Levels

For quick reference, these symbols mark the difficulty level of each task.

Demonstrates a new spin on a common task

Introduces a new skill or a new task

Combines multiple skills requiring in-depth knowledge

Requires extensive skill and may involve other technologies

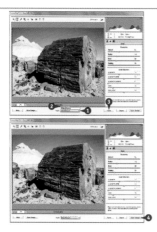

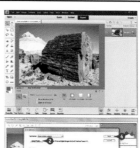

Table of Contents

1 Import and Organize Photos

2 Start Adjusting Your Images in Photoshop Elements

Table of Contents

Table of Contents

Import and Organize Photos

Adobe Photoshop Elements 11 brings a radical change to the Photoshop Elements interface. It is quite different from anything seen in earlier versions of the program. Do not let the changes alarm you, however. Photoshop Elements has been made even more accessible and photographer friendly. The folks at Adobe wanted this version of the program to get full attention on making it as simple to use as possible, and that meant a whole new interface design. They had two principles in mind: clear and immersive. Clear meant that Photoshop Elements would have a clear experience for you, the user, so that how you would work with the program would be clear and direct. Immersive meant that you would be able to immerse yourself in whatever is needed as you need it to make something happen in the program.

Photoshop Elements is still a superb image-processing program, and is certainly one of the best values for the money on the market. Photoshop Elements uses the exact same processing algorithms that Photoshop does, but the interface is now even simpler and set up to make it more intuitive for use. In addition, the Windows and Mac versions of Photoshop Elements Editor are essentially the same, and the tips in this book work the same with either platform except for occasional keyboard commands. Ctrl/⌘+click, for example, shows the Windows key and then the Mac key to use as you click the mouse.

IMPORT your images

You have taken some photos and now you want to get them into the computer. Photoshop Elements makes that easy to do by both downloading your photos from a memory card to your hard drive and having Organizer recognize them at the same time. Organizer helps you sort, delete, and organize your photos. Organizer does not actually hold onto your photographs; your hard drive does. However, Organizer does need to know where those photographs are. It needs, in a sense, a map to where your photos are located. So by using Organizer to import your photos to your computer, you create that map.

When you first open Photoshop Elements, click the Organizer button to go into the Organizer mode. All importing is done through this mode.

This is a simplified way of getting all your images from the memory card onto your hard drive and recognized by Photoshop Elements. For more control over your importing, including importing only part of your memory card at a time, see the completion of this task on the next pages.

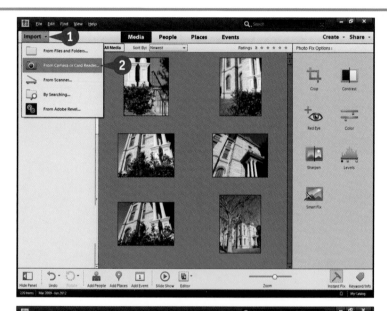

Importing from a Digital Camera or Memory Card

1 Click Import.

2 Click From Camera or Card Reader.

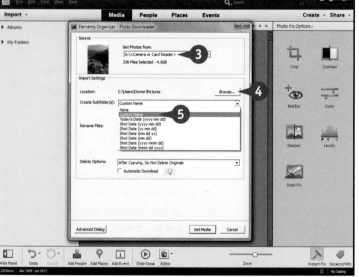

The Photo Downloader dialog box appears.

3 Click here to select your camera or card reader.

4 Click Browse to select a location for your photographs on your hard drive.

5 Click here and select Custom Name from the menu that appears to create a custom name for a subfolder.

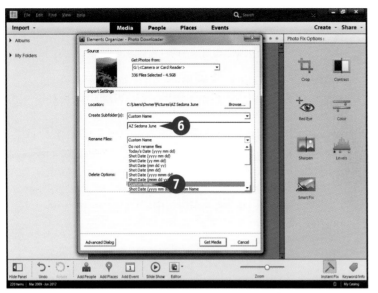

6 Type a name for your subfolder specific to the images you want to import.

7 Click here to give your photos a custom name, name them by date, or keep the original filenames.

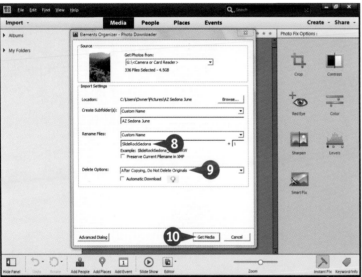

8 Type a new name for your photos if needed.

9 Click here to leave photos on the memory card so that your camera can reformat the card properly.

10 Click Get Media.

The photos now import into your computer.

11 When the Files Successfully Copied dialog box opens, click Yes to include them in the Organizer.

TIPS

Did You Know?

A quality memory card reader is the fastest and most dependable way to download images. A card reader needs no power, can be left connected to your computer, and will not be damaged if accidentally knocked to the floor. Many computers now have SD card readers built into them.

Did You Know?

The Automatic Download check box in the Photo Downloader dialog box sets up your computer to automatically download photos based on criteria set in Organizer Preferences, found in the Edit menu on the PC and in the Adobe Photoshop Elements 11 Organizer menu on the Mac. This can be a problem because it does not enable you to put photos into specific folders for each download, nor does it enable you to rename photos.

Did You Know?

Most photographers prefer to put images into distinct file folders on their hard drives rather than lumping them together into the Pictures folder. Photo Downloader enables you to set up specific folders. You can put photos in a folder based on date and location, for example, inside a larger folder called Digital Photos on your desktop to make them easier to find if the Organizer in Photoshop Elements ever fails.

Commonly, you will shoot several different subjects or locations on a memory card. You may not want all of them mixed together in a single folder. It can be very helpful to keep your photos separated by folders so that you can always find images on your hard drive, even without Photoshop Elements. You have the option in an advanced dialog box to import only the pictures that you want from a memory card. This dialog box is very similar to the Photo Downloader dialog box, but it includes some additional choices you should know about.

The photos being imported in this chapter are from beautiful country around Sedona, Arizona. This area is known for its combination of pine trees and red rock, along with the very pretty Oak Creek.

Photoshop Elements also enables you to import images already on your hard drive. The process is very similar, but does use a slightly different dialog box. This can be useful when you have transferred pictures directly from one computer to another, for example.

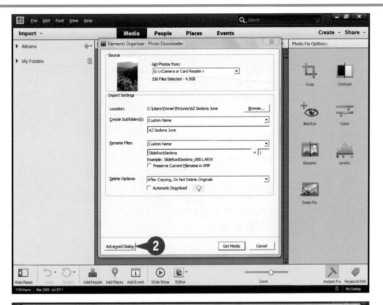

Advanced Importing from a Digital Camera or Memory Card

1 Repeat steps 1 to 10 from the "Importing from a Digital Camera or Memory Card" section to open the Photo Downloader dialog box.

2 Click Advanced Dialog.

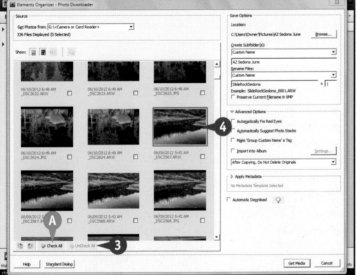

The advanced Photo Downloader dialog box appears.

A All photos are checked to start, so Check All is grayed out at first.

3 Click UnCheck All to deselect all photos to select specific images for import.

4 Click the first photo of your group to import.

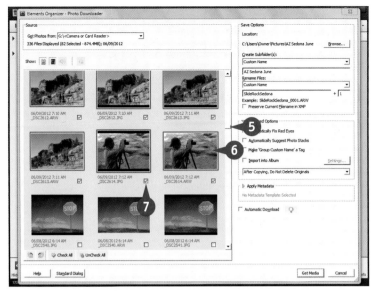

⑤ Scroll down to the last photo in the group.

⑥ Shift+click that last photo to select all photos from the first one to this one, but no others.

Ctrl/⌘+click isolated photos to add or remove them from the group.

⑦ Click the check box under any image to check all that are selected (□ changes to ☑).

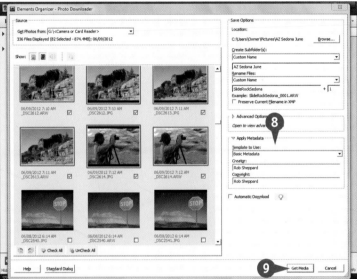

⑧ Click here to open the Apply Metadata section if it is not already open, select Basic Metadata, and type your name for the Creator and Copyright text boxes.

⑨ Click Get Media.

The photos now import into your computer.

⑩ When the Files Successfully Copied dialog box opens, click Yes to include them in the Organizer.

TIPS

Did You Know?

When the Organizer recognizes photos, Photoshop Elements does not move or change them unless you tell it to. Photoshop Elements is simply creating a map to these image files on your hard drive so that it can find and organize the photos as needed.

Try This!

Use the Light Bulb icons. Photoshop Elements scatters tips throughout the program to help you when you do not understand a particular control or option. Click the icon and a tip appears, providing information on how to use the control or option.

Did You Know?

Having your name and copyright information on a photo helps people keep track of your photos. Even if you are not a pro, having your name in the metadata means that if you give your photo files to someone, such as for an organization's brochure, everyone can know whose photos they are.

Use the ORGANIZER INTERFACE

The Organizer in Photoshop Elements makes it easy for you to review many photos at once and in many ways. This latest version of Organizer simplifies access to how you display and work with images so that you do not always have to go to the menus at the top. The previous task showed a good example of this where for importing you simply go to a button called Import.

Removing the panels at the left and right sides lets you see multiple images across your screen, so you can quickly make comparisons among them. This can help you check out your latest photo shoot as well as visually find important images. It can also be a great learning experience as you look to see what you did over time as you took pictures.

Of course, you should look at single images at a larger size. Seeing larger images enables you to find the best photos, whether it means checking sharpness, focus, a person's expression, and so on. The photos seen here are from Slide Rock State Park near Sedona, Arizona.

Imported images first appear in the Media screen.

1 Click My Folders to see all your photographic folders in alphabetical order.

2 Click Sort By to change how images are displayed.

3 Click the small folder icons next to My Folders.

Your folder display changes to show you folders as they are arranged on your hard drive.

4 Click Hide Panel to hide the panel on the left.

5 Click Instant Fix to hide the Instant Fix panel.

Your interface changes to show you a nice display of your images as if they were on a light table. This is called the Grid view.

6 Click and drag the Zoom slider to make the images larger or smaller.

7 Double-click any image.

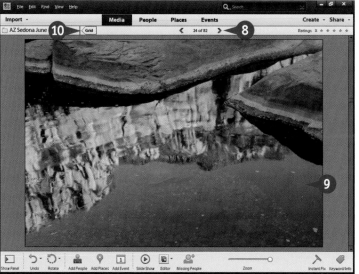

The photo now displays large in the interface.

8 Click the arrows above the photo to move to the next or previous photo.

9 Double-click the photo again to go back to the Grid view.

10 You can also click Grid to go back to Grid view.

TIPS

Did You Know?

The full-screen view can be used as a slide show. Click the center arrow of the bottom toolbar to start playing images or pause the slide show. You can change how long each image is on the screen as well as play music with the photos by clicking the Wrench icon, which gives you settings to try. You can play this slide show only when the Photoshop Elements Organizer is open.

Try This!

The Timeline in Photoshop Elements can help you find photos by date. You can turn it on in the View menu. It works for the entire database, so click the Show All button at the top left of the thumbnails first and then select a specific time; photos from that time period appear below. You can also drag the left and right sliders to limit the dates to show images.

Did You Know?

The Instant Fix panel in the Organizer can be a useful way to quickly make adjustments to your photos. Click the Instant Fix icon at the bottom of the interface to open or close this panel. Then choose controls that enable you to adjust your photo.

Traditionally, going through your pictures, finding the good ones and getting rid of the bad, has been called photo editing. However, when computer engineers developed programs like Photoshop, they decided to call changing pictures in those programs photo editing, too, so the term can be confusing.

Still, one of the most important things you can do with your photographs after importing them into Photoshop Elements is to go through them and edit them based on the original definition of the word. This is a great opportunity for you to learn from both your successes and your mistakes.

Photoshop Elements gives you some excellent tools to do just that. You can compare pictures, look at pictures in different sizes, and discover which pictures work well for you and which do not. A great advantage of digital photography is that it is easy and inexpensive to take multiple shots of a changing scene, such as the waves coming onto a beach, or some variation in composition.

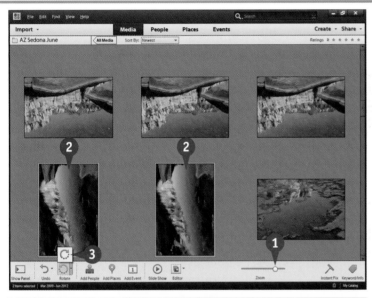

Set Up Your View of the Photos

Leave the left and right panels hidden.

1 Click and drag the thumbnail slider to change the sizes of your photo thumbnails.

2 Ctrl/⌘+click photos to select images that you want to rotate.

3 Click the appropriate Rotate icon to rotate the selected photos.

4 Click the View menu and then Details to show or hide Details.

A Details show up under the photograph and show ratings stars, date and time, and filename.

5 Click the stars to rate your photos.

You can use a system such as one star for those photos you reject, five stars for the best ones, and various numbers of stars in between to define how much you like or dislike particular photos.

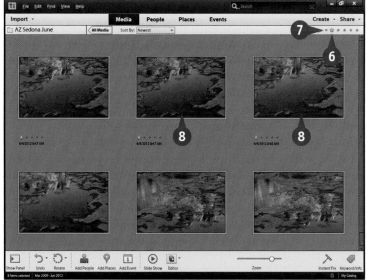

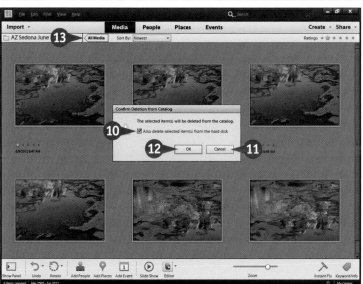

Delete Photos You Do Not Want

#3
DIFFICULTY LEVEL

6 Click one rating star in the upper right of the thumbnail display if you have used a one-star rating for images you want to delete.

7 To limit displayed photos to only those with one star, click the modifier to the left of the stars and select the equal sign.

8 Select all photos with Ctrl/⌘+A.

9 Press Delete.

The Confirm Deletion from Catalog dialog box appears.

10 Select the Also Delete Selected Item(s) from the Hard Disk check box to throw out your rejects.

Make sure the Also Delete Selected Item(s) from the Hard Disk check box is deselected to remove photos only from the Organizer and not the hard drive.

11 If you feel that you made a mistake, you can click Cancel and change the ratings.

12 Click OK to finish the process.

13 Click All Media to get your photos on-screen again.

 TIPS

Remember!
Do not be stuck with too many photos cluttering up your hard drive and your mind. You have the choice of deleting images from Photoshop Elements and/or off your computer altogether. If you really do not like certain images, avoid keeping them just because you do not like deleting photos. Get rid of photos you consider junk. Choose Also Delete Selected Item(s) from the Hard Disk.

Did You Know?
You can control many features of Photoshop Elements with keyboard commands. These enable you to quickly access controls with just a couple of keystrokes. These keystrokes are listed next to the controls in the menus. For example, you can turn on and off the detail display for thumbnails by pressing Ctrl/⌘+D.

Did You Know?
You can turn off the view of filenames using the View menu. Click View and then select or deselect filenames. Clicking Details on or off turns on or off everything under the photo, including filenames.

STACK your images

Once you own a digital camera and a large memory card or multiple cards, taking pictures costs nothing. This means you can freely photograph a subject, trying different angles or varied techniques. However, as you do this, you accumulate a lot of similar photos in your digital files. That can make working with a particular group of photos more challenging because you have to look at a lot of similar images before you come to the new ones.

Stacking enables you to place special subgroups of your photos into stacks that are then displayed as if they were one image. This can simplify the view of your photos in Organizer. You can also use stacks to keep a particular small group of photos together.

In the group of images that were imported on these pages are a number of images that show reflections in the water of Oak Creek in Sedona. The photos are similar enough that they are worth grouping as a stack. Stacks are tools to help you better organize your photos as you go through them.

1 Click the first image of a group that could be stacked.

2 Shift+click the last image of that group.

The whole group is now selected.

3 Click Edit.

4 Select Stack.

5 Select Stack Selected Photos.

4

DIFFICULTY LEVEL

The images are visually stacked so you see only one.

Ⓐ The Stack icon appears in the upper right corner of the stack to inform you it is a stack. You will also see text saying "Photo Stack."

⑥ Click the small arrow at the middle of the right side of the photo thumbnail.

Ⓑ The stack opens and is highlighted as a group.

Ⓒ The Stack icon shows on the first image of the group.

⑦ Click the small arrow at the middle of the right side of the last photo to collapse the stack again.

TIPS

Did You Know?

You may want to simply hide some photos to simplify what you see in Organizer rather than stacking them. Some photos you may want only as a reference, so you do not want to delete them or remove them from Organizer. To hide a photo, go to the Edit menu, select Visibility, then Mark as Hidden. You can make hidden files visible or not appear in the same menu.

Try This!

You can also use stacking to simplify and organize your thumbnail view. For example, you could stack photos of each child at a birthday party so that the entire group of party photos is organized into stacks based on individuals. A Ctrl/⌘+click isolates photos to select them.

Did You Know?

Stacking is simply another method to group photos in a way useful to you. It is based on an old technique slide shooters used when sorting photos. They would pile similar slides on top of each other, making stacks that kept their light tables better organized.

Digital photos are vulnerable to loss from a hard drive failure — and hard drives do fail. There is a saying in the computer industry that it is not if, but when, a hard drive fails. Plus, without a hard copy, you have no other record of the images. By backing them up, you can add more security to your pictures than is possible with traditional film.

Having your images only on the single main hard drive of your computer is asking for trouble. Not only are they at risk of becoming totally lost if that drive fails, but that drive is then more likely to fail because everything on your computer uses it constantly. Plus the added stress of always accessing images increases the potential of that drive failing. That is why many photographers prefer to put their photos on an accessory hard drive and then back up that drive to a second accessory hard drive. These drives plug into a USB, FireWire, eSATA or Thunderbolt port and have come down so much in price that they truly are a small cost to preserving your images.

An external hard drive is one of the best ways to back up the images on your computer's hard drive.

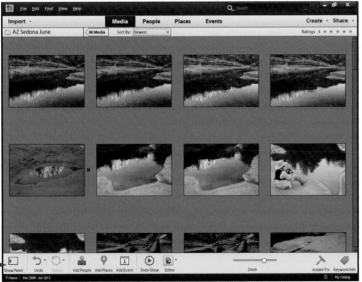

Back Up to an External Hard Drive

❶ Click Show Panel at the bottom left to reveal the Folders panel.

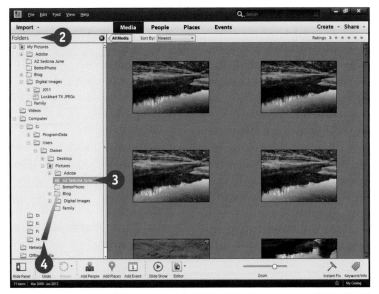

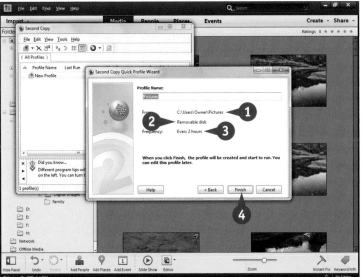

② When the left panel appears, choose the Folders view.

③ Click the folder you want to duplicate.

④ Drag the folder to the external hard drive.

On a PC, the external drive may appear only as a letter. Use Windows Explorer to find which letter your drive represents.

The folder is saved on the external hard drive.

Use Backup Software

Note: *You can obtain special backup software to help you with backing up your photos. All these programs work slightly differently, though the steps are similar.*

① With your backup software open, choose the folder or folders you want to back up.

② Select the location for backup.

③ Select when to make the backup.

④ Click Finish to start the backup.

The backup software saves the folder or new images in the folder to the designated location at the time you specify.

TIPS

Did You Know?

Backup software can make your backups easier. Once you set up backup software for specific folders and a specific accessory drive, the software remembers those locations. The next time that you ask it to back up, it simply compares files in those two locations and adds only what is new. Check out Second Copy for Windows at www.centered.com and Déjà Vu for Macs at www. propagandaprod.com.

Did You Know?

Photoshop Elements Organizer now includes a backup function in the File menu that enables you to back up the catalog and files. Some people like how Adobe has set this up and some people do not. Specific backup software can make this easier, but it does not back up the catalog of Organizer. The catalog holds the organizing database for Photoshop Elements.

Try This!

You can create a duplicate file structure on your backup drive that matches your main computer in order to make your backups simpler. Simply create folders and levels of folders that include the files you want to back up that are the same on both. For example, if your photos are structured by year and then by specific event, use the same year and event structure. Then you can simply copy a folder from one drive to another in the same filing setup.

Use INSTANT FIX

Instant Fix is a very useful tool to help you quickly and easily get automated adjustments of your photos while still in Organizer. This panel offers you one-click adjustments for a number of key photographic controls. These adjustments are not going to be optimum for every photo because they are automated, but they can be a fast way of getting an acceptable adjustment to an image that you can quickly use to make a fast print or to post to Facebook.

A nice thing about Instant Fix is that no adjustments change your original image. A new, duplicate image file is created for JPEG files automatically, and for RAW files, a specific new file is created with a file type of your choice. Each time you click a new control, you get a new file. Smart Fix uses all the automated options in Smart Fix at once for just one new file. Sometimes that is best, but sometimes you do not need or want all those adjustments made.

① Click Instant Fix to open the right panel.

② Select an image to work on. Double-clicking the image displays it large.

③ Click the Instant Fix adjustment icon you want to use.

If your image is a JPEG file, Instant Fix duplicates that file and immediately starts to apply the adjustment.

Ⓐ RAW files cause a dialog box to open for you to choose the file format for the new image file.

④ Choose a file format. Use Photoshop if you think you might work on this new file later in Editor. Use JPEG if you want a small file to use for e-mail or other purposes.

⑤ Click OK.

6 A small window appears informing you that the processing is being done.

#6
DIFFICULTY LEVEL

B The new image appears stacked with the original when seen in the Grid view.

C The Instant Fix icon appears at the top right of the photo to let you know the image has been adjusted.

D The file has a name based on the original with _edited-(*number*) added.

TIPS

Did You Know?

RAW files can never be changed and must be converted to a file format such as JPEG, TIFF, or Photoshop to be used for anything outside of Photoshop Elements. RAW files hold more image information than JPEG files, useful when working on them in Camera Raw, which comes with Photoshop Elements, but they have little advantage in Instant Fix.

Try This!

A great way to photograph in a canyon or valley is to get there early when the light is on the canyon walls, but not on the stream or creek below. That is what you see here. This creates interesting reflections in the water that contrast with the shadowed surroundings. Use Shade white balance and be careful you do not overexpose the reflection.

Try This!

If you are not sure exactly what an adjustment will do to your photo, and they are hard to predict because they are automated, try it and see. This hurts nothing because your original image is untouched. If you do not like the adjustment, just delete it.

CREATE ALBUMS to group your pictures

Albums are a very useful way of grouping your images so you can find particular photos later. You can create an album of specific images from a particular event such as a trip, or you can create an album based on a subject that shows up in many places in your photography. Albums are not specific to any folder of images that you have imported. For example, for the photos shown in this chapter from Sedona, Arizona, you could create an album on just the latest trip there, or you could include images taken at other times you had been there. As another

example, you could create an album related to just reflected scenes that could begin in Sedona and expand to any place you went that had water that might reflect the landscape.

Albums do not duplicate photographs. They only create references to where the pictures are on your hard drive. For that reason, individual pictures could be in many albums, which can help you find them faster in different ways.

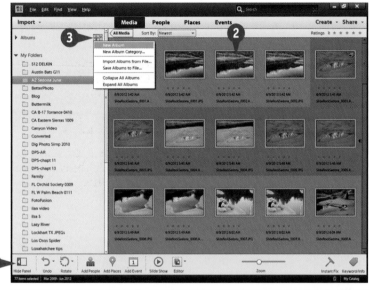

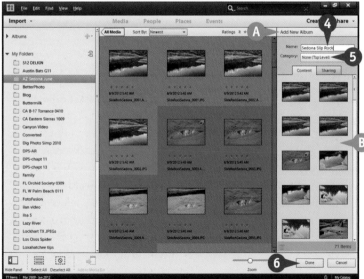

① Click Show Panel at bottom left to show the left panel. The screen shows Hide Panel because the left panel is visible.

Hide the right panel by clicking the Instant Fix icon at the bottom to give more room for your photos to display.

Click Grid to show thumbnails of photos if you have a single image displayed.

② Ctrl/⌘+click photos to select individual images, or click a photo and then Shift+click the last image in a group to select photos in order.

Optionally, press Ctrl/⌘+A to select all photos.

③ Click the large green plus sign to the right of Albums and select New Album to add an album.

Ⓐ The Add New Album panel appears.

④ Type a name for your album.

⑤ You can group albums by using the Album Category function, but start with None (Top Level).

Ⓑ Your selected photos appear in the Content box.

⑥ Click Done.

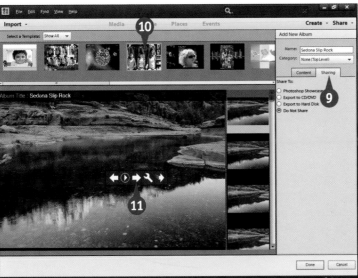

The new album now appears in the Albums panel after Organizer builds its preview images.

⑦ Click Albums to show the albums if they do not appear.

⑧ Click an album to select it.

Remove photos from your album by right-clicking the photo and selecting Remove from Album from the context-sensitive menu that appears. Set up your Mac to use a right-click with your mouse if you have not done so. This is called secondary click in System Preferences.

⑨ Click Sharing for sharing options.

After processing the images for sharing, Organizer displays a new interface to allow you to share your images by exporting your photos as an album.

⑩ Choose a template for the album.

⑪ Use the slide show controls to see how the album plays as a slide show and to change slide show settings. This is only available for PCs.

TIPS

Did You Know?

You can add photos to an album at any time. Whenever you see a photo that belongs in an album, click it and then drag it to the album. The photo is automatically placed in the album and appears there whenever that album is open. Remember you are only creating references to photos and not actually moving any.

Try This!

You can immediately put any new photos just imported into Photoshop Elements into an album. Select all images in that new group of photos, add an album with a name appropriate to that group, and the photos should appear in the Contents box. If not, select and drag the new pictures into that Item box.

Smart Albums!

You can create a Smart Album that automatically adds photos to the album. You set up criteria, such as filenames, keywords, and camera type, in the New Smart Album dialog box, which you access by clicking the Albums plus sign. Any photo with those criteria appearing in Photoshop Elements is automatically included in the Smart Album.

Work with PEOPLE VIEW

People are an important subject for most photographers. Friends and relatives are photographed in all sorts of settings. And today, digital cameras are so much a part of family life that parents and grandparents are constantly shooting all members of the family, especially the kids. This can result in a lot of images containing many people, but those images can be hard to find later. It would be nice to just be able to isolate one person's photos out of the mass of images on your hard drive.

Photoshop Elements offers a handy way of dealing with people through its People view. This view lets you find specific people in different folders long after you even remember taking those images. Once you have located and named the people, Organizer puts that information into its database so you can access it in the People view. People view acts like every other view in Organizer in that you can hide and reveal panels at the left and right, use Instant Fix, show images single or in a grid, and so on.

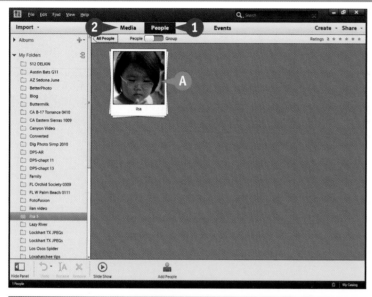

① Click People view to show any people that have been identified in your photos.

Ⓐ People appear in stacks of photos.

② Add people to People view by going back to Media view.

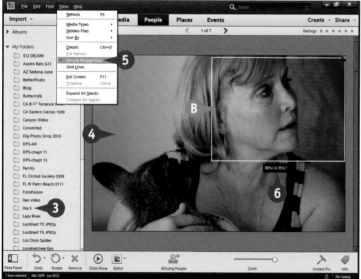

③ Select an album to find people in.

④ Go to a photograph of a person in the Grid view and double-click it to make it large.

⑤ Be sure People Recognition is turned on in the View menu.

Ⓑ A box appears over recognized faces.

⑥ Click Who Is This? and type a name.

After typing a name, press Return or Enter.

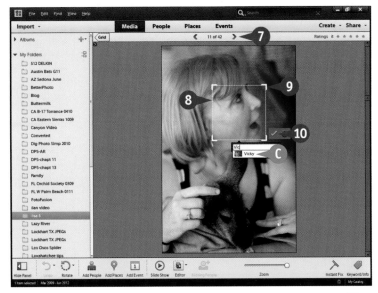

DIFFICULTY LEVEL

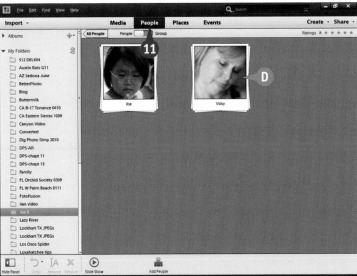

7 Click the arrow above the picture to move to the next image or use the arrow keys on your keyboard.

8 Click and drag the recognition box to better highlight the face.

9 Click and drag the corners of the box to size it better for the face.

C As you type a name, Organizer gives you a recommendation. Use the down-arrow key on your keyboard to select it.

10 Click the green check mark or press Return or Enter on your keyboard.

11 Click People to show the People view.

D A new stack of people photos appears with the person's name.

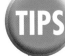 **TIPS**

Important!

Set up your Mac to use a right-click with your mouse if you have not done so. The latest Apple mouse does allow right-clicking if you set it up through System Preferences using secondary click. You can also purchase different designs of right-click mice. Photoshop Elements has many right-click menus that are more easily accessed in this way. Otherwise, you have to press the Control key while clicking, which is much less efficient and can lead to mistakes.

Did You Know?

If a photo contains more than one person, Organizer provides additional boxes to allow you to identify them, too. Each person will have a unique stack in People view even if he or she appears in a photo with other people. If no box appears, click the Missing People icon at the bottom of Organizer to get one.

Did You Know?

Right-click any photo in any view and you get a context-sensitive menu specifically related to working with pictures. As you identify a person in different pictures, in different folders, you might not remember what folder a specific picture in People view is from. Right-click and look for a menu choice that goes back to the folder.

People view can offer you the ability to isolate every person you have ever photographed into individual stacks so that you can always find photos of them throughout your files. That is the good news. The bad news for some photographers is that to do this, you have to take the time and go through every photo, identifying the individuals so that Organizer can put them into People view. People view is a database, and databases work only when you are willing to put in the time and effort to build that database.

People view also enables you to group people into groups such as family or friends. Move the slider at the top of the stacks view in People from People to Group to reveal a Group panel on the right. Drag any stack to any group to add a person to a group. Once you do that, the Group interface of People shows your stacks as ungrouped or in what group they reside. Double-click a group icon in the Group panel to reveal stacks included in that group.

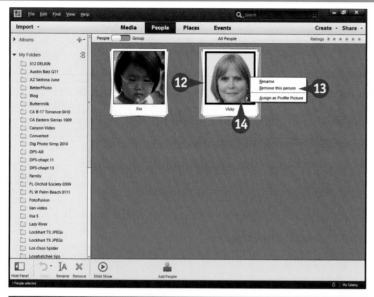

⑫ Move your cursor slowly across a stack, without clicking, to display the images in the stack.

⑬ Right-click when you get to an image you want, then use the context-sensitive menu to remove it, rename it, or select it as the profile photo for the stack.

⑭ Double-click the stack to open it.

Ⓐ The stack opens as Faces or Photos, depending on how it was last seen.

Ⓑ Faces displays just the face of the person identified from the photo, even if the original image had lots of faces.

⑮ Click the switch to slide it from Faces to Photos.

#8

(continued)

Whole photos now appear from the person's stack.

16 Double-click any photo.

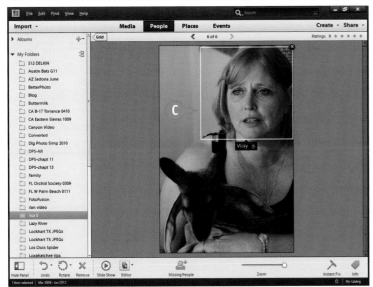

The photo appears as a single image filling the Organizer image area.

C The people recognition box appears around the person's face with his or her name so you can find the face in a crowd if needed.

TIPS

Important!
To add a specific group to the Group mode of People view, open the Group panel on the right. This is available only when you are looking at multiple people stacks. Next, click the green + arrow that appears in the panel. Type a name for the group in the dialog box that appears, and choose to make this its own group or part of another group. Click OK.

Did You Know?
The picture on the stack of people photos is called the *stack profile picture*. It is based on the box that outlined your person when you first identified him or her. Change the position and size of that box as you identify the person to get a better profile image later.

Did You Know?
Groups, Albums, and Views are all simply ways that Organizer offers you to better organize your photos. None of these groupings changes your photos or moves them in any way on your computer. These are essentially "virtual groups" that Organizer is using to help you separate and define your photographs into manageable groups.

Work with PLACES VIEW

Global positioning system, or GPS, uses satellites to allow you to pinpoint your location anywhere in the world. You can use GPS units and even your smartphone to determine your coordinates so you can return to a location later or to search for a specific location. This has made people far more aware of where they are as they travel.

Although you cannot access GPS satellites with Photoshop Elements, you can pinpoint locations of your photos anywhere in the world with Places view. This section of Organizer must be able to connect with the Internet in

order to use it because it needs to access a world database of Google maps. You can then pinpoint your photo locations on that map so that later you can always use that as a reference as to where you were.

The photos seen here were taken at the Petrified Forest National Park near Holbrook, Arizona. This is a striking location of high desert, rainbow-colored hills, and of course, the remains of an ancient forest, now preserved in rock.

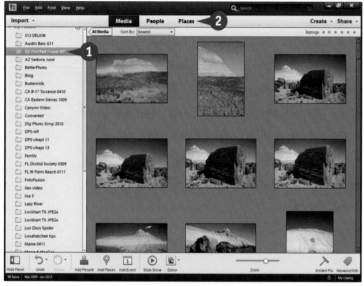

1 Click a folder to display its images in Media.

2 Click Places.

Nothing appears in Places until photos have been placed on a map.

3 Click Add Places.

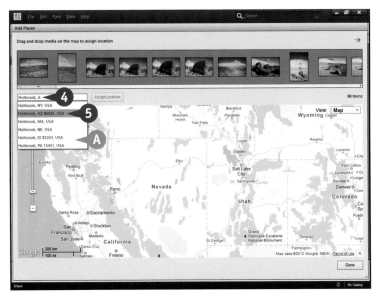

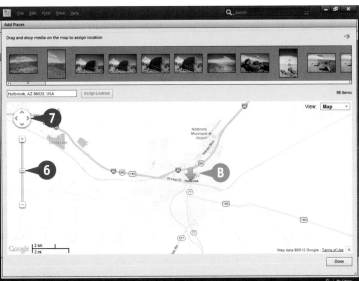

A map now appears along with a filmstrip of images above it. The filmstrip is based on the folder you selected at the left.

④ Type in the search box a place where your photographs were taken. This can be a nearby town.

Ⓐ As you type, and depending on the speed of your Internet connection, you get a list of suggestions.

⑤ Click the location you want.

Otherwise, simply press Enter or Return when you finish typing your location.

The map now shifts to display the searched-for location.

Ⓑ A green arrow marks the searched-for spot.

⑥ Use the Google map resize controls to resize the map to help find your photo location.

⑦ Use the Google map position controls to move the map around. You can also click and drag on the map to do this.

TIPS

Did You Know?

You do not have to start in Media view to work with Places view. You can access folders when you are in Places. However, it is a little disconcerting to go to Places and see no images when you first open a folder and no images have been placed on a map. By going to Media view first, you can look at your images and get an idea of what you have there before you start working with a map.

Did You Know?

Google Maps is often used by people exploring the Internet to find specific locations around the world. This includes an extensive database of maps that show everything from an overview of the entire planet down to the house and street where you live. It is used by many businesses, such as Adobe for Photoshop Elements, to provide an interactive map service.

Did You Know?

The Petrified Wood National Park is an unusual location in Northeastern Arizona right off of I-40. Parts of the park offer trails through ancient forests, but all the trees look like they have been cut down and chopped into sections. Over a very long time, colorful minerals have seeped into the wood, making it a rock that still has a wood-like appearance.

This can be a fun way to interact with your photos after a trip. You can relive where you went as you place your photos on the map. Images can be placed individually at precise locations or as groups at a more general meeting spot or anything in between. It is up to you.

You can place your photos in extremely accurate positions on the map or just attach them in a general location. This depends on how large you blow up the map as you work with locating your camera position when you took the pictures. Places always puts a marker on a very specific location, so if you want to be totally accurate, you need to blow up the map to a level that lets you do that.

You must decide how much time you want to spend doing this map work. Just like working in People view, you can spend a lot of time here, and that does not appeal to all photographers.

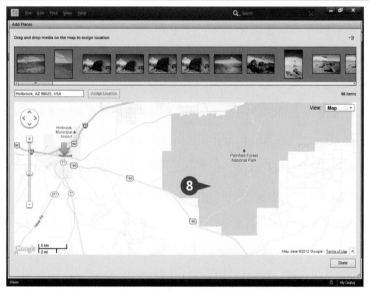

Your map now should clearly show your location.

⑧ Size your map so that you can see the location well enough to place your photos. Sometimes in natural areas without roads, Google maps does not give enough references for you to place your photos if the map is enlarged too much.

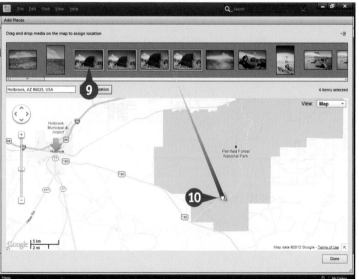

⑨ Ctrl/⌘+click photos to select individual images, or click a photo and then Shift+click the last image in a group to select photos in order.

Optionally, press Ctrl/⌘+A to select all photos.

⑩ Click and drag the selected photos to place them on the map.

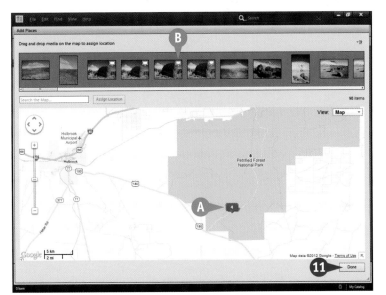

A A marker now appears on the map where the photos were taken. The number of photos for this location shows up on the marker.

B The photos gain a small Places icon at the upper right to show they have been placed.

⑪ Click Done when you have placed all the photos you want to place.

Places now displays your placed images.

⑫ To see where the images are on a map, click the Map icon to display the map.

⑬ Double-click a photo to show where it is on the map.

⑭ Double-click the icons on the map to display the photos at that location.

TIPS

Did You Know?

The global positioning system (GPS) is a direct benefit of space technology. It uses satellites to triangulate your position nearly anywhere on the planet (you must have clear access to the sky). It was started 40 years ago by the U.S. Department of Defense for military purposes, but is now a backbone of travel systems across the globe.

Try This!

By default, all tags showing where your photos have been placed appear on the map when the map is in Places view. That can be confusing. Change the display to only show the visible images by clicking Show Only Media Visible on Map at the bottom of the map.

Did You Know?

Petrified wood is heavy! Its wood has been replaced by agate-like rock so that it weighs nearly 200 pounds per cubic foot. Even a small log can therefore weigh over a ton! It is illegal to remove petrified wood from the park; doing so will net you a large fine and a bad back.

Work with EVENTS VIEW

Much of life is based around events, from family events such as births, graduations, and weddings, to public events such as parades and fairs. One way of organizing your images is to collect them into groups by events, and Photoshop Elements Organizer enables you to do exactly that. A reminder: These groups are collections that simply organize your photos; they do not move them on your hard drive.

The event being organized here is the Kinetic Sculpture Race in Humboldt County in far northern California. This is a unique, public event that occurs every year over the

Memorial Day weekend. Participants create remarkable machines that can only be human powered and are put together with quite creative and artistic designs. Over the three-day event, racers must travel between Arcata, Eureka, and Ferndale while traversing county roads, sand dunes, and even a passage across water. The race is done in three sections, with a camp out for racers between each. Judges even check to be sure racers have sleeping bags and toothbrushes on board for each participant before they can race!

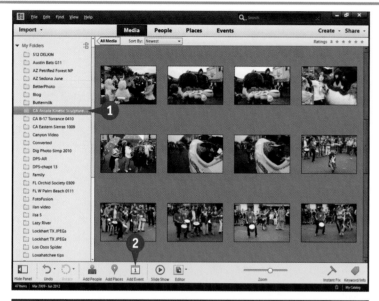

1 Click a folder in the Media view that holds photos from an event.

2 Click Add Event.

The Add New Event panel appears.

3 Type a name for the event.

4 Type a description for the event.

28

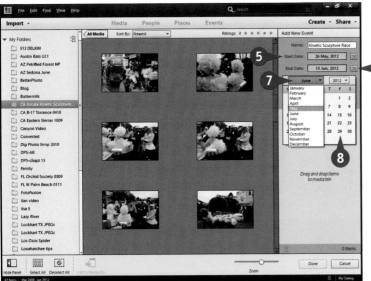

5 Set the start and end dates of the event.

6 Click the calendar icon to get a calendar.

7 Click the month and year to get a drop-down menu so you can select each.

8 Click the day of the month.

9 Ctrl/⌘+click photos to select individual images, or click a photo and then Shift+click the last image in a group to select photos in order.

Optionally, press Ctrl/⌘+A to select all photos.

10 Click and drag the selected photos to include them in the event.

TIPS

Did You Know?

Everything you shoot has a date built into the metadata of the image file as saved by the camera. Organizer already recognizes that and even stacks all your images by date if you go to Events, then slide the Events/Dates switch to change it to Dates.

Try This!

If you know you want to place an entire folder of images into an event, you can select all the images before you click Add Event. If you make that selection first, all your selected images will already be in the content section of the Add New Event panel when the Add New Event panel opens.

Did You Know?

The Humboldt County Kinetic Sculpture Race is the original kinetic sculpture race and bills itself as the Kinetic Grand Championship. It started out over 40 years ago when a Ferndale sculptor enhanced the look of his son's tricycle, and an artist friend challenged him to a race. Today, racers get prizes for many things, from the expected race winner to artistic merit to the first racer to break down leaving town.

This is the third of the three main collections of images available to you in Organizer: People, Places, and Events. These three categories appear prominently at the top of the Organizer interface along with the main way of seeing all your images, Media. Media is simply everything in Organizer and is not a collection of specific images based on specific criteria the way that People, Places, and Events are. Media is organized by the way you put your original images into folders that appear in the Folders view at the left or the directory tree showing the exact location of the folder on your hard drive, also available on the left.

Some photographers are more detail oriented than others and will spend more time developing these collections. The advantage of doing that is that you will have a better system for accessing unique images in your photographs. The disadvantage is, of course, the time needed to do that. No one approach works for every photographer.

Ⓐ Your photos now appear in the content area of the Add New Event panel.

⑪ Click a photo and then click the trash can icon to remove it from the content area.

⑫ Click Done.

You return to the main Media view.

⑬ Click Events.

Your a stack of images in Events now represents your event.

14 Move your cursor slowly across a stack, without clicking, to display the images in the stack.

15 Right-click when you get to an image you want, then use the context-sensitive menu to set it as the "top" photo for the event or to choose other options.

16 Double-click the stack to open it.

17 Click All Events.

The All Events screen for Events appears. All events that you have defined and described as detailed in this task appear here.

Did You Know?

At the bottom right of an event stack is a small *i* icon. Click it to see the full description for the event in a small display with the stack. This display can be very helpful if you have put in a lot of information about an event so that you can see it quickly.

Try This!

To access a full-screen mode for your event and play it as a slide show, go to the View menu and select Full Screen. You can also access this with the F11 key on most computers, though this depends on how the function keys are set up for use on your computer. This Full Screen mode can be used throughout Organizer to fill your screen with photography, not a computer program.

Did You Know?

When event stacks are displayed in Events, a calendar panel appears on the right. It can be turned on and off with the calendar icon below. This panel lets you change what event stacks are being displayed by selecting specific years and even months as needed.

USE KEYWORDS to tag your images

In Organizer, you can connect special words to your images called *keywords*. You can be as specific as you want with keywords to allow you to quickly search for specific photos. In previous versions of Organizer, you could do only keyword tags. In Photoshop Elements 11, you can now type specific keywords for your photos without using tags.

You have to spend the time attaching keywords to your photographs in order to use keywords. You may know that you have a photograph of a bear somewhere in your

collection, but if you have not associated the keyword "bear" with that image, it could be very hard to find.

You can simply add keywords to large groups of selected pictures, or, if you want to be able to really find specific images, you can add a lot of very specific keywords to individual pictures.

The photos seen here are from the Kinetic Sculpture Race. Keywords for them could be as specific as individual names for the unique vehicles plus other details or as generic as "parade." This depends on your needs.

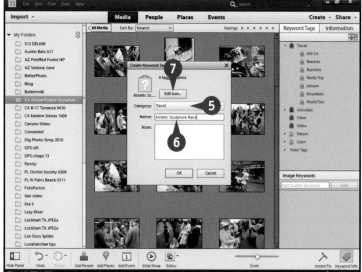

Using Keyword Tags

1. Click the Keyword/Info icon to open the Keyword Tags panel of Organizer.

2. For more space, close the folders panel at the left by clicking Hide Panel.

3. You can start with the Keyword Tags listed.

4. Click the large green plus sign at the top right of the panel.

The Create Keyword Tag dialog box appears.

5. Choose a category.

6. Type a name for your keyword tag.

7. Choose an icon if desired by clicking Edit Icon.

(A) A new keyword tag appears in the category you chose in step 5.

(8) Select the photos that need this keyword.

The selected photos have a blue frame around them.

(9) Clicking and dragging the selected photos onto the tag means they gain that tag.

You can also put a keyword on a specific photo by clicking and dragging a tag to a photo or group of selected photos.

To search for images by keyword, be sure you are displaying all photos. When you are in the Media view, click All Media if it is visible just below Media.

(10) Type a keyword or set of keywords into the search bar.

(11) Photoshop Elements finds the images and displays them as you type.

 TIPS

Try This!
You can search using Keywords and Keyword Tags over your entire collection of images or just in a specific folder. To limit a search to specific items in an album, click the album first. To search throughout your images, be sure you have checked All Media just under Media. If All Media is not visible, you are showing all media.

Important!
Pick keywords that help you find your photos. Your keywords will be unique to your type of photography. Adding keywords that others use but do not fit your images will make your searches confusing. Ask yourself, "What do I need to find?" in order to create keywords that work for you and your needs.

Customize It!
You can add as much or as little information as you want to keyword tags. The Create Keyword Tag dialog box includes the option to add notes such as a specific address for a location. Notes are not requirements, only options that some photographers use frequently, and others not at all. Use what you need and what works for you.

Keyword Tags are a simplified version of keywords that have been with Photoshop Elements for a long time. They make keywording drag-and-drop simple, but they get rather unwieldy if you want to do extensive keywording. Now you can type in keywords directly for heavy use of keywords.

It is important to understand that you can add keywords to one picture and only one picture, to a few, or to hundreds. Keywords enable you to be very specific, down to putting a specific name on something that appears only in one picture. They also enable you to be broader in your approach and put a single word across a whole group of pictures so that you can find that group again. Keywords work across all pictures within Organizer so that you can find pictures throughout Organizer by simply searching for keywords in the search bar at the top of the interface.

The best time to add keywords is when you first import pictures into Photoshop Elements. At that time, you remember the most about your pictures.

Using Keywords

1 Click one or more photos to add keywords to. Ctrl/⌘+click photos to select multiple images, or press Ctrl/⌘+A to select all photos.

2 Click the Keyword/Info icon to show the Keyword Tags panel.

3 Click Show/Hide Panel to show or hide the left panel to change how much room your photos have to display.

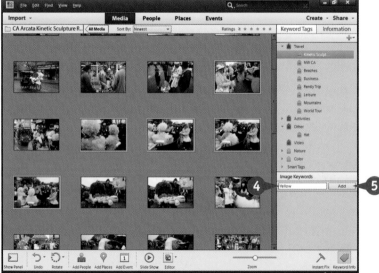

4 Type your keywords in the Image Keywords box.

You can also type multiple keywords at the same time by separating them with commas.

5 Click Add to add the keywords to the photo or photos.

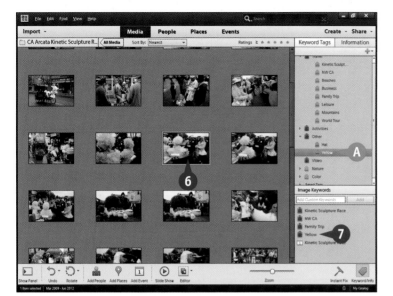

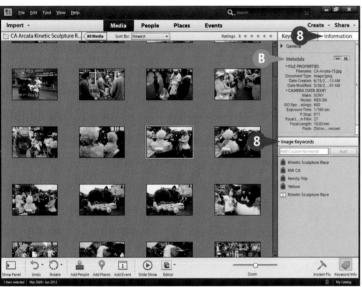

A The keyword now appears as a new keyword tag.

6 Click a photo.

7 The photo's keywords appear in the Image Keywords box.

8 Click Information to swap the Keyword Tags panel for a simpler panel that accepts direct input of image keywords.

B Information displays information about your photo, including metadata about shutter speed, f-stop, and so on.

TIPS

Try This!

You can quickly narrow a search down to very specific photos if you have many keywords for each photo. To do this, type your keywords in the search box at the top of Organizer and separate each keyword with a comma. Organizer then looks for images that include all the keywords and only those keywords.

Did You Know?

Professional photographers frequently use extensive keywords to help them find photographs in their files. When a client wants something specific, such as young people at a Fourth of July parade, keywords help find photos with those criteria. Keywords would include "young people," "Fourth of July," "parade," and so on.

Try This!

You can type a list of keywords based on common descriptions of things in your photos. You can then import this list into Photoshop Elements by clicking the arrow next to the large green plus sign under Keyword Tags and selecting From File. This file must be an XML (Extensible Markup Language) file. You can save a Word file as an XML file for this purpose.

Start Adjusting Your Images in Photoshop Elements

A challenge all photographers face is that the camera simply does not capture the world the way people see it. That does not mean the camera is better or worse, just different, but that difference can mean photos are not at their optimum coming from the camera.

That is where Photoshop Elements comes in. With most images, you need to spend a short time tweaking them so they accurately reflect what you originally saw. In this chapter you learn some basic steps to get your photos looking more the way you expect a photograph to look. Sometimes you will hear people say that an image has been Photoshopped, meaning it is no longer a reliable interpretation of the world. However, sometimes you have to use Photoshop Elements to correct and fix photography's shortcomings in order to get that true world view in an image.

This chapter also reflects a workflow based on the basic needs of a photograph: having good blacks and whites, having proper midtones for the subject, and having accurate and reliable color. A few of the steps, such as setting blacks and whites, adjusting midtones, and performing color correction are important for any photograph, and are also important when processing RAW files or using layers.

DIFFICULTY LEVEL

To start working on photos in Photoshop Elements, you need to get a picture into the Editor workspace of Photoshop Elements. You can work with Organizer to do this, or you can get images directly into Editor from the Editor's File menu.

Many photographers worry about adversely affecting an image and therefore are cautious when working on it. If you immediately save any picture as a new file after opening it in Photoshop Elements, you are protecting your original image file. This frees you to work on your image without worrying about permanently damaging it. You cannot damage your original because you are not working on it at this point.

This task and all the other tasks in this chapter are directly related to JPEG or TIFF files. If you shoot RAW files, you will be working with Adobe Camera Raw, which comes with Photoshop Elements and is covered in the next chapter.

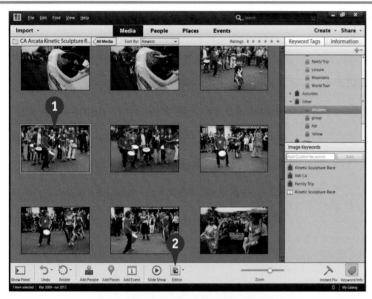

① Click a photo to select it.

② Click the Editor icon at the bottom of Organizer.

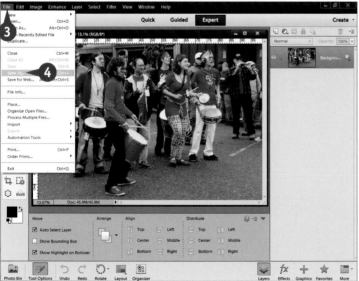

Ⓐ The photo opens in Editor.

③ Click File.

④ Select Save As.

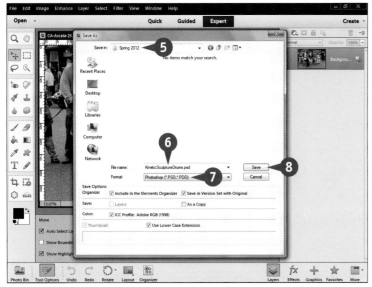

The Save As dialog box appears.

⑤ Choose a location to save your photos.

⑥ Give your photo a name that makes sense to you.

⑦ Choose either Photoshop (.psd) or TIFF (.tif) for the format.

⑧ Click Save.

If you chose Photoshop in step 7, your photo is saved without any additional steps.

If you chose TIFF in step 7, you see TIFF Options choices.

The TIFF Options dialog box appears.

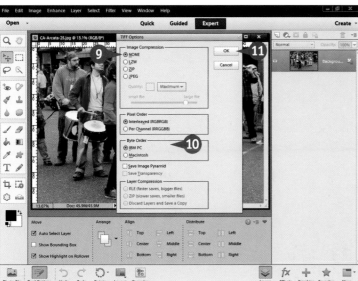

⑨ Select NONE for image compression, although LZW can be used if your photos will be opened in a limited number of programs, including Photoshop Elements.

⑩ Leave the radio buttons in the Pixel Order and Byte Order sections at the default settings.

⑪ Click OK.

Photoshop Elements saves the photo.

TIPS

Try This!

You can open photos directly from Editor. Simply click Open at the top left. This takes you to the Open dialog box. Navigate to where your digital photos are kept, and then find the folder and the image. When you click a photo once to select it, a preview appears. Click Open to open it in Editor.

Did You Know?

Photographers can save images in Photoshop, TIFF, and JPEG formats. You should not use JPEG as a working file format, that is, a format that you use to work on images while you are in Editor. JPEG is a compressed file format and should be used only for archiving images when you need to keep file sizes small or for email and web purposes. Both Photoshop and TIFF enable you to open, adjust, and save an image as much as you want without any loss of quality.

Did You Know?

Sometimes it helps to see the rulers around the image, and sometimes you want to hide them. You see both ways displayed in this chapter. This is easy to turn on or off. Go to the View menu and click Rulers to show or hide them. Set the dimensions for the rulers in Preferences, under Units & Rulers.

Photoshop Elements has been designed to work well as soon as you install it. You could leave the preferences alone and the program would work fine. However, Editor has preferences you can set to make the program run more efficiently on your specific computer and to make it more suited to the way you work. You access the preferences at the bottom of the Edit menu in Windows and in the Adobe Photoshop Elements 11 menu on a Mac. If you are not sure about any of the choices, leave it alone — what

you see here are some key options that can be worth checking. Adobe put a lot of thought into the defaults, so they do work.

In Preferences, you can choose to affect all sorts of things, including how files are saved, the performance of Photoshop Elements with your computer, plug-ins, and more. Most of the options are fairly self-explanatory, and if you are not sure what they do, you can always try them and then reset everything later if needed.

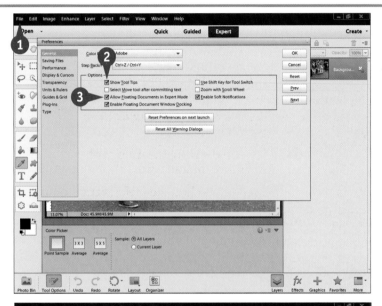

① Click Edit on a Windows computer, select Preferences, and then click General to open the Preferences dialog box.

On a Mac, click the Adobe Photoshop Elements 11 menu first.

② Select Show Tool Tips to display tips about tools when the cursor is positioned over them.

③ Select Allow Floating Documents in Expert Mode to allow your images to float within the interface.

④ Click Saving Files.

⑤ From the On First Save drop-down menu, select Save Over Current File for efficient work or Always Ask if you want to be extra safe.

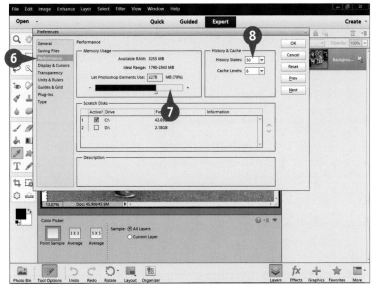

6 Click Performance.

7 Under Memory Usage, set the usage in the Let Photoshop Elements Use field to the upper part of Ideal Range unless you have less than 2GB of RAM.

This setting is not in effect until Photoshop Elements is closed and opened again.

8 Choose History States of at least 50 so you have room to back up in the Undo History panel.

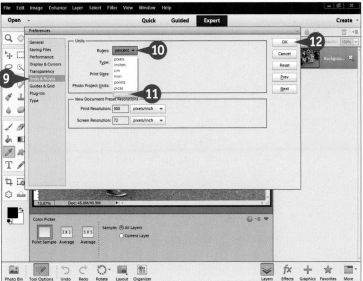

9 Click Units & Rulers.

Often Photoshop Elements users find it difficult to locate this option to change the way rulers show measurements.

10 Click on the Rulers option box to get a drop-down menu.

11 Select the type of measurement that works best for you.

12 Click OK to close the Preferences dialog box.

Photoshop Elements saves your preferences.

TIPS

Did You Know?

When Photoshop Elements runs out of RAM or "thinking space," it needs someplace to work, and uses space on a hard drive. This is called *scratch space*, and the drive being used is the *scratch drive*. You should have a minimum of 2GB free on any drive used for scratch space so that Photoshop Elements never runs out of room to think.

More Options!

Color Settings are a group of preferences that have their own separate settings. You access them in the Edit menu in both Windows and on a Mac. You will do okay when they are set at the defaults, but you get more capabilities and options for how color can be adjusted if you select Always Optimize for Printing. This gives you what is called the AdobeRGB color space.

Did You Know?

A color space is something a computer uses to describe how colors are rendered. A common color space for JPEG files is sRGB, which works fine for many images but is a smaller color space than AdobeRGB. AdobeRGB gives you more flexibility and options when you are adjusting color and tonality.

YOU CANNOT HURT your pictures

Experimenting with controls in Photoshop Elements is one of the best ways of learning this program. If you are not sure how something works, just try it and see what it does. You have the most flexibility with photo editing in the Expert mode, though the program opens in Quick mode. Just click on Expert.

As long as you have done a Save As for your original image (see task #12), you cannot hurt the original image because you are now working on a copy. And as you work, you can always undo everything that you have already done. As long as you do not save what you have done, no change is made to the file you are working on except what you see within Photoshop Elements. The History window gives you even more options for undoing your adjustments. Knowing this can help you freely try things and discover the possibilities for your image, such as this lively group of drummers from the Kinetic Sculpture Race in Arcata, California.

Reverse Adjustments

1. Click Enhance, select Adjust Lighting, and then select Levels.

2. Randomly make some adjustments. You do not have to know what you are doing.

3. Click Edit.

4. Select Undo Levels.

 Note: Alternatively, press Ctrl/⌘+Z.

5. Select Revert to go back to the last saved version of the open file.

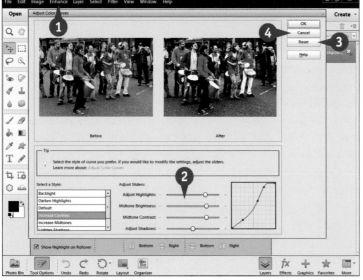

Reset a Dialog Box

1. Click Enhance, select Adjust Color, and then select Adjust Color Curves.

 The Adjust Color Curves dialog box appears.

2. Randomly make some adjustments with the sliders. You do not have to know what you are doing.

3. Click Reset to bring the adjustments back to their default settings.

4. Click Cancel to close the dialog box.

Use History

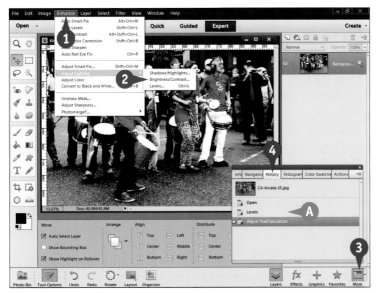

#14

DIFFICULTY LEVEL

1 Click Enhance.

2 Randomly make some adjustments from Adjust Lighting and Adjust Color. You do not have to know what you are doing.

3 Click More at the bottom right of the interface.

4 Click the History tab.

Ⓐ All adjustments appear in the History panel.

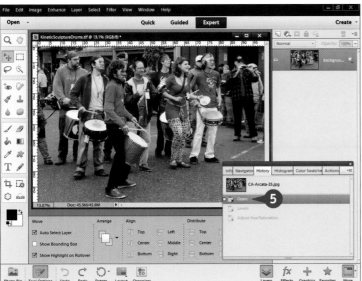

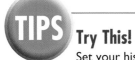

5 Click any adjustment in the History panel to go back to an earlier adjustment.

Note: You can also keep pressing Ctrl/⌘+Z to back up in this panel.

TIPS

Try This!

Set your history for more or fewer adjustment steps or states by clicking Edit in Windows or the Adobe Photoshop Elements 11 menu on a Mac, selecting Preferences, and then selecting Performance (see task #13). History states represent the specific actions you have done that appear in History. Too many states can slow your computer down, but too few can be frustrating to work with.

Important!

You will see keyboard commands throughout the book. This is one place where Windows and Mac differ within Photoshop Elements. Ctrl (Control) in Windows is the same as ⌘ (or Command) on a Mac. Alt in Windows is the same as Option on a Mac.

Caution!

There is one way you can lose your ability to back up from adjustments. If you make a lot of adjustments to a picture and then save and close it, you lock those adjustments to the picture. Save your photo as you go, but only when you are sure that your adjustments are okay. Later in this book (see task #25), you learn how to make nondestructive adjustments that enable you to close and save an image with those changes intact and still adjustable.

A common problem for photographers is getting too much in a picture. Sometimes this comes from not being able to get close enough to the subject. You may also find that you like an image with a different set of proportions compared to when you shot the photo. You might want a square from a horizontal, for example.

Luckily, Photoshop Elements makes this easy to do. You can crop your picture down to the essential elements of that image. *Cropping* is simply cutting off parts of the

picture to reveal the image previously obscured by extra details. Cropping to strengthen an image and get rid of junk is best done early on in the process. Cropping to a specific size should be done after you have adjusted your photograph optimally.

The street scene from the Kinetic Sculpture Race shown here has extraneous detail on the left and right sides of the photo that can be removed. You can do a Save As so you do not save over the changed file.

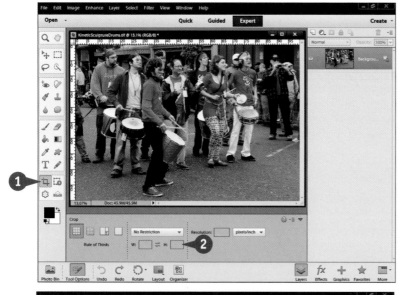

1 Click the Crop tool in the Toolbox at the left.

2 Delete any numbers in the Width, Height, or Resolution boxes.

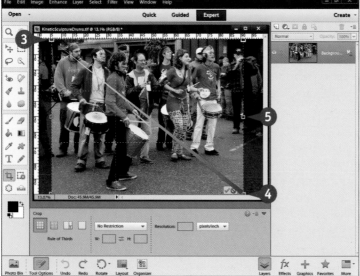

3 Click a corner of the area you want to keep.

4 Drag your cursor to the opposite corner of the area and release.

5 Click any edge of the crop box.

6 Drag that edge left or right, or up or down, to change the size of the crop box.

7 Click the green check mark to complete the crop.

A The red circle with the diagonal slash cancels the crop box.

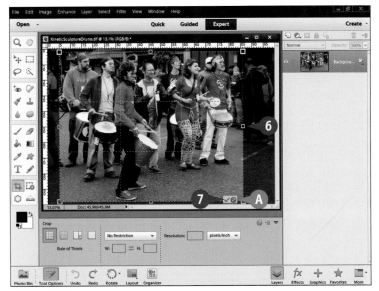

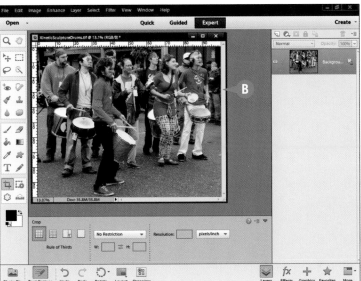

B The cropped image now appears in the work area at the same pixel size, but less of the original image appears because of the crop.

Note: *You can resize a cropped image to fill the work area by pressing Ctrl/⌘+0.*

TIPS

Try This!

If the Crop tool is not cooperating, you can reset it easily. This is true for all tools. At the right side of Tool Options below your photo is a menu icon of lines and an arrow. Click it to see options for resetting this tool or all tools. Click Reset Tool.

Try This!

Every tool in Photoshop Elements has a Tool Options that displays all the options available for that tool. Do not be afraid to try any of them to see what it does. Remember you can always reset any tool with the Reset Tool menu at the right. You can also hide Tool Options by clicking the down arrow at the far right of the box or the Tool Options icon below. Return Tool Options to view by clicking the Tool Options icon again.

Did You Know?

Cropping out the junk early on in the photograph helps as you process the image in Photoshop Elements. Whenever you make any adjustment, Photoshop Elements looks at the entire picture. Details in the picture that really do not belong can throw off your adjustment.

Everybody takes crooked pictures at times. It is easy to get caught up in the scene and not see that a horizon is off. But given today's digital tools, there is no excuse now for crooked photos. Photoshop Elements makes it easy to straighten a crooked photo.

You might miss a crooked horizon on the LCD of your camera when you are out taking the picture. However, when you view that photo on the computer, you will see that the horizon is not oriented correctly. This is not something people viewing the photo typically overlook.

Pictures can have crooked verticals, too, and the steps you take to correct them are the same as those for crooked horizontals.

You can correct a crooked photo in a couple of ways. The method you choose depends a lot on the photograph, the degree of crookedness, and your workflow needs. In this image of competitors in the Kinetic Sculpture Race, they are going up a sand dune, but the camera is crooked, so it does not look like they are working hard at all.

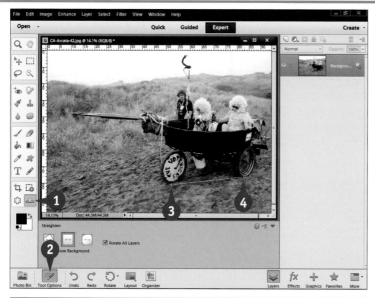

Use the Straighten Tool

① Click the Straighten tool.

② Select the Remove Background icon.

③ Click one side of a crooked horizontal line.

④ Drag and release the mouse button when you have created a line across something that should be straight.

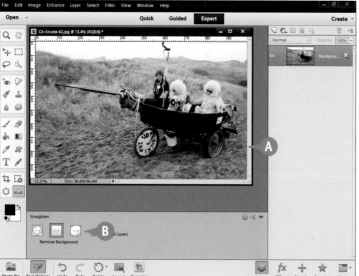

Ⓐ Photoshop Elements makes the crooked line horizontal and crops the image appropriately to make a complete photograph.

Do not be afraid to try this multiple times until the image looks right. Just use Ctrl/⌘+Z to undo what is wrong.

Ⓑ Also, experiment with the other cropping icons at the left in Crop Options.

Straighten with the Crop Tool

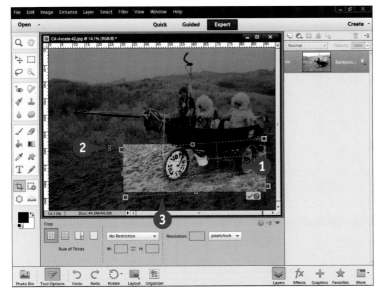

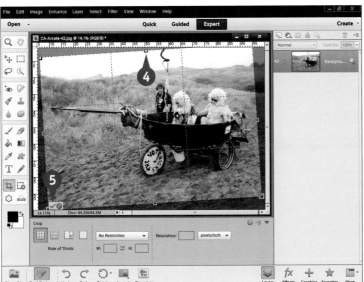

1 Using the Crop tool, make a narrow crop selection near something, such as a line, that should be horizontal.

2 Position your cursor outside the bounding box until it turns into a curved, two-headed arrow.

3 Click and drag to rotate the bounding box so that an edge is parallel to something that should be horizontal.

4 Expand the crop box until it covers the correct parts of the photo.

5 Click the green check mark to finish.

Photoshop Elements crops the image and straightens the image.

Note: Using the Crop tool for straightening the image allows you to both crop and straighten at the same time.

TIPS

Try This!

Extreme angles can be fun. Try rotating the crop box to odd and unusual angles and see what happens to the photo. Sometimes you find interesting, stimulating results, but other times you get nothing. Keep trying!

Did You Know?

There is a Photoshop joke that applies to Photoshop Elements, too. How many Photoshop Elements experts does it take to screw in a light bulb? One hundred and one — one person to screw in the bulb and a hundred to describe another way to do it.

Photoshop and Photoshop Elements are powerful, flexible programs. Use the tools that work for you and ignore people who tell you that you are doing it all wrong. You have to find your own way through Photoshop Elements. Doing so can take some work and time, but it is well worth it when you can work more efficiently.

Guided Edit in Photoshop Elements guides you through making adjustments to your photo while you actually work on the photo. It includes good instructions on exactly what to do. It is also a good way to learn the controls of the program.

The Guided Edit feature gives you a lot of different options for adjusting the picture, while keeping distracting controls hidden. Guided Edit does not cover everything in Photoshop Elements, but it does provide a good overview of the program. When you click any option in Guided Edit,

you go to the control you need as well as instructions on how to use it. Guided Edit contains 26 controls grouped into three categories: Touchups, Photo Effects, and Photo Play. Each control has specific guidance on how to use it.

The steps that follow show two controls working on a photograph of contestants struggling across the Manila dunes during the Kinetic Sculpture Race. The photograph uses a wide-angle lens to show off the racers with their entourages going back into the distance.

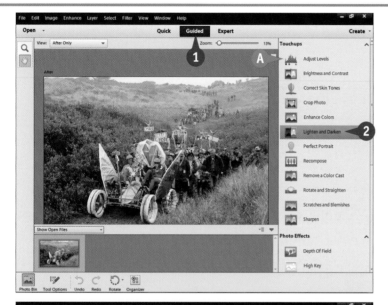

Use Lighten or Darken

1 Click Guided.

A A new panel appears.

2 Click Lighten and Darken.

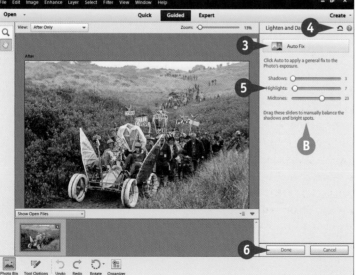

B Lighten and Darken instructions appear in the right panel.

3 Click Auto Fix to see if automated processing helps.

4 Click the Reset icon if it does not help.

5 Adjust the shadows, highlights, and midtone contrast.

6 Click Done when you are finished.

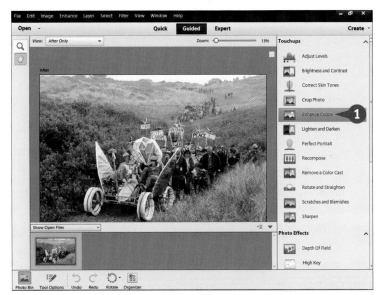

Use Enhance Colors

1 Click Enhance Colors.

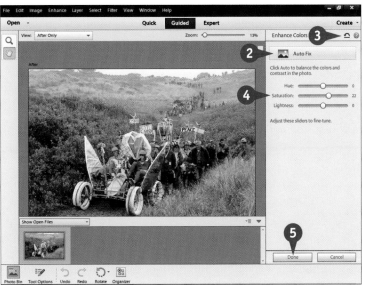

2 Click Auto Fix if your colors seem off.

Photoshop Elements adjusts the colors.

3 Click the Reset icon if it does not help.

4 Adjust the Hue and Saturation sliders to change the colors.

Note: *The Lightness slider is not very effective.*

5 Click Done when you are finished.

TIPS

Caution!
It is easy to overdo several controls in the Guided Edit panel, creating problems when you want to print your photo or use it in other ways. Be very careful with how strongly you use the brightness and contrast, sharpen, and saturation slider controls so the results are not too extreme. No warnings about this appear in the panel.

Try This!
When using the Guided Edit panel, you may find that you inadvertently get adjustments you thought you canceled. That is not a problem. No harm is done, but do not try to correct the adjustment while still in the Guided Edit panel. Go to Expert mode and use your History panel.

Remember This!
The panels in Guided Edit include a reset icon. This can be a real help. On some of the panels, you can easily adjust several controls, making it hard and confusing to try to readjust them back to zero. Instead, click the Reset button.

Without a strong black in most images and something, even small, that is white or close to it, a photo will not use the full range of any display medium. Without that proper black and white, the picture will not have the best color, the best contrast, or the best overall look. Photographers are often amazed at how much adjusting only the blacks and whites affects the look of the picture. This is a good starting point for any photograph.

Adjusting the blacks — the plural refers to all areas of black in an image — is subjective. Some photographers prefer a

strong, large area of black within a photograph. Others prefer just a few blacks or only some colors showing up in the threshold screen. Whites are not so subjective. You have to be very careful not to overbrighten them.

Events like the Kinetic Sculpture Race are great places to photograph people. Cameras are everywhere and people in these events love being photographed. This is a low-risk way to expand your photography of people you do not know.

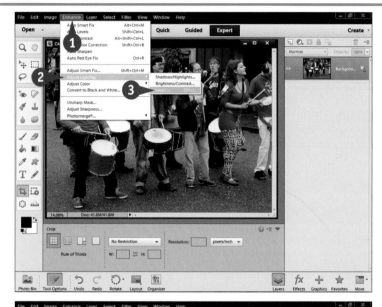

Be sure you are in the Expert mode.

1 Click Enhance.

2 Select Adjust Lighting.

3 Select Levels.

The Levels dialog box appears.

4 Press Alt/Option as you move the black slider under the graph, or histogram.

A A threshold screen appears, showing when pure black appears in the photo.

5 Move the slider until at least something black or strongly colored in the image appears.

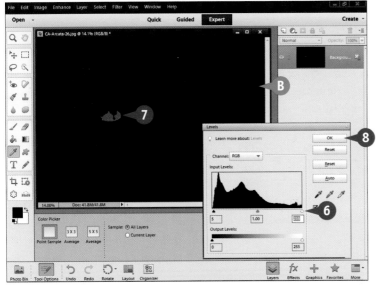

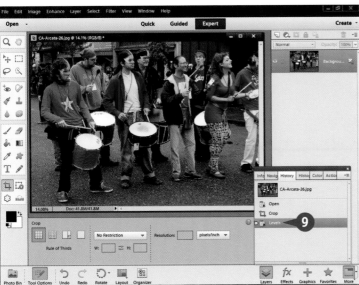

6 Press Alt/Option as you move the white slider under the graph or histogram.

B A threshold screen appears showing when pure white appears in the photo.

7 Move the slider until at least something shows.

White is very sensitive, so you can stop when colors appear on or near your subject. Do not worry about very bright areas not part of your subject.

8 Click OK when you are done.

The image in the work area now has better color and contrast.

9 Click between Levels and other states in History to see the differences.

Remember that History can be shown by clicking More and selecting the History tab.

Did You Know?

JPEG is a common photo format that digital cameras use. It stands for Joint Photographic Experts Group and represents a very sophisticated form of file compression for images. It allows the saved file size to be quite a bit smaller than the actual megapixels of a camera would indicate. You do have to be careful to minimize the compression or you will lose some of your ability to make adjustments.

Caution!

Not all photos have blacks. If you try to get blacks in the threshold screen on a foggy-day image, for example, the picture will look harsh and unappealing. Because setting up blacks is subjective, you really have to pay attention to your photograph and its needs, as well as to your interpretation of the scene.

More Options!

You may find that some pictures do not seem to have a pure black. All that shows up in the threshold screen is a color. Strongly colored pictures act like this. Do not try to get a pure black, but be sure that you are getting a strong color at least somewhere. That color shows that a channel has been maxed out, which may be enough.

When you set blacks properly, you often find your photo is too dark. Actually the whole photo is not too dark, but the *midtones*, the tonalities between black and white. In addition, you may find that many digital photos have their dark tones too dark, making the photos muddy or murky with ill-defined and dark colors that do not reveal themselves well.

Middle tones affect the overall brightness of the image, the colors of the photo, and the ability of a viewer to see detail within the picture. Some photographers refer to

brightening the midtones as "opening up" certain tonalities, which is a good way to look at it. You are trying to open up certain parts of the picture so that the viewer can better see them.

This adjustment is subjective, with no right or wrong. You have to look at your picture and decide on the right interpretation for the subject and for how you saw it. It is important, however, to calibrate your monitor so that your adjustments are predictable and consistent.

① Click Enhance.

② Select Adjust Lighting.

③ Select Levels.

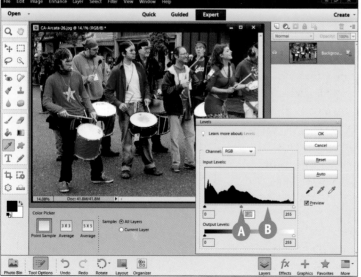

The Levels dialog box appears.

Ⓐ Move the middle slider left to brighten the photo.

Ⓑ Move the middle slider right to darken it.

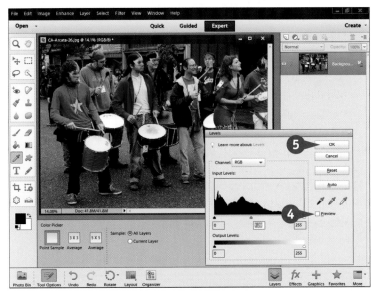

④ Select and deselect the Preview check box to turn the view of the adjustment on and off.

This enables you to better see what is happening in the photo.

⑤ Click OK when you are done.

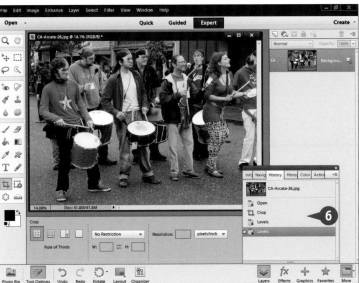

The image in your work area now has more open midtones and color.

⑥ Click among the states in History to see the differences.

The two Levels make it easy to see the different adjustments between blacks and whites and midtones.

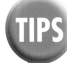

TIPS

Did You Know?

By separating the adjustments into two instances or uses of Levels, you can more easily see the adjustments and make corrections to them. This step-by-step approach also keeps the steps separate in History. That makes it easier for you to find exactly where a particular adjustment is affecting your picture.

Did You Know?

The graph in the Levels dialog box is called a *histogram*, which is a chart of the brightness values of the pixels in your photograph. As you adjust Levels, you may see small gaps, or white lines, appear in the histogram. Gaps are not a problem. Whether this *combing* of the histogram (as it is called) is a problem depends on what you see happening to the photo. Pay attention to your photo, not arbitrary computer rules.

Important!

The middle slider in the Levels dialog box is a midtones slider, but it affects more than just the very middle tones. As you work in Photoshop Elements, you will start noticing differences between the dark tones with details, middle tones, and bright tones with details.

ADJUST YOUR MIDTONES with Color Curves

Another way of adjusting midtones is to use Color Curves. Do not be misled by this name. Although the Color Curves adjustment affects color to a degree, it really is a way of affecting tonalities.

The midtones slider in the Levels dialog box affects midtones separately from blacks and whites, with most of the adjustment near the middle tones. Color Curves enables you to separate these adjustments by using what are called parametric sliders. The sliders in Color Curves are called *parametric* sliders because they affect very

specific parameters. They include making highlights brighter or darker, changing the brightness or darkness as well as the contrast of middle tones, and making shadows brighter or darker.

This gives you more control over the whole range of tones in your picture between the blacks and the whites. This can enable you to open up dark areas, while keeping bright areas at their original darkness, for example. This is important because the camera often captures tonalities in a scene far differently from the way you see them.

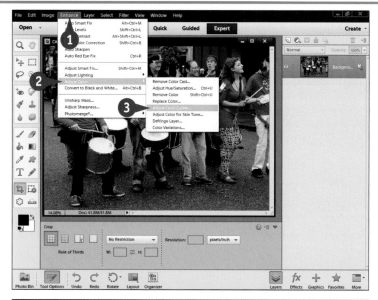

❶ Click Enhance.

❷ Select Adjust Color.

❸ Select Adjust Color Curves.

The Adjust Color Curves dialog box appears.

❹ Move the parametric sliders to adjust specific tones in your photo.

Moving the sliders to the right makes tones brighter or contrast higher.

Moving the sliders to the left makes tones darker or contrast less.

Ⓐ The graph, which shows curves for the adjustments, changes as you move the sliders, but you do not have to know anything about it to use this tool.

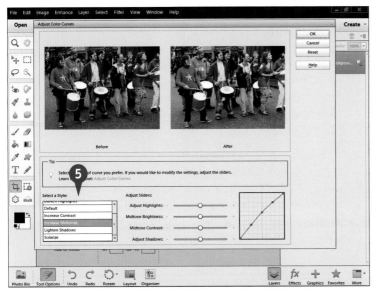

⑤ Select a style at the left side to create adjustments semiautomatically based on the short descriptions that appear in the tip section.

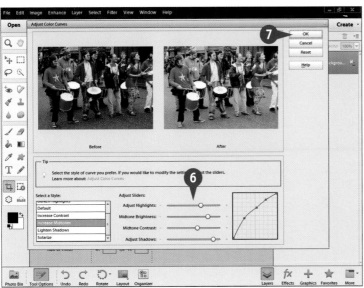

⑥ Click and adjust the parametric sliders as needed to tweak the style.

The image in your work area now has adjusted midtones.

⑦ Click OK when you are done.

TIPS

Did You Know?
Right in the middle of the Adjust Color Curves dialog box you will see a tip. Photoshop Elements provides tips throughout the program. If you are unsure about some adjustment, for example, you can often click the blue highlighted part of the tip to learn more about the adjustment. You will also find a little question mark in the Tool Options area that you can click to learn more about a tool.

Did You Know?
Color Curves is named after an important adjustment in Photoshop called Curves. As you adjust individual tonalities within a picture, such as highlights separately from shadows, the graph creates curves in its main line, thus the name Curves. The graph represents black at the bottom left and white at the top right.

Try This!
Quick adjustments are better than slow adjustments. Many photographers try to make small adjustments when working in Photoshop Elements. Seeing the difference between a good and a bad adjustment is easier if you make the adjustments quickly.

One challenge that consistently faces photographers is a scene that has very bright highlights, or bright areas, and very dark shadows, or dark areas, all within the photo you want to take. The camera almost always has trouble balancing the brightness throughout the picture. You can see the shadows and highlights just fine with your eyes, but the camera cannot see them the way you do.

Photoshop Elements can help with this with an adjustment control called Shadows/Highlights. This control searches out the darkest parts of the picture and then adjusts them

while limiting the adjustment to those tones. It also finds the brightest parts of the picture and then limits any adjustments to them. Shadows/Highlights is a very handy control to know about, but you should use it after you adjust blacks and whites as well as midtones.

In this shot of judges checking out a kinetic sculpture, the judges have some very dark clothing, whereas the sculpture has extremely bright foil on it. The camera needs help to balance these.

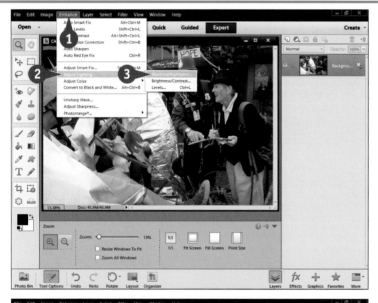

1 Click Enhance.

2 Select Adjust Lighting.

3 Select Shadows/Highlights.

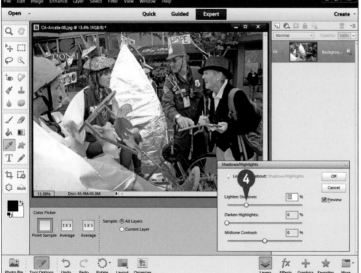

The Shadows/Highlights dialog box appears.

4 Click the Lighten Shadows slider and move it left or right until the shadows look better.

Doing these adjustments carefully one at a time is important to see how they affect the appearance of the photograph.

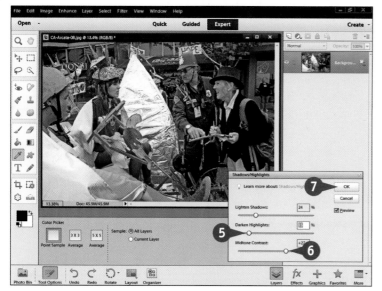

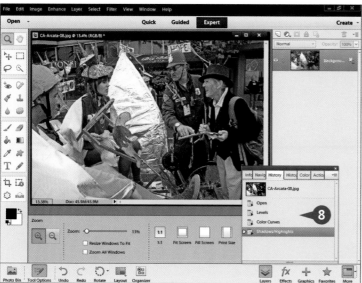

5 Click the Darken Highlights slider and move it to the right to make your highlights have more color and detail.

6 Click the Midtone Contrast slider and move it to the right or left to make the picture look more natural.

7 Click OK to finish.

The adjusted photo now appears in the central work area of Photoshop Elements.

8 Click History states to see if the adjustments are doing what you want done to your image.

TIPS

Important!

Shadows/Highlights is no magic bullet — it cannot cure all contrast problems in a photograph. Your picture must have detail to work with in the dark and light areas. Shadows/Highlights cannot add detail that the camera did not originally capture, so it helps to be aware of what your camera can and cannot do with contrasty scenes.

Did You Know?

Noise creates a sandlike pattern in a picture and can be very annoying. Noise is rarely noticeable in bright areas with normal exposures. However, it lurks, hidden in the dark areas of the picture. When you brighten dark areas with Shadows/Highlights, noise often becomes more obvious. See task #32 for more on noise.

Caution!

The Shadows/Highlights control is easy to overdo. Watch your picture. Do not simply adjust it so you can see lots of detail in shadows or more detailed highlights. That can result in unnatural-looking images. Make your adjustments so that your picture looks like it was taken on this planet!

CORRECT COLOR to remove color casts

Color casts are those slight overall colors that diffuse through the picture. They make neutral colors no longer neutral, and can hurt the appearance of colors so the colors are no longer accurate to the way you saw them. Color casts can cause problems for your subject and your rendition of the scene.

Many outdoor scenes have natural color casts, especially at sunrise or sunset. Auto white balance in digital cameras can be a problem in many outdoor scenes. It often gives an overall bluish color cast to the image. This might not

be obvious, but it will often weaken the warm colors of a photo.

Color casts come from all sorts of things, such as fluorescent lights, blue skies, and improper white balance, and compromise the look of an image. White balance in a digital camera reduces color casts due to the color of light. This helps, but you can still get a picture with color casts that need to be corrected, especially with auto white balance.

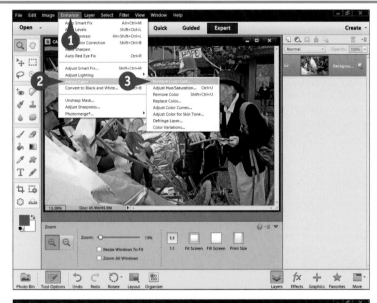

① Click Enhance.

② Select Adjust Color.

③ Select Remove Color Cast.

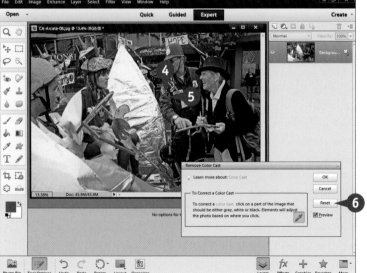

The Remove Color Cast dialog box appears.

④ Position your cursor over the photo; the cursor turns into an eyedropper.

⑤ Click the eyedropper on something that should be neutral in color — a white, gray, or black.

Color casts are removed, but the first click might not work.

⑥ Click Reset if the colors are not right.

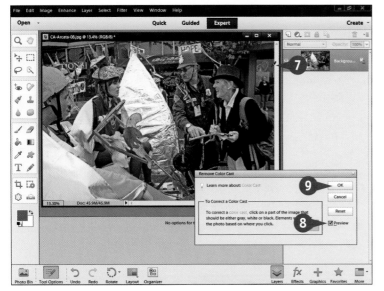

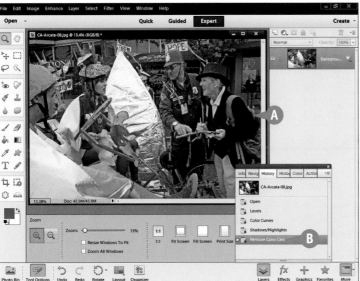

7 Keep clicking different tones that should be neutral, clicking Reset if the colors are bad, until you get a good color balance.

8 Click the Preview on and off to be sure you like what you are getting.

9 Click OK to finish.

#22

DIFFICULTY LEVEL

A The photo now has better color.

B The adjustment shows up in the History.

TIPS

Did You Know?

The Levels dialog box has three eyedroppers on the right side. The black and white eyedroppers affect blacks and whites, but they are heavy-handed and not as effective as using the Levels sliders with threshold screens. The middle eyedropper is, in fact, essentially the same eyedropper as the one used in the Remove Color Cast dialog box.

Did You Know?

Skin tones can be tricky, often picking up undesirable color casts. Correct them by clicking Adjust Color for Skin Tone in the Enhance menu. In this control, you click the skin of a person, and Photoshop Elements adjusts the color of the whole picture to make the skin look better. You can further tweak this with some sliders.

Try This!

As you click around in your photograph, you will often find the picture changes to some rather odd colors. That is not a problem because you can click the Reset button. However, you may sometimes find these colors interesting. You can even try clicking any color in the picture just to see what happens.

Certainly many photographs look their best when the colors are rich and at a good intensity. Saturation is the intensity of a color and is adjusted with Hue/Saturation. Unfortunately, this control in Photoshop Elements has some problems if you overadjust it. Many photographers find a color is too weak, so they start pushing saturation. The weak color is better, but the rest of the image looks garish. Brighter, more intense colors do not automatically translate into a better photo.

Although you can adjust the overall colors with Saturation, be careful that you do not overdo it. An adjustment of 10

points or so is usually plenty. The best way to adjust the saturation in a picture is to adjust individual colors. Your camera does not capture colors equally, so adjusting individual colors is a better way of enriching color in any photograph.

Hue/Saturation also enables you to adjust the color of the color, or its *hue*. Using the techniques described here with the Hue slider, you can, for example, correct the hue of a blue flower that the camera has not correctly captured.

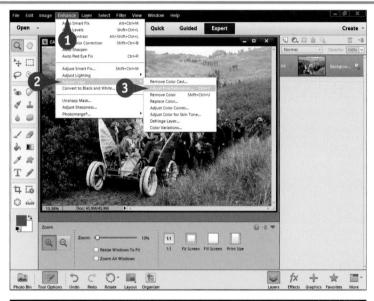

1 Click Enhance.

2 Select Adjust Color.

3 Select Adjust Hue/Saturation.

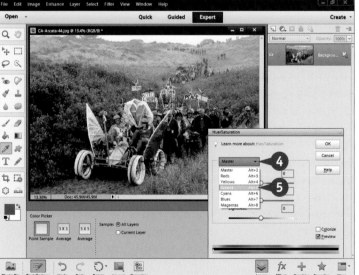

The Hue/Saturation dialog box appears.

4 Click the Master drop-down menu.

5 Click the first color you want to adjust.

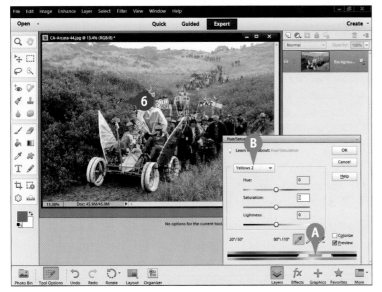

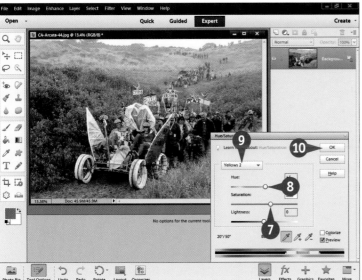

The Master menu now changes to the color you have selected, and Photoshop Elements restricts adjustments to that color.

6 Move your cursor over the photograph and click on something with the color you want to adjust.

A The color bar changes to restrict your changes to that color.

B The Master menu may also change to Adobe's name for the color.

7 Click and drag the Saturation slider to the right to increase saturation.

8 If needed, click and drag the Hue slider left or right to change the hue of the color.

9 Click in the Master drop-down menu again to pick a new color to adjust.

10 Click OK to finish.

TIPS

Did You Know?

Clicking inside your photo on a specific color is a great way to limit adjustments to that color. Adjustments affect only that color or colors very similar, but they affect the color throughout the photo. The program sometimes gives surprising names for the colors when you do this, but you can ignore the names.

Did You Know?

Lightness looks like it should be a good control in Hue/Saturation. Unfortunately it is not. It tends to dull colors instead of making them lighter or darker. Using it in small amounts is okay, but you will find that your colors do not look their best if you try to use it more than that.

Caution!

Be wary of oversaturating your pictures. This control quickly blocks up your colors so that you cannot see detail well and makes them look garish if you are not careful. Make your adjustments quickly so that you can see how different the colors are changing and so that your eye does not get used to the gradual color changes.

USE QUICK EDIT to work fast

Sometimes you have pictures that you want to work on quickly. You may have promised some prints to a friend, or maybe you need to get them ready for presentation. Although all the controls described in this chapter work well, one challenge is that you have to open up each control individually. That takes time.

In Photoshop Elements Quick Edit, you have a number of adjustments all in one place that do not need to be opened separately. Although you cannot control these adjustments as much as the main controls, and they are

not as flexible, they include a very useful before and after feature that makes it very easy to see what they do. You simply move your cursor over the small thumbnails in the adjustment panel to see how the after image is changed.

Quick Edit also includes some auto controls. These can be helpful for fast adjustments, but be wary. They can take you in the wrong directions for your picture because they are based on computer engineering formulas instead of what your picture actually looks like.

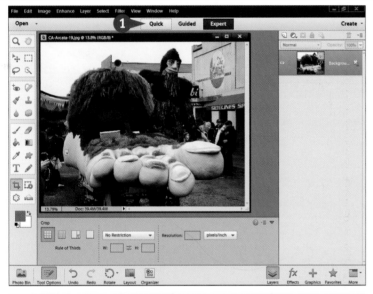

① Click Quick.

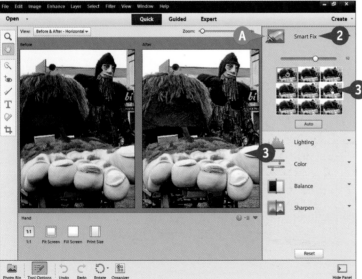

Ⓐ The Quick Edit panel opens with a variety of adjustments.

② Click Smart Fix.

③ Run your cursor over the small thumbnails and watch the changes occurring in the After image.

Note that the cursor changes to a small hand with a horizontal arrow. This means the cursor can be used to tweak an adjustment by clicking and dragging left and right on the thumbnail.

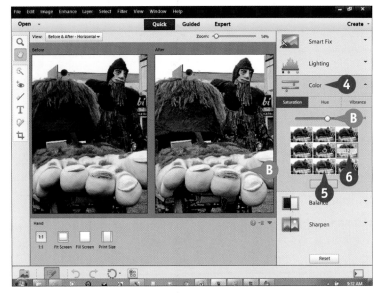

4 Click another adjustment category such as Color.

5 Run your cursor over the small thumbnails to find a change close to what you like.

6 Click and drag left and right to tweak that adjustment.

B Changes appear in both the After image and the slider.

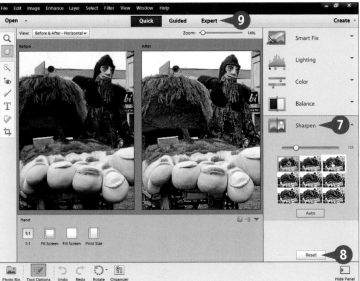

7 Go through as many adjustments as you want in this way.

8 Click Reset to start over.

9 Click Expert to go back to the main Editor interface.

TIPS

Try This!
To undo any adjustment in Quick Edit as you go, immediately press Ctrl/⌘+Z. Reset will reset everything. If things get mixed up, go back to Expert mode and use the History panel.

Did You Know?
Smart Fix is a useful adjustment when the photo looks a bit off right from the start. With earlier versions of Photoshop Elements, you often got better adjustments using the other controls. However, the new thumbnails and activated cursor that lets you click and drag to refine an adjustment make a big difference in helping you get exactly what you want from Smart Fix.

Try This!
You can also use Quick Fix as a starting point for other adjustments. You do not have to make this an either/or question; that is, use Expert or Quick Edit. Use Quick Edit to start the process and then refine your adjustments in Expert mode. If you do this, do not use the Sharpen panel area.

Chapter
3

Work with RAW Photos in Photoshop Elements

Many photographers think the RAW format is an unprocessed image direct from the sensor. It is not. Some processing to affect color, contrast, and noise is applied to the image data as it is translated from an analog sensor signal to a digital image file. RAW is a unique and little-processed image compared to JPEG files. You can get outstanding results from digital photos whether they are shot in JPEG or RAW, though it is important to set your camera to record JPEG at the highest quality.

However, RAW maximizes the information that comes from your sensor and includes a great deal more tone and color steps than are possible with JPEG. This gives you a lot more flexibility when

processing an image. RAW files enable you to dig more detail out of bright areas in a picture, unearth more tones in dark areas, and ensure better gradations when adjusting smooth gradients like skies and out-of-focus sections of a photo.

One problem is that RAW is a proprietary camera file. Every time a new camera comes out, so does a new version of that RAW file. This can be frustrating when you try to process your files in Photoshop Elements Camera Raw and you cannot. You have to update the Camera Raw part of Photoshop Elements to access the new version, and you have to wait until Adobe has unraveled the new version as well.

DIFFICULTY LEVEL

A RAW file is an incomplete photograph. You cannot display such an image file or even print from it without some sort of processing. You can always display a JPEG image in all sorts of programs on your computer, plus you can take a JPEG file straight from the camera and have a print made. That is an advantage of JPEG files. However, RAW files include a great deal of tonal and color information that you can use while processing such files in Camera Raw, Photoshop Elements' RAW software.

No changes are ever made to the original RAW file. All adjustments are instructions that the computer uses to interpret and process the RAW file. This is called *nondestructive processing* because no pixels from the original file are ever changed. This can be very freeing to you as a photographer because it means you can try almost anything and never damage the original file.

The image here is of a petrified log and badlands hill in the early morning in the Petrified Forest National Park.

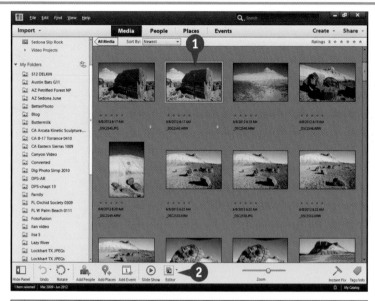

① Click a RAW file.

You can display file names by going to the View menu, clicking Details, and then File Names.

② Click the Editor icon.

When you open a RAW file directly in the Editor or from Organizer, Camera Raw, which is Photoshop Elements' RAW software, opens.

Ⓐ All adjustments are made as instructions from the right side panel as to how to convert the RAW file to a file that Photoshop Elements can use.

B The Camera Raw interface offers a lot of adjustments that do not require you to go to a menu.

C The interface also includes a simple toolbox of frequently used tools for photographs.

TIPS

Did You Know?

Whenever you work on a photograph in Photoshop Elements as described in the last chapter, you are working on pixels. Those pixels are then changed, which is called *destructive editing*, because the original pixel data is "destroyed" as you apply changes. Camera Raw enables you to make nondestructive changes.

Try This!

You can change the magnification of the displayed photo in Camera Raw by using the magnifier in the toolbox and clicking or dragging over the photograph. You can also click the magnification number at the lower left of the photograph to get a drop-down menu of specific magnification sizes.

Did You Know?

JPEG is a processed RAW file. The camera takes the image data coming from the sensor and processes it quickly. The JPEG is a locked-down, camera-processed RAW file. It is good that this file is processed optimally for the particular camera being used, and the file size is much reduced, but it also means the flexibility of the original RAW file is lost.

The world does not always cooperate and give you the opportunity to make perfect pictures every time. Sometimes, reality does not fit the frame your camera defines. At other times, stuff creeps in along the edges of your picture that really does not belong with your subject. Or you may find that you simply need to tighten up the composition of your photo so that the subject shows up more clearly to the viewer.

Blacks can be especially important in giving a photograph and its colors strength. Adjusting blacks is very subjective, but also important. You will find that some photographs need minimal black areas, whereas others need quite large areas of black throughout them. Photoshop Elements helps you out, in a way, by calling this adjustment Blacks. Whites are now adjusted by a Whites slider, a new feature for Photoshop Elements 11. Whites used to be adjusted with Exposure, and now Exposure is a totally new control that can be used for midtones as described in the next task.

Cropping is what enables you to refine your photo to the key elements of your subject and scene as well as keep out the details, or the "junk," that detract from your image.

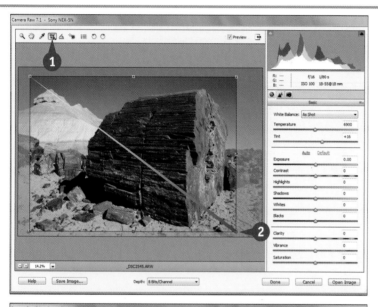

① Click the Crop tool to select it.

② Click and drag over the photo to start your crop.

③ Drag the edges and corners of the crop box to make the cropped area larger or smaller.

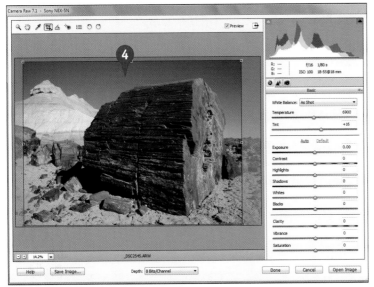

4 Click inside the photo and drag the crop box to reposition it.

#26

DIFFICULTY LEVEL

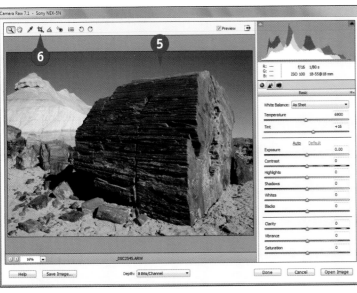

5 Press Enter to see the photo as cropped in the work area.

6 Click the Crop tool at any time to go back and recrop the image.

No crop is permanent; a crop can be changed at any time.

 TIPS

Did You Know?

You can recrop at any time. This is part of the whole idea of the nondestructive processing of an image. Camera Raw remembers how you cropped a particular RAW file, and lets you change that at any time, even after closing the file (Done or Open Image) and reopening it.

More Options!

You can rotate your crop box by simply positioning your cursor outside the box so that the cursor changes to a curved double-arrow cursor; you then click and drag to rotate. You can remove or clear your crop by clicking and holding the Crop tool to get a menu that includes Clear Crop.

More Options!

You can crop to specific proportions within Camera Raw; however, they are not specific to inches. You can get the specific proportions by either right-clicking the photograph when using the Crop tool to get a context-sensitive menu, or by clicking and holding the Crop tool to get the same menu.

Chapter 2 describes the importance of adjusting blacks and whites in a photograph. This is a very important adjustment to make in Camera Raw because it sets the tonalities for everything else. You can not only adjust the blacks and whites in Camera Raw, but you can also adjust the brightness of the very dark areas and the very bright areas separately. In addition, you can bring out added detail in the darkest and brightest areas that might otherwise be lost.

Blacks can be especially important in giving a photograph and its colors strength. Adjusting blacks is very subjective, but also important. You will find that some photographs need minimal black areas, whereas others need quite large areas of black throughout them. Photoshop Elements helps you out, in a way, by calling this adjustment Blacks. Whites are now adjusted by a Whites slider, a new feature for Photoshop Elements 11. Whites used to be adjusted with Exposure, and now Exposure is a totally new control that can be used for midtones as described in the next task.

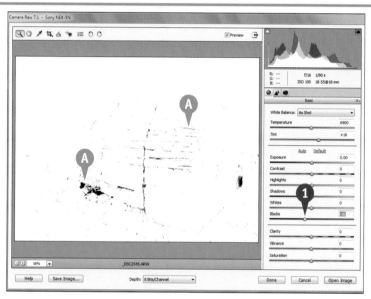

1 Press Alt/Option and click and drag the Blacks slider to the left.

The blacks threshold screen appears.

A Watch where the pure blacks and maxed-out color channels appear.

Note: Anything that shows as pure black will be a pure black in the photo. Anything that shows as a color will be a maxed-out color in that area.

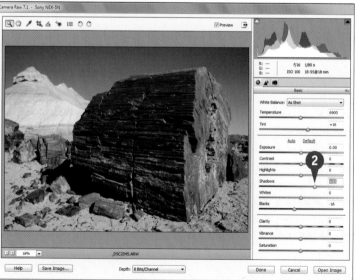

2 Adjust the Shadows slider to give a boost to the darkest areas.

Beware of overadjusting Shadows so that the photo looks unnatural.

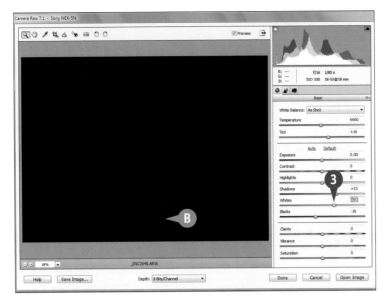

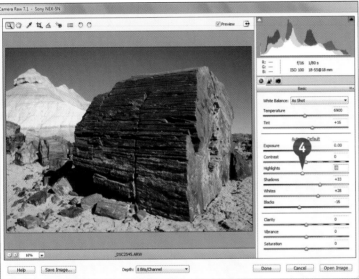

③ Press Alt/Option and click and drag the Whites slider to the right.

The whites threshold screen appears.

Ⓑ Watch where the pure whites and maxed-out color channels appear.

Whites are very sensitive and should be adjusted cautiously. You can adjust Whites both + and – to get better results.

④ Adjust the Highlights slider when highlights look weak and washed out.

Often the Highlights slider is not needed and might just make your photo look dull. Never feel you have to use either the Highlights or Shadows sliders.

TIPS

Did You Know?

Photographers often refer to the black areas of a photograph as the *blacks* but not because black comes in different brightnesses — it obviously does not. This use of the term *blacks* refers to all the small areas of black scattered throughout the photograph.

Did You Know?

Some people wonder why you need to adjust both the Blacks and Shadows sliders. They seem to counteract each other. However, such an adjustment gives a different, better look to the dark areas of the picture than occurs if you adjust either one alone or neither one at all.

Important!

Always adjust your blacks first, before using the Shadows, Whites, and Highlights sliders. Setting your blacks right away enables you to better see your adjustments for tonality and color. If you adjust Shadows first, you often find the picture starts to look very gray.

Chapter 2 also describes adjusting midtones in a photograph. Once again, this is a very important adjustment to make in Camera Raw. It makes the overall picture lighter or darker. This is where you work to deal with exposures that are a little too dark or a little too bright.

Midtone adjustment makes the picture look right — neither dark and muddy nor bright and washed out. Adjusting your overall tonalities in Camera Raw enables you to get the optimum results from these tones as well.

You adjust midtones using two sliders in Camera Raw in Photoshop Elements: Exposure and Contrast. Sometimes you will change only the Exposure slider, but just as often you will adjust both. You rarely adjust only the Contrast slider for most general types of photography, though it can be interesting for certain effects. Brightness and Contrast go well together for adjusting the midtones of your photograph. You should note that Exposure is a totally new control to Camera Raw in Photoshop Elements 11, even though earlier versions had an Exposure slider.

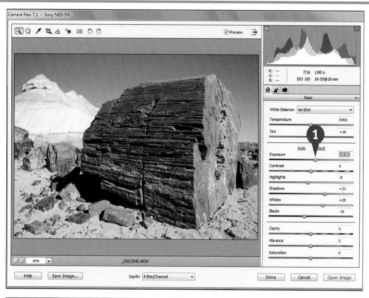

1 Click and drag the Exposure slider to make the overall photo brighter or darker.

This does not affect either the blacks or the whites, although it can affect both bright and dark tones.

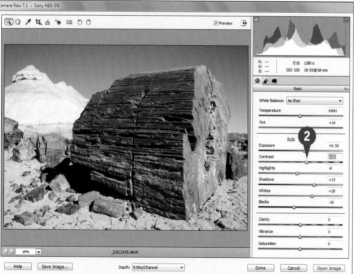

2 Adjust the Contrast slider to affect the overall contrast of the photo.

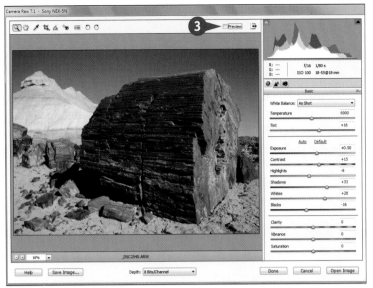

3 Select and deselect the Preview check box to compare before-and-after adjustments.

4 Readjust the Exposure and Contrast sliders as needed to adapt to the interaction of these controls' changes.

5 Readjust Highlights and Shadows, too, as needed.

TIPS

Important!

Adjust your blacks and whites first. Adjusting these tones truly does affect everything else in the photograph. Without a good black in most pictures, colors never look as good, and images never print as well. Remember, though, that blacks are subjective, and not all photos have them.

Did You Know?

Blacks, whites, and midtones strongly affect color in the picture. Color is not simply a part of your subject; it is subjective and strongly affected by tones all around it. This is why adjusting your blacks, whites, and midtones before trying to control color is so important.

Important!

RAW is no magic bullet that can correct a bad exposure. You need to be especially sure that your bright areas are exposed properly in your image. RAW files have a lot more flexibility in how you can adjust an image, but they cannot bring in detail or tones that the camera and sensor did not originally capture.

Color casts are slight tints of color that appear over the entire photograph. If you are photographing at sunrise or sunset, you want a warm color cast for the photograph. But often, color casts are a problem.

One problem that occurs with digital cameras is that auto white balance is inconsistent and often gives a bluish color cast to outdoor photos. You should therefore shoot a specific white balance instead of using auto white balance. Choose a white balance that matches the conditions or a white balance that warms up the scene.

However, you can correct unwanted color casts easily in Camera Raw by quickly making a correction and then undoing or redoing it as needed if you do not like it. Because everything in Camera Raw is nondestructive, this is never a problem. By repeatedly making corrections to color to clean up color casts in a photograph, you can learn about color casts and how to better see them.

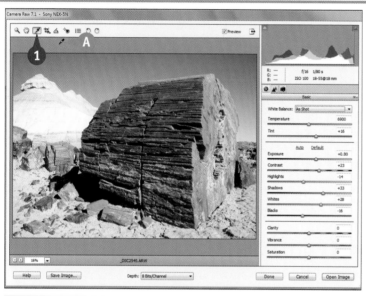

① Click the White Balance tool (the eyedropper) in the toolbox.

Ⓐ The cursor turns into an eyedropper.

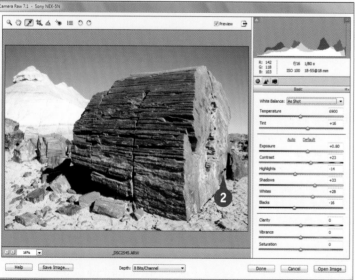

② Position the cursor over the photograph and click something that should be a neutral color.

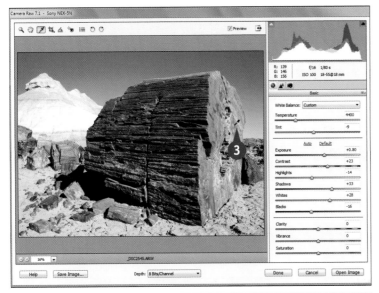

Camera Raw makes that neutral color neutral and removes a color cast. Note that it can also create a different color cast that may or may not be appropriate to the photo.

③ Try clicking another location to see if you get a better color.

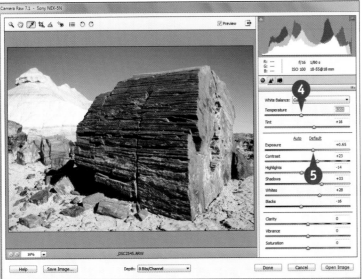

When the color looks good, stop clicking the photo.

If the color looks really bad, press Ctrl/cmd+Z to undo the last adjustment.

④ Change the Temperature and Tint sliders to further adjust the color.

⑤ Readjust Exposure, Contrast, Shadows, and Highlights if needed to get the best-looking image.

TIPS

Try This!

You can use Camera Raw's white balance settings to affect your photograph. Click the White Balance down arrow to get a drop-down menu of white balance settings. Click any one to see what it does to a photo and what the image looks like. These are not the same as settings on your camera, but Adobe interpretations of white balance settings.

Caution!

Because the white balance settings in Camera Raw look like the settings on a camera, you might think they are the same settings, and that you could use them the same way even if you did not set a specific white balance while shooting. Although similar, they are not the same as what you get from setting a white balance during shooting.

Important!

RAW is sort of a magic bullet when it comes to white balance. You can change your white balance settings as much as you want without any harm to the picture, plus you can adjust a picture that is way out of balance quite easily. Still, selecting a white balance setting in your camera is best because this makes your colors more consistent and makes for less work in the computer.

Although paired in the interface, Vibrance and Clarity are two distinct adjustments in Camera Raw in Photoshop Elements. Vibrance can increase or decrease the intensity of a color. It is like Saturation, an older, much more heavy-handed tool, but Vibrance does not oversaturate colors as easily and has a strong effect on skies.

Clarity adjusts the contrast of midtones, the visual effect of which is hard to explain. A way to see how it affects an image is to drag the slider all the way to the right, look at

the effects on the picture, and then drag the slider all the way to the left and view those effects. Then move the slider in the direction that seems best for your picture, though generally not to one of the extremes.

These controls affect something that has been called *presence* in a photograph. Presence refers to how an image grabs your attention and makes it more "present" for you. It comes from the theater where an actor is said to have presence when he really comes alive for the audience.

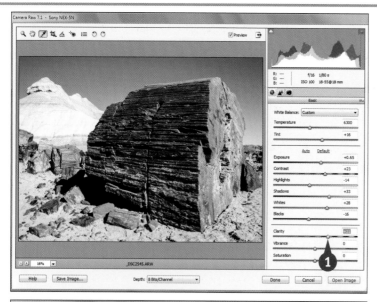

1 For an image with interesting midtone detail, move the Clarity slider 20 to 40 points to the right.

This can be particularly effective for landscapes and architecture. Clarity can make some subjects look too harsh, such as faces, and all subjects look harsh if overdone.

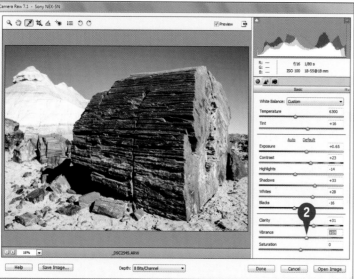

2 To give your photo a little boost in color, move the Vibrance slider 10 to 35 points to the right.

You really have to watch what happens to your image. For the scene shown here, Vibrance very quickly makes the already intense blue sky too blue.

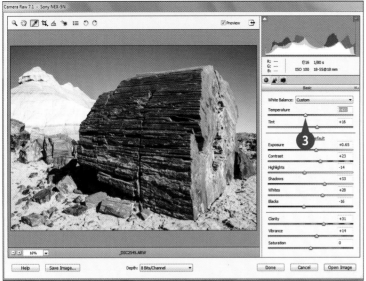

3 If the color looks good but seems to pick up a color cast, try adjusting the Temperature and Tint sliders.

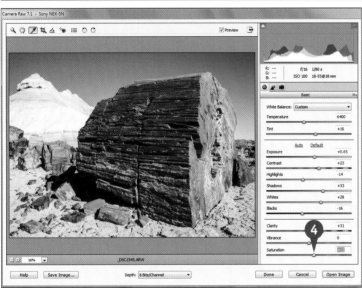

4 If you feel the photo still needs more lively colors, try moving Vibrance back to 0 and moving the Saturation slider 12 points or less.

Be wary of using the Saturation slider because its effects are easily overdone.

TIPS

Try This!

Whenever you want to reset a slider in Camera Raw, double-click the slider adjustment "knob." This immediately resets any slider to its default. It can be a good way of seeing exactly what your adjustment is doing to a picture. Just remember what your setting is before you double-click.

Did You Know?

Some people confuse Clarity with sharpness. Clarity is not sharpness, but a way of affecting a very specific contrast within your picture — the contrast of midtones. This can make a picture look sharpened, but Clarity is not as refined an adjustment as sharpening.

Attention!

Portraits and increased Clarity do not always go well together. Clarity intensifies pores, wrinkles, and defects in a person's skin, which is not always very flattering. In fact, portraits sometimes look better if Clarity is decreased so that skin texture is not as pronounced.

Traditionally, the standard recommendation for sharpening has been to sharpen your image at the very end of your processing. This is because some adjustments to a photograph can affect sharpening. If you are doing all your adjustments in Photoshop Elements, that would be true.

However, the sharpening tools in Photoshop Elements Camera Raw offer newer algorithms than those in the main program, and they work quite well. In addition, you are doing most of your strong adjustments in Camera Raw, so sharpening here is appropriate. Finally, Camera Raw smartly applies sharpening at the right time during

processing of the RAW file when you are done, no matter when you apply that sharpening while working on your photo.

With experience, you might find certain photographs require much more adjustment in Photoshop Elements itself. When that happens, you may decide to do sharpening at the end of all your adjustments. Photoshop Elements has good sharpening tools, so doing sharpening there instead of in Camera Raw is okay. But if Camera Raw becomes an important part of your workflow, do most of your sharpening in it.

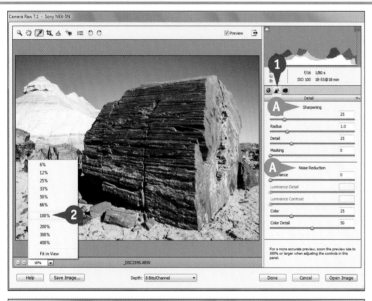

1 Click the Detail tab in the adjustment panel on the right.

A This opens the Sharpening and Noise Reduction adjustments.

2 Click 100% in the magnification menu at the lower left so that you can better see the sharpening effects.

3 Click the Hand tool and click and drag on the image to reposition the view of details in the photo.

4 Move the Amount slider to the right until the image starts to look sharp, but no more.

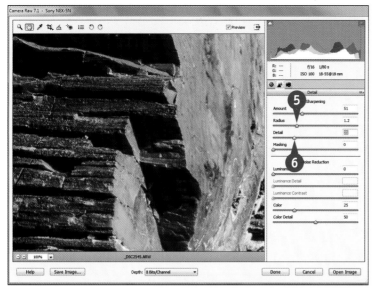

⑤ Try moving the Radius slider a little to the right to see if it helps your photo.

⑥ Use the Detail slider to enhance small detail in the photograph.

#31

DIFFICULTY LEVEL

● ● ○ ○

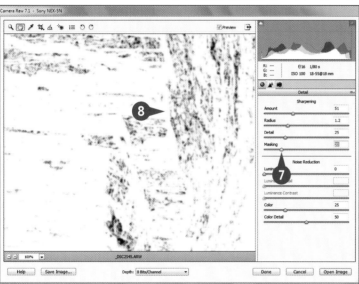

⑦ Use the Masking slider to limit your sharpening to the strongest edges.

⑧ Press Alt/Option to see the mask where white allows the sharpening and black blocks it.

Masking can be very important when your subject is sharp and the background is out of focus.

Did You Know?

Amount controls the intensity of the sharpening. Radius affects how far sharpening is applied around pixel-sized detail. Detail modifies how strongly Radius interacts with Amount on details. Masking changes where sharpening is applied by blocking it from less-detailed areas, such as skies.

Try This!

Press and hold Alt/Option as you adjust any of the Sharpening controls, and the image changes to a black-and-white rendition of how that control is affecting the picture. Some photographers find it easier to see the sharpening effects this way because color can be distracting.

Did You Know?

High megapixels can be confusing when sharpening. The 100% setting is larger than you normally look at a photograph unless the print is really big. This can make the detail look less sharp than it really will appear in the final print. Simply use the 100% setting as a guide to using the sharpening sliders.

CONTROL NOISE in your photo

Noise is inherently a part of digital photography. The latest cameras control noise extremely well, especially with proper exposure. Cameras with smaller image sensors have more noise — smaller sensors include the APS-C and Four Thirds sizes as well as all compact or point-and-shoot cameras. Higher ISO settings increase noise, and underexposure of a scene also increases noise in the final picture. All this makes noise more apparent in an image. and as you sharpen the photo, this noise will also be sharpened making it more noticeable.

This is why Camera Raw includes Noise Reduction in the Detail tab along with Sharpening. Noise is most noticeable in even-toned areas like sky, so look for it there while you reduce it.

You can affect two types of noise — the sandlike pattern of luminance noise and the color pattern of color noise. Be careful about overusing noise reduction because it can make fine details in your photograph soft. If you find you have severe noise in an image, you need special software designed specifically for noise reduction.

1 Click 100% to 200% in the magnification menu at the lower left so that you can see noise more clearly.

2 Press the spacebar to get the Hand tool and move the photo to find a dark, smooth area that shows noise, such as sky.

3 Move the Luminance slider to the right until the noise starts to smooth out, but no more.

A If you find you are having problems with important detail in the image as you reduce noise, try adjusting the Luminance Detail and Luminance Contrast sliders to compensate.

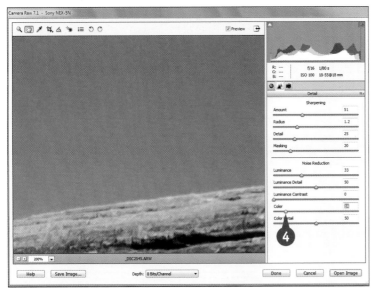

You can move the Color slider to the right if you see colored speckles that represent color noise.

④ Move the Color slider to the left from the default setting if, as in this example, no color noise is present.

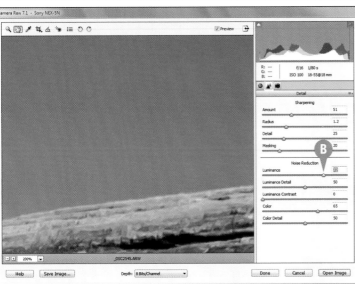

Ⓑ Avoid high amounts of Luminance or Color noise reduction, as shown here, because it can adversely affect the small detail and color in your photo.

TIPS

Did You Know?

Dark areas show noise more quickly than any other parts of a photograph when they are brightened. This is why you should avoid underexposing your pictures, forcing you to brighten dark areas, thereby increasing noise.

Caution!

Noise is essentially tiny details in your picture. Reducing noise can also reduce other tiny details, so you need to be careful about how strongly you use the Noise Reduction sliders. The Color slider can also affect small but important color detail in your picture.

Check It Out!

When noise starts to become problematic in a photograph, you must use other methods of noise reduction than what Camera Raw provides. Dfine from Nik Software (www.niksoftware.com) and Noiseware from Imagenomic (www.imagenomic.com) are two programs that work well with Photoshop Elements. See task #94 for more about Dfine.

Often, you photograph a subject or scene in a variety of ways. Yet the exposure and the light are basically the same among all these shots. The photos you see here are of the same area of Petrified Forest National Park, taken at approximately the same time. The light and exposure do not change much. It would be a nuisance to have to process each one of these individually.

Camera Raw in Photoshop Elements enable you to apply multiple adjustments to photographs at the same time.

Process one image to your liking and then apply those same adjustments to all the rest. That is a big timesaver.

This also benefits photographers who shoot certain subjects in standardized ways, such as portraits under a specific lighting setup. Portrait photographers, especially, often take a lot of pictures of a single subject or several subjects with few changes in exposure or lighting. Processing all those pictures would really be a pain if you could not do something to adjust all of them very quickly.

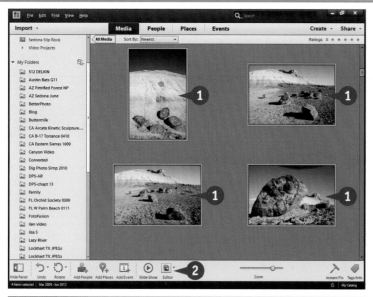

① Ctrl/⌘+click to select several similar RAW images in Organizer that need the same sorts of adjustments.

② Click Editor to move the images to Camera Raw.

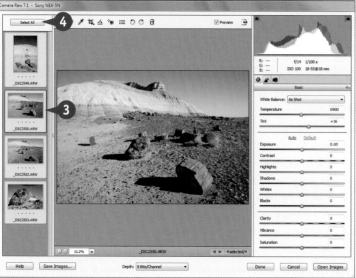

Camera Raw opens, now with a series of photos on the left. Be patient with your computer if this does not happen quickly.

③ Click the photo that can be adjusted most easily first.

That photo appears in the work area.

④ Click Select All to select the whole group of photos.

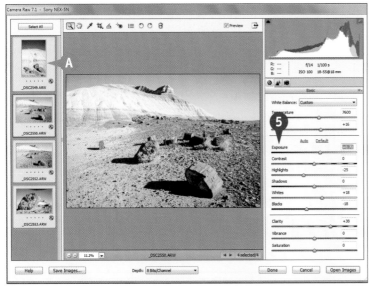

5 Adjust the work area photo as best you can.

A Adjustments are automatically applied to the other selected photos, as well.

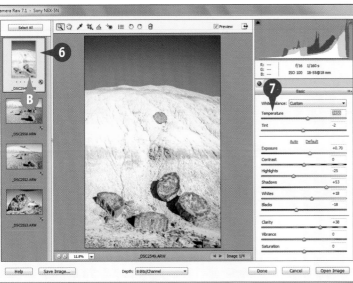

6 Click any individual photo.

7 Refine the adjustments on that photo as needed.

B Adjustments are applied only to this photo.

 TIPS

Try This!

You can use the following technique when you want to change one or two adjustments for your group of pictures and not have everything changed as you go. Make adjustments needed for all of the photos first; in other words, only the specific adjustments needed for all the group pictures. Then go in and perform the normal adjustments to individual pictures as needed.

Check It Out!

As you make adjustments, an icon appears at the lower right-hand corner of your image that tells you adjustments have been made. This helps you keep track of which images have been adjusted if you are adjusting a group of photos one at a time.

Warning!

As you adjust your photographs in Camera Raw, you may notice a small yellow triangle with an exclamation point in it in the upper right-hand corner of the images. This is a warning icon, but not something you have to worry about. It indicates your computer is working on processing these images for display.

Once you are done working on your image in Camera Raw, the photos cannot stay there. Camera Raw is a separate program from Photoshop Elements, so you have to transfer your pictures out of that program, which processes them as they move into Editor.

Everything you do in Camera Raw is just instructions on how to process and convert the image from the RAW file to an actual picture file. That offers a great benefit because you can make any adjustments you want to a photograph,

yet they have no effect on the original image file. You get an effect only when that file is converted to an image that can be used outside of Camera Raw.

These instructions are also saved as a separate, companion file to your RAW file, called an XMP or sidecar file, so that if you open that RAW file again in Camera Raw, all your adjustments are still there. This file is a very small file, and you will see it next to your RAW file if you look in Windows Explorer or Mac Finder.

Move Your Picture to Photoshop Elements

1 Click the Depth pop-up menu.

2 Choose 8 Bits/Channel.

Note: At this point, you have some options to how you deal with the photo moving from Camera Raw. Clicking Done in the next step or clicking Open Image in step 4 do two different things.

3 Click Done.

This saves your image processing instructions to the XMP file and closes Camera Raw. Use Done when working with a group of images that you want to adjust, but you do not need to open them all in Photoshop Elements for final work now.

4 Click Open Image.

DIFFICULTY LEVEL

The photo opens into Photoshop Elements, converted from the RAW file based on the adjustments you made in Camera Raw.

You can now do additional adjustments to the image in Photoshop Elements.

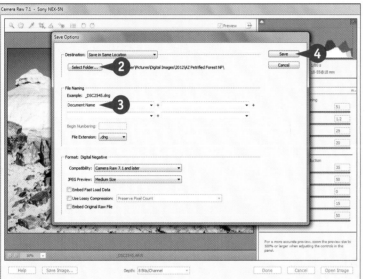

Save Your Picture as a DNG File

You can save your image as a DNG file, which is a special Adobe RAW file that Adobe promises to always support.

1 Click Save Image.

The Save Options dialog box appears.

2 Choose a destination.

3 Name your file.

4 Click Save.

TIPS

Did You Know?

Bit depth represents how much processing flexibility you have in an image file. You are processing in Camera Raw at the maximum capability of 16-bit regardless of what you choose for export bit depth from the Depth option. Unless you are planning to do a lot of processing in Photoshop Elements, you can easily use the smaller 8-bit file there.

Why Does My File Not Open?

Photographers get frustrated when their RAW files do not open in Camera Raw or Photoshop Elements. RAW files are proprietary and every new camera has a nuance that changes the file format. Adobe cannot program Camera Raw for the new file until the camera is released, so there is a delay in being able to open a new camera's RAW files. You then have to download an updated version of Camera Raw to open the new camera's now recognized files.

Did You Know?

A DNG file is Adobe's RAW file — DNG is short for digital negative. It is a generic file that supposedly guarantees you will always be able to use a RAW file even if the manufacturer no longer supports your camera's proprietary file. The latter seems unlikely, but if you are the cautious type, you can save your images as DNG files.

Chapter

4

Choose Local Control Features

Ansel Adams used to say that when you took the photograph, the photographer's work was only partly done. A problem everyone has, from the top pro to the beginning amateur, is that the camera does not always interpret the world the way that people see it. A photograph of a beautiful natural scene is not the same as that natural scene. The scene must be interpreted using the limitations of the camera and the possibilities you have for working on the image in Photoshop Elements.

One way to deal with these challenges is to work at seeing the world from your camera's perspective. What can or can it not capture? Check your LCD to see what the camera is truly seeing and decide if

you need to try something different to get a better photo.

Another way to correct these problems is to isolate them while processing a photograph so you can adjust them separately from the rest of the image. This is called *local control* as compared to overall or global control over the whole image. With Photoshop Elements, you have the ability to select and isolate very specific parts of the picture and then make corrections to that isolated area so that no other parts of the picture are affected. That can make a big difference in how a photograph interprets a real-world scene.

DIFFICULTY LEVEL

CREATE AND USE a selection

Creating selections is a key way of isolating a part of the picture for adjustment separately from the rest. A selection is a little bit like a fence. If you build a fence in the middle of a field and put all the cows in there, they eat the grass there and nowhere else. If you create a selection in the middle of the picture, any adjustments that you make occur inside that selection and nowhere else.

Photoshop Elements offers a number of ways to create selections. The reason for the choice of selection tools is to make selections easier, more effective, and more precise

for the specific needs of individual pictures. In this task, you learn what a selection can do, how it works, and how it combines with adjustments to control where an adjustment occurs.

Architectural details always make interesting subject matter for photographs. The old power plant in Redondo Beach, California, is an amazing structure, filled with wheels and pipes that make interesting designs in a photograph. This image was shot with an iPhone.

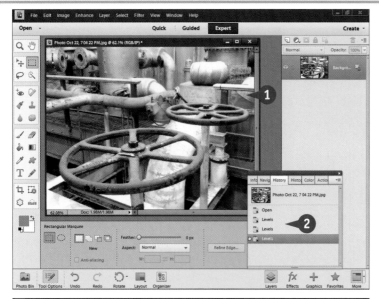

① Open an image into Elements Editor.

② Do your basic adjustments as described in Chapters 2 and 3.

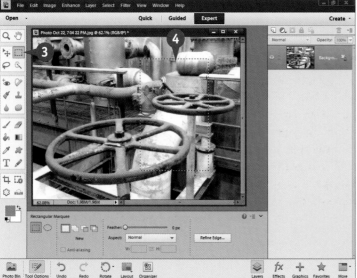

③ Click the Rectangular Marquee tool in the Toolbox.

④ Click and drag a rectangular selection inside your picture.

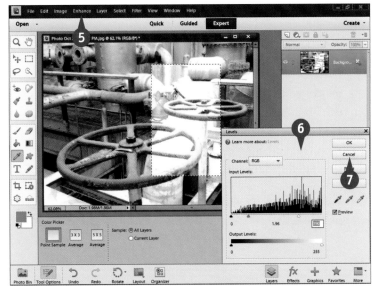

5 Click Enhance, select Adjust Lighting, and then select Levels to open the Levels dialog box.

6 Make an extreme adjustment in the Levels dialog box to see the effect.

7 Click Cancel.

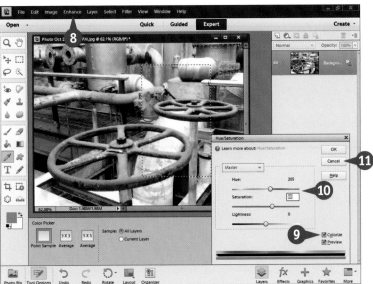

8 Click Enhance, select Adjust Color, and then select Adjust Hue/Saturation to open the Hue/Saturation dialog box.

9 Select the Colorize check box.

10 Make an extreme adjustment with Hue and Saturation so that you can see the effect.

11 Click Cancel.

TIPS

Try This!
As you experiment with new controls in Photoshop Elements, you will typically close one file and open another to see the effects on varied subjects. You can always close and open images from the File menu. You can also close any open photo by clicking the small X in the image name tab that sits above the image.

Change It!
Once you have a selection, you can easily get rid of it and start a new selection at any time. Press Ctrl/⌘+D to deselect your selection. You can also click your cursor outside of a selection to deselect, as long as you are still using a selection tool.

Did You Know?
Colorize is an interesting part of Hue/Saturation because it does not simply change colors in a picture — it adds colors to a picture. When you select that check box, the adjustment adds whatever color is chosen in the Hue area to the photograph. You can then adjust the intensity of this color using the Saturation slider.

USE MARQUEE TOOLS for specific shapes

The rectangular and elliptical selection tools in the Toolbox are called the marquee selection tools. These basic marquee tools select exactly what you expect, rectangle and ellipse shapes. Experimenting with them when you are learning selections is great because they are so obvious. You can make a selection and then experiment with it to see how it works, or even to see how a particular adjustment might affect the image without adjusting the whole photo.

These tools tend to work very well with photographs of architecture and other man-made structures because those

structures typically have rectangles and ellipses. The tools' shapes are so specific, however, that most photographers use them infrequently because most photographs do not have these specific shapes. Still, when you do need them, they give you specific, precise shapes in a hurry.

The fascinating thing about photographing an old industrial structure is all the different shapes and forms within it. Smartphones with their built-in cameras give you a chance to photograph places even when your main camera is at home. Photoshop Elements can help you improve photos from these devices as well.

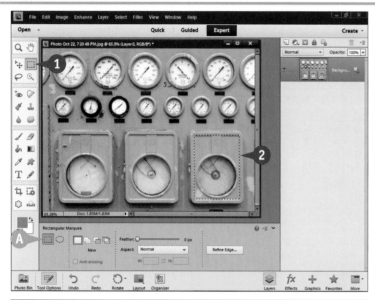

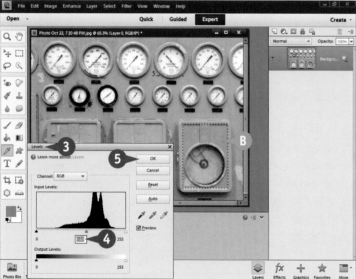

Use the Rectangular Marquee Tool

1 Click the Rectangular Marquee tool in the Toolbox.

A If the rectangular tool is not showing, click the Elliptical Marquee tool that will be showing, then click the rectangular button in the Tool Options panel.

2 Click and drag a selection around an area that works with the shape.

3 Choose an adjustment appropriate for the selected area inside your photograph.

4 Make the adjustment.

In this example, the brightness of the selected area is adjusted with the appropriate sliders in Levels.

5 Click OK.

B The adjustment occurs only inside the selected area.

Use the Elliptical Marquee Tool

#36

DIFFICULTY LEVEL

1 Click the Elliptical Marquee button in the Toolbox Options panel.

2 Click and drag a selection around an area that works with the shape.

The Elliptical tool takes some practice getting used to.

Experiment with it to see how it might work for you. You can drag from the center if you press Alt/Option as you click and drag.

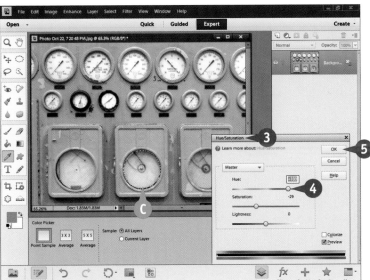

3 Open an adjustment appropriate for the selected area inside your photograph.

4 Make the adjustment.

5 Click OK.

C The adjustment occurs only inside the selected area.

 TIPS

More Options!
The marquee tools also do square and circle selections. To get a square, choose the Rectangular Marquee tool and press and hold Shift as you make the selection. To create a circular selection, choose the Elliptical Marquee tool and press and hold Shift as you make the selection.

Try This!
Once you have created a selection, you can move it to a better place in your photograph, as needed. While still using your selection tool, simply click in the selection area and hold down the mouse button. Then drag the selection to a new area. You can also move your selection with the arrow keys.

More Options!
In past versions of Photoshop Elements, added tools were often hidden underneath the Toolbox icons. For example, the Elliptical Marquee tool was hidden under the Rectangular Marquee tool. Now these options are both readily accessible and easily seen in the Toolbox Options panel.

Photoshop Elements gives you freehand tools such as the Lasso, the Polygonal Lasso, and the Magnetic Lasso for selecting around any shape.

The Polygonal Lasso is probably the easiest to use. You simply click to start and then move your cursor along a shape, clicking as you go to anchor the selection. You can move the cursor anywhere without effect so you can carefully find exactly the spot to select before you click. Complete the selection by clicking the beginning point or double-clicking anywhere. The Magnetic Lasso is an

automated lasso that finds edges for you if you have a strong edge where your selection needs to be. The Lasso tool itself works totally freehand, but it can be hard to control without a lot of practice.

One challenge photographers frequently face is a dark shadow. On this building, a strong shadow appears on the structural detail on the left. It needs to still look like a shadow, but it can be selected and brightened to balance the rest of the image.

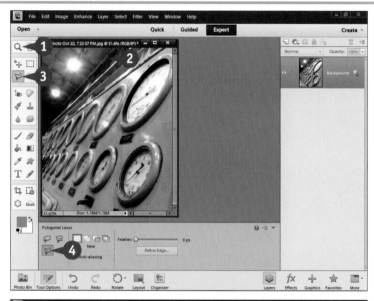

1. Select the Zoom tool or magnifier in the Toolbox.

2. Click the area you need to select to magnify it. This is shown magnified in the next step.

3. Click to select the Lasso tool in the Toolbox.

4. Select the Polygonal Lasso tool in the Tool Options.

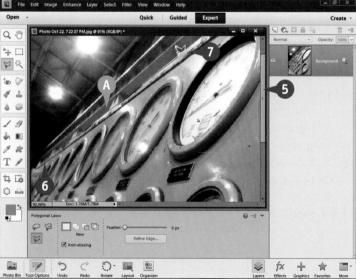

5. Use the scroll bars around the edges of the image to reposition the active part of the photo.

6. Click at one edge where you want to make a selection.

7. Move the cursor along the edge, clicking regularly to anchor the selection edge.

A. The selection follows your cursor.

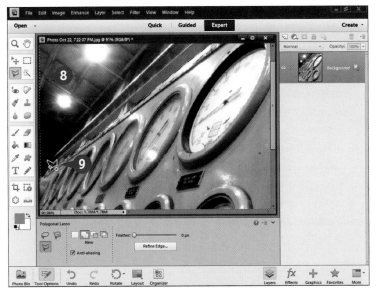

⑧ Click and move your cursor around the area that you want to select.

⑨ Finish the selection by clicking where you started.

A small o appears at the cursor's lower right when positioned over the starting point.

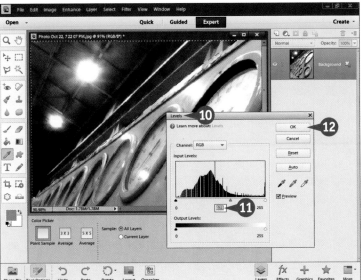

⑩ Choose an adjustment appropriate for the selected area inside your photograph.

⑪ Make the adjustment.

In this example, the top part of the building has been darkened using Levels.

⑫ Click OK.

⑬ The adjustment is made only inside the selected area.

Important!

Selections definitely take practice. When you first start using selections, you may find it frustrating to make your selections go exactly where you want them. With practice, you get much better. You can also find ideas in the rest of this chapter that can help you create selections more easily.

Try This!

The Magnetic Lasso is very useful when you have a picture in which, for example, your subject contrasts strongly against a simple background. The Magnetic Lasso looks for contrasting edges and finds them for you. This makes selecting easy as long as you have those edges.

More Options!

Because the Polygonal Lasso goes in a straight line from click to click, you might think it is not useful for curves. In fact, this tool is actually good for curves because you can control it easily: Just move your cursor in short distances as you click around a curve.

USE AUTOMATED TOOLS for easy selections

The diversity of selection tools in Photoshop Elements includes automated tools that help you find edges and create selections quickly for certain types of pictures. One of them, the Magnetic Lasso, was described in the previous task.

Three more very useful automated selection tools are the Magic Wand, the Selection Brush, and the Quick Selection tool. The Magic Wand is used for areas that have a consistent tone or color. Click that area and the Magic Wand finds all pixels similar to the color and tone where

you clicked. The Selection Brush enables you literally to paint a selection in the picture by brushing your cursor over an area. The Quick Selection tool is sort of in between. You use it to brush through an area; it finds additional pixels that match that area in tone and color.

Scenes that show a lot of sky can be difficult to adjust overall because when the sky looks good, the ground does not, and vice versa. By selecting the sky, you gain options for adjusting the ground and sky separately.

① Click the Magic Wand in the Toolbox and Toolbox Options. This part of the Toolbox includes three tools that are chosen in Toolbox Options.

② Click in an even-toned, colored area to begin the selection.

Ⓐ A selection is created based on the color and tone where you click.

③ Change the Tolerance for the tool if the selection goes too far or does not go far enough.

④ Click the tool once in an unselected area or twice if those areas are small; click once to remove the old selection, and click once again to create a new selection.

You may also find that it helps to click in different places.

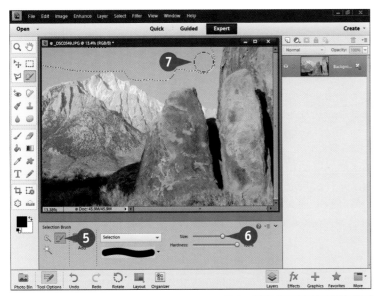

Press Ctrl/⌘+D to deselect the selection.

⑤ Click the Selection Brush tool.

⑥ Choose a brush size that seems appropriate to the area you are selecting.

⑦ Paint over an area you want to select using the Selection Brush.

⑧ Change the size as you go to better match the area you are selecting.

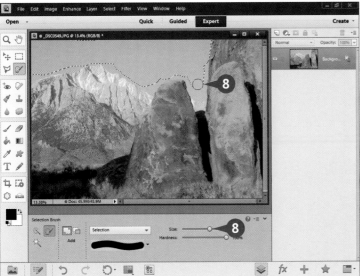

TIPS

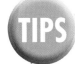

More Options!

The Contiguous check box for the Magic Wand is very useful. When the check box is selected, the selection captures only contiguous, or connected, areas. When it is deselected, the selection looks for any places in your photograph that have the same colors and tone, connected or not.

More Options!

The Tolerance setting for the Magic Wand is an important option. It tells the tool how to look at tones and colors within the picture to make the selection. Set it lower to restrict your selection, and higher to make it find more parts of the picture.

Save It!

Once you have a good selection, you may want to keep it so that you can go back to the selection later. You can save that selection. Click the Select menu and select Save Selection. Type a name for the selection, keep New Selection selected, and click OK.

EXPAND OR CONTRACT *your selection*

Making good selections takes practice. Making a perfect selection in one try can be difficult for anyone. Luckily, Photoshop Elements has features that enable you to improve a selection and make it do what you want it to. You can easily add to or subtract from a selection as needed.

This is very important because it makes selecting easier. You do not have to worry about making a selection perfect from the start. In fact, making your first selection very quickly and then refining that selection to the final area is

often easier and faster than trying to do it exactly right as you go. No matter what you do, you will often find little jags, corners, and other odd shapes easier to deal with after you have done your first selection work.

The rocky landscapes seen here are from Alabama Hills near Lone Pine, California. This boulder-strewn landscape has been part of many Hollywood films for over 80 years. It is an amazing place to photograph because the geology of the place is so visible and accessible.

① Click the Zoom tool in the Toolbox.

Note: It usually helps to magnify the selected area so you can better see the edges.

② Click the area to magnify it.

③ Click the Quick Selection tool in the Toolbox and Tool Options.

④ Click the Size slider to change the brush to a size appropriate to the areas you need to select.

⑤ Click and drag to brush a selection. This tool looks for more than the area you brush over; it also finds similar tones and colors.

Ⓐ Be sure the middle selection type is selected. This adds to a selection so you can click and brush multiple times to add to the selection until it covers the area needed.

6 Select the right selection type, Subtract, to subtract from the selection.

7 Click and drag the Quick Selection tool to remove part of a selection.

Remove all excess selection areas.

8 Refine your selection by adding to it or subtracting from it until you get the selection you want.

B You can repeatedly go back and forth between the default add function and the subtract function of the Quick Selection tool. Remember that the brush automatically adds to a selection unless you use the Subtract function.

TIPS

Try It!

The Lasso tool is ideal for adding to and subtracting from a selection. It can be hard to use when trying to make a large selection, but for little adjustments and selection refinements, it works well. Press and hold Alt/Option to remove part of a selection, and press and hold Shift to add to a selection when using the Lasso tool.

More Options!

You might have noticed that your cursor changes when it goes over the word *Size* in the Options bar. Your cursor becomes activated and you can simply click Size and drag left and right to make the brush size smaller or larger respectively without using the Size slider. Many numerical options in Photoshop Elements work this way.

Try This!

You can make any brush tool larger or smaller very quickly by using the keyboard. To the right of the letter P are the bracket keys, [and]. Press [and the brush gets smaller. Press] and the brush gets larger. You will find this very handy for sizing your brush perfectly.

SELECT WHAT IS EASY and invert

Photographs can be challenging at times. You want to make an adjustment to a very specific part of the picture, but selecting that area is difficult.

You may discover that selecting something beside, around, or behind your subject is easier than selecting the object. This would not help you if it were all you could do, because you do not really want to select that area. However, Photoshop Elements enables you to make a selection and then invert it or flip it so that what was selected is now unselected and what was unselected is

now selected. Often, when you look at a picture, you can find easier ways of making a selection than simply creating an outline around what you want to select.

The rocky opening from Alabama Hills shown here is a good example of this. It would be nice to hold the color in the sky and landscape seen through the opening while brightening the rocks around it. With the opening selected first, the selection can be inverted to end up with a selection of the dark rocks.

① Select the easiest part of the scene to select. In this case, it is the opening instead of everything around the opening, which is really what needs to be adjusted.

② Click Select.

③ Choose Inverse.

Everything except the opening is now selected.

4 Fix problems with the selection by using Shift plus a selection tool to add to the selection or Alt/Option plus a selection tool to subtract.

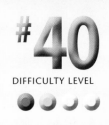

5 Open an adjustment dialog box based on what you need to change, such as Levels.

6 Make an adjustment.

A The adjustment applies to the area that originally needed work, but not to the opening, which did not.

TIPS

More Options!

Remember that you do not have to do a complete selection in one try. You can use this technique to do the best you can, such as selecting the sky and inverting the selection. Then you can add to that selection or subtract from it using other selection tools. Simply press and hold Shift while selecting to add, or Alt/Option to subtract. You can also use the Add or Subtract selection types in Tool Options.

Try It!

Sometimes the outline around your selection can be distracting. Pressing Ctrl/⌘+H temporarily hides the selection outline, yet the selection is still there. Press Ctrl/⌘+H again, and the selection outline reappears. Do not forget that you used this command or you will get frustrated that controls are not working right because of a "hidden" selection.

Put It Together!

Use whatever selection tools make it easiest to get your selection started. Then use the Inverse command as well as adding to and subtracting from a selection to refine your selection as needed. Using multiple tools like this helps a lot in getting better selections.

BLEND EDGES by feathering

Selections create a hard edge between selected and unselected areas, a hard edge that is really not normal in a photograph. Magnify any photograph and you rarely see a razor-sharp edge anywhere. This is because of the way light works as well as how things go in and out of focus in an image. Using an unmodified selection this way can look very unnatural in the picture.

You can see this in the photo used here when you look at the edge of the foreground rocks and the background.

The image you see has been enlarged to show the edge, which looks unnatural when simply selected and adjusted.

Photoshop Elements gives you the opportunity to make this edge blend in. This is called *feathering*. Feathering has to be adjusted for every selection because how much of a blend is needed depends entirely on the subject in the photograph. This is why feathering after you have made a selection is best because if you do not like the effect, you simply undo it and try another amount. The selection remains unchanged.

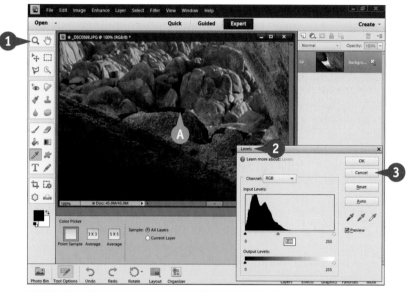

1 Use the Zoom tool to magnify an image with a selection so you can see the edge clearly.

2 Open an adjustment control appropriate to your photo and make a strong adjustment so that the difference between selected and unselected areas is extreme. You are trying to see the effect, not make your image perfect.

A Note the hard edge between adjusted and unadjusted areas.

Pressing Ctrl/⌘+H hides and unhides the selection outline to make the edge easier to see.

3 Click Cancel.

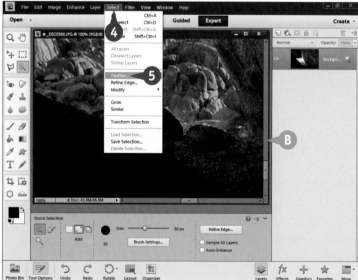

B The image now appears with the selection and no adjustment. The selection is hidden.

4 Click Select.

5 Choose Feather.

The Feather Selection dialog box opens.

6 Type a moderate number for Feather Radius such as 10–25.

Note: The amount of Radius is relative and will be "large," "moderate," or "small" based on the size of the selection and the number of pixels in the photo.

7 Click OK.

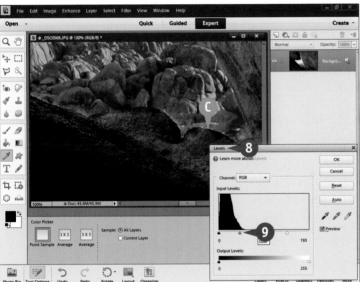

8 Open an adjustment dialog box, the same one you did before that was appropriate to your image.

9 Make a strong adjustment now that really changes the selected area. You are doing this to see the effect, not for a finished adjustment.

C Note how the adjustment now blends nicely in the photo.

TIPS

More Options!

To get the equivalent of a feathered edge on your selection when using the Selection Brush, choose a soft-edged brush. After choosing the Selection Brush, use the Hardness slider in Tool Options to give it 0 hardness. You can see the difference between a soft- and hard-edged brush by the softness or hardness of the brush stroke icon to the left of the Hardness slider.

Did You Know?

When you choose an adjustment control after making a selection, the dialog box that opens shows you what is happening only inside the selection. For example, the Levels dialog box shows something distinctly different for the selection than if you use Levels for the entire picture. The control affects only that selected area.

Change It!

Feathering values affect how far a selection blends between the selected and unselected areas. If the photograph has fairly sharp edges as in the example, you typically use a low number, such as one between 5 and 10. If no sharp edge exists or you want the blend to cross a wider part of the picture, use a high number, even one between 60 and 100.

Feathering softens edges and helps them blend, but that is not the only way to help an edge work better with your image adjustments. Sometimes a feather expands the adjustment edge, even though soft, too far across the edge. Photoshop Elements offers additional edge controls in something called Refine Edge. This is available in the Selection menu, but it also can be accessed with a Refine Edge button in some selection tools' Tool Options.

When you create a selection, Photoshop Elements creates something called a *mask*. The selection is not as simple as

a line barrier between what is selected and what is not. The selection shows the edge of the mask. A mask blocks out anything from happening under it. Everything inside a selection is then covered by that mask.

In Refine Edge, you can even see the mask displayed in multiple ways. This can help you better see the edge and what you might need to do. Edges are critical to good selection work in Photoshop Elements, so having this Refine Edge tool makes edge work easier.

① Click the Select menu and choose Refine Edge.

Ⓐ The Refine Edge dialog box appears.

② Click View in View Mode for a drop-down menu.

Ⓑ The mask appears white by default.

③ Click the Overlay option. This makes the mask a translucent red.

④ Click Smart Radius to help Refine Edge better locate the edge.

⑤ Adjust the Radius slider to change how the edge appears and how the selection interacts with that edge.

⑥ Use the Define Radius tools to help refine where the edge appears and how it acts there.

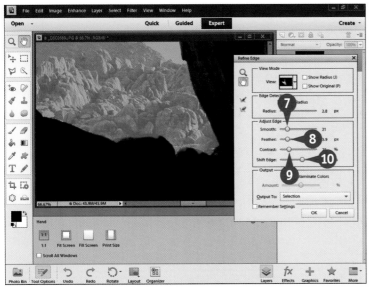

7 Adjust Smooth to smooth out a rough selection.

8 Change Feather to soften and blend an edge.

9 Adjust Contrast to affect how the feather blends.

10 Shift the edge of the selection if it is not lining up properly with the edge of the object.

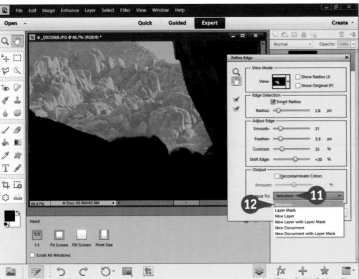

11 Click the Output To button for a drop-down menu.

12 Choose a way to use or output your refined selection back to the image.

13 Click OK.

 TIPS

Attention!

Refine Edge is exactly that, a way of refining a selection edge. It is not a way of making a better selection. No tools are here to help you add to or subtract from a selection. You need to do that work with a specific selection tool, then go to Refine Edge to help you better blend the edge of the selection with the image.

Test It!

Experiment with feathering. Feathering is not some absolute thing for which you can pick an arbitrary number and be done with it. The same feathering numbers can look perfect on one photograph and awful on another. You can easily try different settings with the Feather slider in Refine Edge and keep trying until you like the effect.

Did You Know?

Ansel Adams was a master landscape photographer who spent a lot of time in a traditional darkroom. He felt that the original exposure was only an approximation of what he really saw at the scene. He used his time in the darkroom to bring out the best in his images so that the scene was interpreted more closely to the way he actually saw it.

The Smart Brush combines the Selection Brush with a whole range of preset adjustments that you choose and then use on your photograph. These adjustments specifically define how such things as color, contrast, and special effects are applied to your photograph in restricted areas. They are easy to use, and are well worth experimenting with to see what all the presets can do for your photographs.

In this photo, the soft light of a hazy sunset is not giving the rocks the boldness they need. The Smart Brush is being used to intensify the contrast in just the rocks.

Although you do not have to know anything about layers or layer masks to use the Smart Brush, this tool uses layers and layer masks for its effects. You will see a new layer appear in the Layers panel when you use the brush. Layers and layer masks are covered in Chapter 5. As you learn to use layers, you will also gain more control over the Smart Brush.

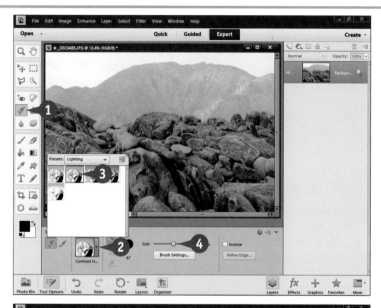

1. Choose the Smart Brush from the Toolbox.

2. Click the Preset drop-down menu.

3. Choose the preset appropriate for your photo's needs.

4. Change the size of your brush with the Size slider until the size is correct for the space.

5. Brush the preset change onto the photo over the area that needs the adjustment.

A. A selection appears, marking the edges of the adjustment.

⑥ Continue brushing over the image until the whole area is selected and adjusted.

⑦ Add or subtract from the changed area with the plus and minus brushes.

Examine the change; if it is good, continue working on the photo.

⑧ Double-click the red Smart Brush icon to refine the adjustment.

Ⓑ An adjustment box opens that automatically gives you the correct adjustment controls.

⑨ Change the adjustment to refine the work that the Smart Brush started.

This adjustment is up to you and varies depending on the type of brush you choose.

⑩ Click the small X to close the box.

TIPS

Did You Know?

The Smart Brush is a very handy tool because you can reopen its adjustment and readjust the controls as much as you want. No harm comes to your picture when you do this, which makes it a great tool to experiment with. Just click the appropriate Smart Brush working icon on your image for each adjustment.

Did You Know?

You can start a new Smart Brush adjustment using the same adjustments by clicking the first Smart Brush icon again. This enables you to perform the same adjustment, but at different locations in the photo and with different amounts. The Smart Brush working icons change color as you add Smart Brush adjustments.

Test It!

To totally remove a Smart Brush adjustment, you need to remove the layer on which the adjustment was made. That is easy to do. Simply go to the Layers panel, click the layer named for the adjustment you want to remove, and then drag it to the trash can icon above the layers. This is explained in more detail in the next chapter.

Create Adjustment Layers for Nondestructive Changes

The great advantage of working with Photoshop Elements is being able to use layers. Even photographers who use Lightroom often need layers, and Photoshop Elements can be a good companion to that program. A lot of photographers stop before mastering layers, and that is a big mistake for users of this program. You gain a huge amount of flexibility and capability simply by understanding and using layers. They may take a little effort to learn, but once learned, they offer a lot of important benefits. Layers separate the varied things you might do in processing an image to allow higher image quality and more possibilities.

A good place to start learning layers is by using adjustment layers and layer masks. Adjustment

layers give you a great range of flexibility and power that you do not get when working directly on the pixels of an image. You can change adjustments in an adjustment layer as much as needed without worrying about hurting the photo.

Adjustment layers are a lot like filters on a camera. If you put a filter on your lens, the scene does not change, but it does look different coming through the lens and onto your sensor. An adjustment layer does something very similar, changing how the pixels of a photograph appear yet not actually changing any pixel in the underlying picture.

Understand HOW LAYERS WORK

One reason that many photographers get intimidated by layers is that layers seem very much of the computer and alien to taking pictures. Mentally step away from Photoshop Elements and the computer and you discover you already know quite a bit about layers. A layer cake is made up of actual layers — you can see them from the side, but you cannot see them from the top.

This is important to keep in mind because layers in Photoshop Elements act the same way. They are simply a stack of digital things, from adjustment layers to actual photographs. The stack has a top and a bottom, the top covers up everything underneath it, and you examine a stack from top to bottom. Real-world layers, such as a stack of papers, appear to us in exactly this way, too.

The photograph here shows some of the red rock formations that show up in the desert near Las Vegas, Nevada. This particular formation is in the Lake Mead National Recreation Area.

A photo is here, but all you can see is a blue rectangle.

Ⓐ The original photo is at the bottom of the layer stack, but is not visible.

Ⓑ The red rock has been separated from the original image as a separate layer, but also is not visible.

Ⓒ A solid color layer blocks any view of the original photo, just as if you painted blue on a piece of plastic over a photo.

Ⓓ The top layer can be moved down just like shuffling paper or photographs in a stack.

Ⓔ Notice the blue layer is solid and covering up the original photo.

Ⓕ The layer above the blue layer has separate picture elements, and the two layers combine to look like a blue sky behind a floating rock.

G Now the blue layer has been turned off by clicking its eye icon.

H The photo, though actually made up of two layers, changes so that it looks like the original.

44

DIFFICULTY LEVEL

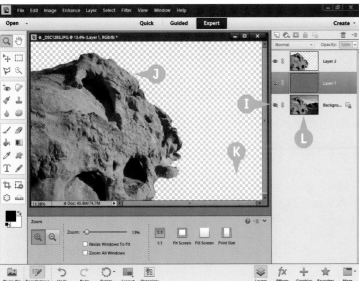

Because layers separate parts of a photo, you can easily change one part without affecting another.

I The bottom layer or Background has been turned off by clicking its eye icon.

J Now only the rock part of the photo appears with a checkerboard pattern underneath.

K The checkerboard pattern means that the area contains no pixels.

L The original photo is still there, untouched.

TIPS

Did You Know?

If for any reason you discover that your panels are not appearing, select the Window menu. It has a list of items to display in the Photoshop Elements interface. You can turn any of them on or off by clicking the name of the panel.

Try This!

You can easily move layers up and down in the Layers panel. Click a layer and drag it to a new position. Look at the line between layers as you move a layer. When it thickens, your layer is ready to be dropped into position. Photoshop Elements automatically opens a space for it and shifts the other layers to make room for it.

Did You Know?

The biggest benefit of layers is the ability to isolate parts of a photo. This enables you to work separately on those parts, and having layers gives you more options for blending separate elements in different layers.

Understand HOW ADJUSTMENT LAYERS WORK

Adjustment layers include many of the adjustment controls that you have seen so far in the book. An adjustment layer even shows the same sliders and other parts of the original adjustment's dialog box.

Yet using an adjustment layer is considerably different from adjusting directly on the photograph's pixels. These special layers are basically instructions. As you make an adjustment, the underlying picture appears to change, yet it really does not. What changes is the view through the adjustment layer, sort of like looking through an adjustable filter. You can adjust and readjust the controls in an

adjustment layer because the underlying picture never changes. The adjustments are nondestructive because pixels are not damaged in any way. In this task you try an adjustment layer to see how these layers work.

Most people who visit Las Vegas have no idea of the vast and beautiful desert landscapes that exist just outside the city limits. Lake Mead National Recreation Area is a wonderful place for photographers because it is both accessible and little used by the masses of people visiting Las Vegas.

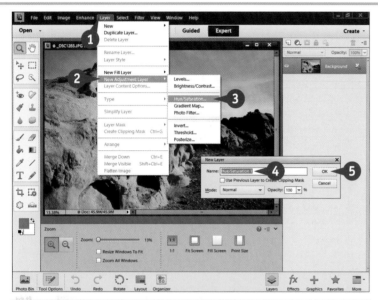

Use the Menu to Add an Adjustment Layer

1 Click Layer.

2 Select New Adjustment Layer.

3 Select Hue/Saturation.

A New Layer dialog box opens.

4 You can change the layer's name by typing it into the Name box or leave it Hue/Saturation 1.

Leave the other options at the default settings.

5 Click OK.

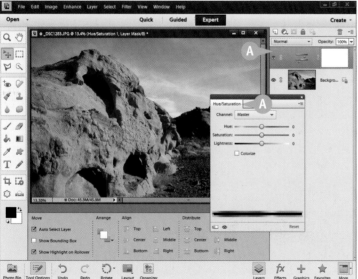

Ⓐ A Hue/Saturation adjustment layer is then created, and the Hue/Saturation adjustment panel appears.

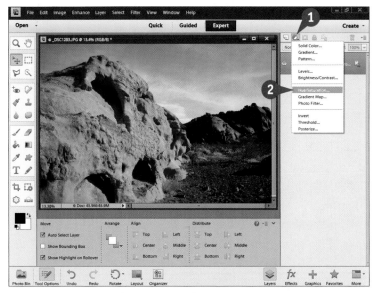

Use the Icon to Add an Adjustment Layer

DIFFICULTY LEVEL

1 Click the Adjustment Layer icon at the top of the Layers panel.

2 Select Hue/Saturation.

B The Hue/Saturation adjustment panel opens; it looks nearly identical to the dialog box that you open by selecting Adjust Color and then Adjust Hue/Saturation in the Enhance menu.

C The difference is that an adjustment layer appears automatically over the original picture, now the Background layer.

TIPS

Did You Know?
Opening an adjustment layer with the Adjustment Layer icon on the Layers panel is quick and easy. You simply click the black and white circle to select the adjustment you want. Opening an adjustment layer with the Layer menu gives you the same list but adds the ability to name the layer immediately and change its blending mode, its opacity, and how it is grouped with other layers. You do not always need all of that.

Try This!
Naming your layers can help you keep track of what they are doing to your picture. You can name or rename a layer at any time by simply double-clicking the name in the layer and typing a new name. These names do not always show up on these pages because of the screen resolution needed to reproduce what you see in the book.

Did You Know?
The extra menu choices that show up when you click the Adjustment Layer icon in the Layers panel are called *fill layers*. These unique layers enable you to add a color, gradient, or pattern to a layer stack. You can also easily adjust fill layers without changing the underlying photograph.

The great advantage of using adjustment layers right away is that you can make changes to the photograph without making changes to the pixels. The result is that you can easily readjust any change you make without any harm to the photograph.

Sometimes you may want to adjust the picture directly, such as if you know when working on a picture that you will not need to change it later. Then you will not use an adjustment layer. But the plusses of using an adjustment layer are so great that you will find it worth learning to use them and putting them into your normal workflow.

With adjustment layers, you can always adjust and readjust a picture at maximum quality. This is quite simple to do. You double-click the Adjustment Layer icon for the particular adjustment. The adjustment panel immediately reopens, and you can make any changes you want. This enables you to tweak an image in the later stages of processing if you discover that your first adjustments do not mesh with the later adjustments as well as you would like.

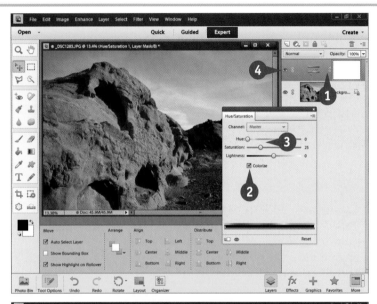

Apply an Adjustment Layer

1 Repeat the steps from the previous page to add a Hue/Saturation adjustment layer.

2 Select Colorize.

3 Change the Hue and Saturation sliders so the picture looks like it was shot with a strongly colored filter.

4 Click the eye icon at the left of the adjustment layer in the Layers panel.

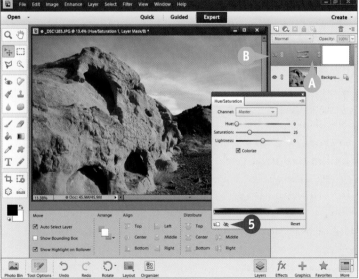

Ⓐ The new color goes away, yet the adjustment layer is still in the Layers panel. The layer's effects are hidden.

Ⓑ The eye icon has a red slash through it.

5 Click the eye icon at the bottom of the adjustment panel. You can click either icon to hide or reveal a layer.

C The color comes back.

Clicking the eye icon simply turns the visibility of a layer on and off.

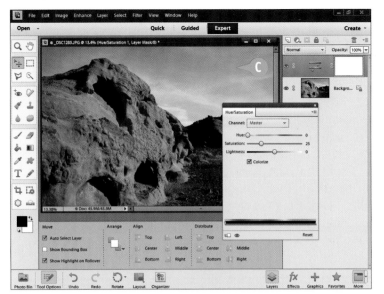

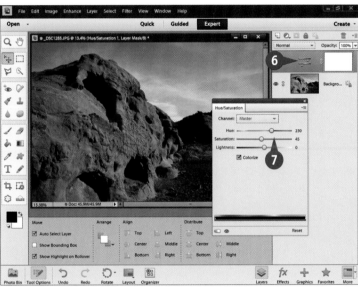

6 Click the Adjustment Layer icon at any time, and the Adjustments panel reopens.

7 Change the Hue and Saturation sliders to change the color again.

Note: The underlying picture seen as background is not affected, yet the appearance of the photograph has changed.

TIPS

Important!
When the adjustment controls of the Adjustments panel are open, everything else in the Photoshop Elements interface is accessible. For example, you can click the eye icon for a layer and change the layer opacity or visibility if the Hue/Saturation adjustment is open.

Try This!
Using Hue/Saturation to colorize an image can be an interesting way to create a one-color or monochrome photograph. You can change the hue to give the color a bluish cast, a sepia tone, and more. This is a simple way of changing the picture without actually getting rid of the original color picture.

Important!
When you have layers and save your photograph with a PSD (or Photoshop) file format, all the layers are saved with the file. You can close the image and open it days later — all the layers will still be there. In fact, you can double-click an adjustment layer and go back to exactly what you used before, or you can change it.

The workflow described in the first part of this book for adjusting an image is still important: Set blacks and whites, adjust midtones, correct color, and so on. But now you will be making the adjustments with adjustment layers.

The photo you see here is of one of the mountains bordering the Red Rock Canyon Conservation Area, also near Las Vegas, Nevada. The image has been saved as a Photoshop PSD file. The Photoshop file format is ideal for working with layers. This same image will be used for

several tasks to allow the Layers panel to gain multiple layers.

Start by adjusting blacks and whites using the Levels adjustment panel. Blacks and whites are critical to how the rest of the picture looks. Adjust blacks depending on the subject, your interpretation of that scene, and your experience with working on pictures. Whites are very sensitive and usually have a more limited range of proper adjustment. Naming this Levels layer Blacks-Whites is a good idea so you know what it is doing as you add layers later.

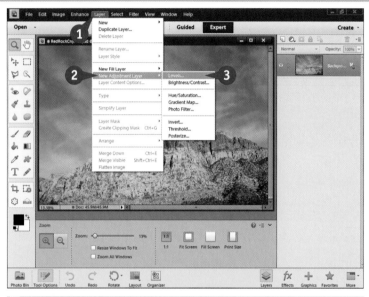

1 Click Layer.

2 Select New Adjustment Layer.

3 Select Levels.

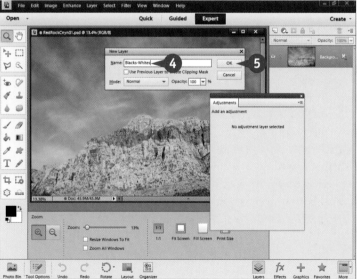

A New Layer dialog box opens.

4 Change the layer's name to Blacks-Whites by typing it in the Name box.

Leave the other options at the default settings.

5 Click OK.

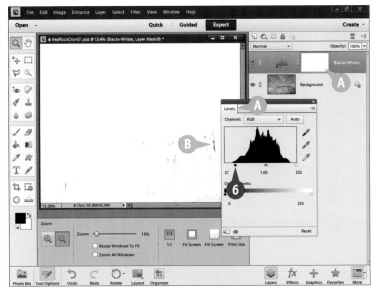

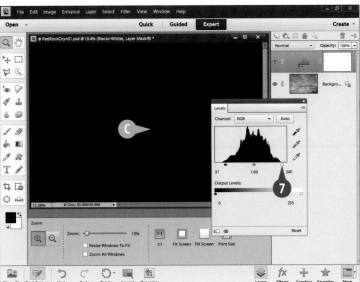

Ⓐ An adjustment layer is added, and the Levels adjustment panel opens.

❻ Adjust blacks by pressing Alt/Option as you move the left black slider.

Ⓑ A blacks threshold screen appears, showing you where the blacks and maxed-out dark colors occur as you adjust.

Note: This screenshot shows more of the Layers panel so you can see the layer name. You can click and drag the edge of the panel to resize it.

❼ Check whites by pressing Alt/Option as you move the right (white) slider.

In this photo, no adjustment of whites is needed, but it is still important to check whites.

Ⓒ A whites threshold screen appears, showing you where the whites and maxed-out light colors occur as you adjust.

Did You Know?

Threshold screens show you where certain tones appear in a picture. This makes it easy to figure out when the tones are either pure black or pure white. The colors show maxed-out channels and can be used when a picture is filled with color so that a pure black or white is hard to find.

Get Rid of Layers!

If you decide that the layer you are working on is messed up, you can easily get rid of it. Simply click that layer and drag it to the trash can icon at the top right of the Layers panel.

Did You Know?

The histogram, or graph, in the Levels adjustment panel gives you an idea of what needs to be adjusted for blacks and whites. A big gap at either side means that no data is there, which translates as no tones. Most photographs look best when no big gap appears on either side, which is what you aim for when adjusting blacks and whites.

You first adjust blacks and whites on your photograph with a Levels adjustment layer. Now you will add another Levels adjustment layer to change the midtones. Photoshop Elements does not offer Color Curves as an adjustment layer, but Levels offers a lot of flexibility when used as an adjustment layer.

Adjusting midtones is important because it affects the overall brightness or darkness of the picture. Do not use the black slider or white slider for this purpose.

Because the middle slider appears in the first layer, Levels, you might wonder why not adjust midtones there? By

keeping your adjustments on separate layers, you gain more flexibility in readjusting parts of your picture later. It also allows you to precisely find the right layer affecting a particular part of your picture.

Name that Levels layer Midtones so that you can know exactly which layer is which simply by reading the names. If you follow a consistent workflow, the first layer above the original picture — also called the Background — will always be blacks and whites, and the second layer will be midtones.

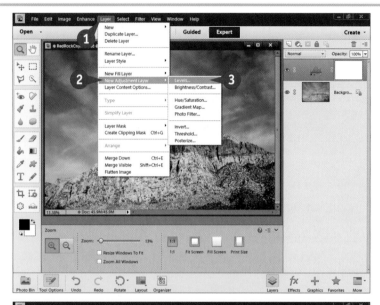

1. Click Layer.
2. Select New Adjustment Layer.
3. Select Levels.

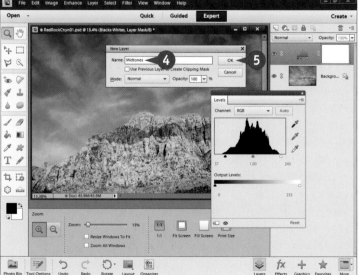

A New Layer dialog box opens.

4. Change the layer's name to Midtones by typing it in the Name box.
5. Click OK.

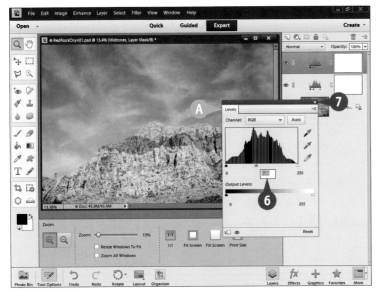

A The Levels adjustment panel opens.

6 Adjust the midtones by moving the middle slider left or right.

The photograph and its midtones get brighter as you move the slider to the left, darker as you move the slider to the right.

7 Click the small X at the top right of the Adjustments panel for a PC, top left for Mac.

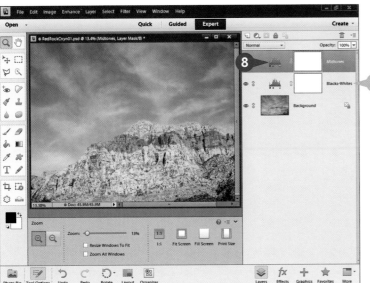

The panel collapses to make the Layers panel more visible.

8 Double-click the adjustment icon in the layer to reopen the panel.

You can also move the position of the adjustment panel by clicking and dragging the top of the panel.

B Two adjustment layers now sit on top of the original picture and affect how it looks.

Note: This screenshot shows more of the Layers panel so you can see the layer name. You can click and drag the edge of the panel to resize it.

Try This!
Cropping is important when you are working with layers. You can crop at any time using the technique described in task #15. Cropping occurs across all the layers and is a destructive form of processing, so limit your cropping at first to just getting rid of problems.

Important!
Name your layers. You will find this makes working with layers a lot easier as you add more layers during the process. It can get confusing as to which layer is doing what. In addition, named layers can help you see the process used in working on the picture — simply look at the layers from the bottom to the top.

Did You Know?
As you adjust an image, you will discover white lines or gaps appearing in the Levels histogram. These are not necessarily a problem. They become a problem only when tonalities such as gradations in your photograph start to break up. This breakup will be very obvious, looking like steps of tone where there are none, for example.

CORRECT COLOR with an adjustment layer

Color casts — subtle colors that contaminate the colors and tones throughout the photograph — can be a problem with any type of photography. Examples include bluish landscapes at sunrise and greenish hair. Color casts were a serious problem when everyone shot film because they could be hard to get rid of. Film reacted to light in one way, but that one way depended on what kind of film it was. With digital photography, correcting color by removing problem color casts has become a lot easier.

When you correct color with an adjustment layer, you gain a great deal of flexibility. If you decide that a previous color correction is not quite right as you continue to work on a photograph, you can always reopen the adjustment and do it again. This is a great advantage of the nondestructive nature of adjustment layers. In addition, you can use the opacity of the layer to change how strongly the adjustment affects the photograph.

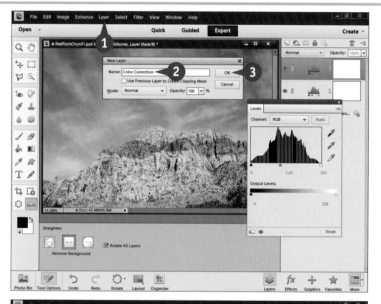

1 Click Layer, select New Adjustment Layer, and select Levels.

2 Change the layer's name to Color Correction by typing it in the Name box.

3 Click OK.

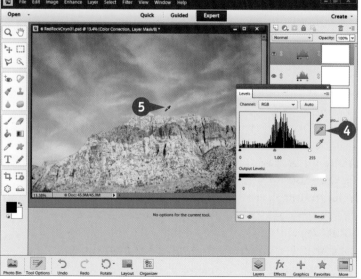

4 Click the middle eyedropper in the Levels adjustment panel.

5 Move the cursor into the picture and click something that should be a neutral white, gray, or black.

This removes a color cast from a neutral tone every time you click.

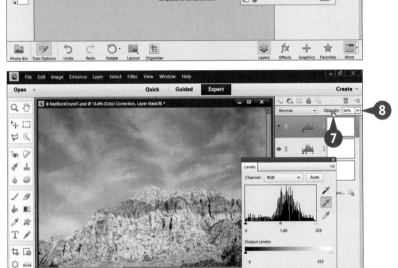

6 Try clicking different neutral grays throughout the photograph to see what you get.

Sometimes you get the right color on the first click, and sometimes it takes a number of clicks.

If you like the overall color, but it is too strong, you can change the opacity of the layer.

7 Position your cursor over the word Opacity.

The cursor changes to a hand with arrows.

8 Click and drag left or right to change the opacity of the layer.

TIPS

Did You Know?

Opacity is the opposite of transparency. Both terms refer to how much you can see through something, a layer in this case. Lower opacity for adjustment layers means the layers' adjustments lose some of their effects.

Important!

The first layers in the workflow described here are all Levels. Although all the adjustments could be made in one Levels control, this would give you a lot less flexibility. By separating the adjustments into separate layers, you can separate each control to an individual layer. This means you can more easily readjust each control individually.

Did You Know?

The middle gray eyedropper might be better called the white balance eyedropper because that is what it affects. Clouds can be a good place to try it on because they often pick up unwanted color casts. When you first click on a cloud, however, the image might look way too colored. Try changing the layer opacity to see if you get what you want.

ENHANCE COLOR with an adjustment layer

Colors in a photograph often need to be enhanced. The camera simply is not capable of seeing colors in the world the same way you do. Sometimes the camera and sensor capture colors that have an unpleasant color cast in them; correcting it was discussed in the previous task.

Other times, the colors are out of sync with what you saw in the scene — colors might be stronger or weaker than what you envisioned for the photograph. This is very common when you have a number of bold colors in a photograph, and also when you have colors that show up

in both bright and dark areas of the photograph. Because of this, it is usually better to adjust colors individually instead of trying to correct everything with one overall color adjustment.

Many times, you also need to give a slight boost to the color to make the picture livelier or more dramatic. You can do all these things with a Hue/Saturation adjustment layer. In this task, you learn a different way of opening an adjustment layer.

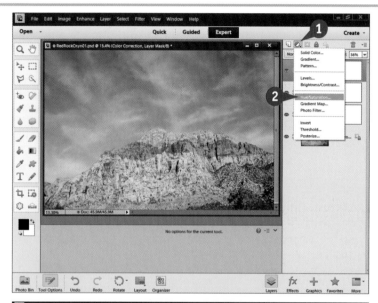

① Click the Adjustment Layer icon in the Layers panel.

A menu appears.

② Select Hue/Saturation.

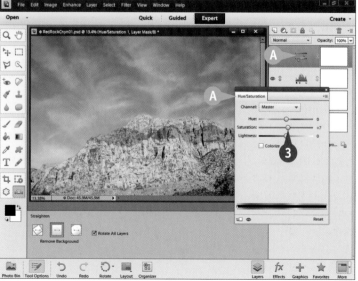

Ⓐ The Hue/Saturation adjustment panel appears along with a new adjustment layer in the Layers panel.

③ Click and drag the Saturation slider to the right to increase saturation between 5 and 15 points as needed.

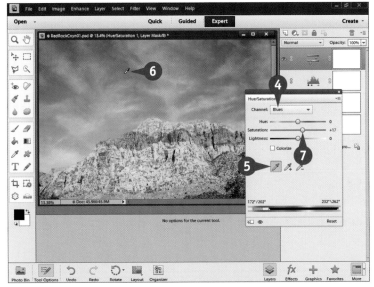

④ Click the Channel drop-down menu and select a specific color to adjust.

⑤ Click the left eyedropper.

⑥ Move your cursor over the photograph and click on the color you want to adjust.

⑦ Click and adjust the Hue and Saturation sliders for this new color as needed to adjust the color.

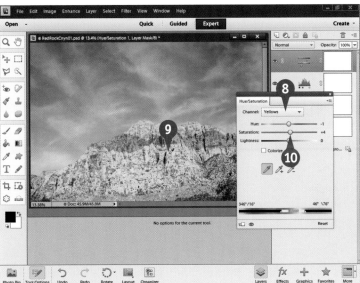

⑧ Click the Channel drop-down menu again and select another specific color to adjust.

⑨ Click the color you want to adjust.

⑩ Click and adjust the Hue and Saturation sliders for this new color as needed to adjust the color.

You can adjust saturation better when you work with individual colors, and this can avoid problems with saturation.

Caution!

When working with Hue/ Saturation, be careful that you do not oversaturate colors. This can make the picture look garish and unattractive very quickly. It is tempting to increase the saturation of your picture to make the colors look bright and lively, but this can also create a harsh quality for the image.

Did You Know?

When you click a color in the photo after you have chosen a color channel in Hue/Saturation, you will see the color bars at the bottom of the adjustment panel change. This reflects the way the adjustments are being restricted to a very specific set of colors. The upright bars on the color bars show the limits of where the colors are being adjusted.

Did You Know?

You can change the size of the layers in the Layers panel. You may want them bigger so that the icon appears larger. Do this by clicking the menu icon at the top right of the panel, and then going to the bottom of that drop-down menu and selecting Panel Options. This gives you choices for the size of layers.

FIX PROBLEM EXPOSURES with layer blending modes

At times your picture may be simply too dark or too light. The camera makes a mistake in exposure, or the photographer sets the camera incorrectly. You end up with a picture that needs immediate correction, either to make it brighter or make it darker.

Photoshop Elements gives you a way to do this in its layer blending modes. You need to add an adjustment layer to your photograph. It really does not matter which adjustment you choose because you will not be using the adjustment layer for its original adjustment purpose. You

are simply using this layer so that Photoshop Elements has something to work with when communicating between layers, which is what layer blending modes do. When you first open the blending modes, you see a long list of choices — ignore them and concentrate on two key modes for photographers: Multiply and Screen.

These photos were shot in the Mojave Desert outside of Las Vegas, in both the Red Rock Canyon Conservation Area and the Lake Mead National Recreation Area.

Fix a Too-Bright Photograph

1 Click the Adjustment Layer icon and select Levels.

A The Levels adjustment panel appears along with a new adjustment layer in the Layers panel.

2 Click the blending modes drop-down menu, which says Normal by default.

3 Click Multiply.

B The whole photo darkens by about one f-stop.

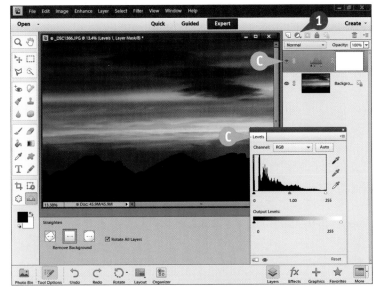

Fix a Too-Dark Photograph

DIFFICULTY LEVEL

1 Click the Adjustment Layer icon and select Levels.

C The Levels adjustment panel appears along with a new adjustment layer in the Layers panel.

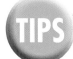

2 Click the blending modes drop-down menu, which says Normal by default.

3 Click Screen.

D The whole photo lightens by about one f-stop.

TIPS

Caution!

These blending modes are no substitute for good exposure. They really can help when you run into problems and challenges with specific images, but you should not use them as a habit because they can only fix limitations in the picture and not capture what was originally in the scene.

More Options!

Noise can be a problem when you use Screen as a blending mode. Noise is always in a picture but is usually well hidden in the darkest parts of the image. Because Screen brightens those dark areas, it also often reveals noise. That is not a problem of Screen, but a fact of life for digital photography.

Did You Know?

Neither Screen nor Multiply has controls other than on or off. You either use them or you do not. However, the layers that they affect do have an important control that you can use: Opacity. With Opacity, you can reduce the effect of Screen or Multiply as you reduce the opacity.

You may have wondered what the white boxes in the adjustment layers are. Those represent layer masks. Layer masks allow you to choose how much of the photograph an adjustment layer affects. Very often a photograph needs to be adjusted in different ways across the image. It may be too bright in one area or the wrong color in another. Chapter 4 describes how to use selections to control adjustments in specific areas. Layer masks increase this type of control, and unlike selections, they are never "deselected" and can always be changed.

Layer masks affect what a layer does or does not do. They do not affect anything in the photograph itself except as they change what their layer does.

White in a layer mask allows the layer to appear fully, whereas black blocks it. By applying white or black to a layer mask, you can then effectively control specific areas in a photograph and, in those areas, whether a layer works (white) or is not allowed to work (black).

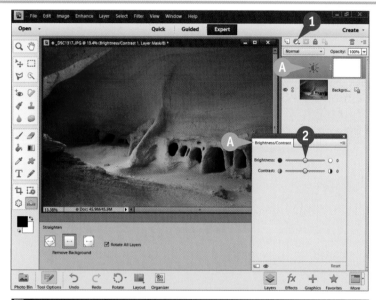

① Click the Adjustment Layer icon and select Brightness/Contrast.

Ⓐ The Brightness/Contrast adjustment panel appears along with a new adjustment layer in the Layers panel.

② Change the Brightness slider to –100 so that the picture gets very dark.

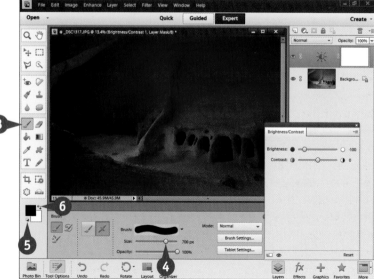

③ Click the Paintbrush in the Toolbox.

④ Set the brush to a large size using the Size slider in Tool Options.

⑤ Click the small white-over-black icon below the colors at the bottom of the Toolbox.

This resets your foreground, or top, and background, or bottom, colors.

⑥ Click the curved arrow between the foreground and background so that black is on top.

The top color is the foreground color and the color for your brush.

7 Click and paint two lines across your picture to create an X.

B A black X now appears in the layer mask icon.

You did not draw a dark X on the picture, but in the layer mask.

The black X in the layer mask then blocks the original adjustment, a darkening of the image, which creates the lighter X in the picture.

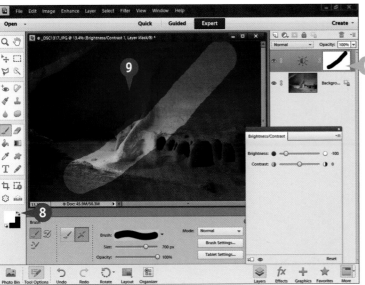

8 Click the curved arrow between the foreground and background colors so that white is on top.

9 Paint out the X in your photograph by painting white over the black.

C This removes the black, which then allows the effect of the adjustment layer to reappear.

TIPS

Did You Know?

Layers plus layer masks are an important benefit of Photoshop Elements and Photoshop. They can take some time to master, but it is worth it. Layers plus layer masks give you a high level of flexible, nondestructive adjustment. They totally isolate parts of a photo from other parts so that you can adjust only what you want adjusted.

Important!

Layer masks affect what a layer does, but not the actual adjustment. This is an important distinction. Putting black in a layer mask might block a darkening effect and make the picture brighter, or it could block a brightening effect and make the picture darker. You have to think in terms of black blocking an effect and not creating its own effect.

Practice!

Layer masks can be counterintuitive for the photographer. Yet they are an extremely important tool to understand. You can do it! It just takes practice. You have to add adjustment layers with different sorts of controls and then paint in black and white to see how the layer mask works to block or allow those adjustments.

COMBINE TWO PHOTOS *with layer masks*

This chapter has been mostly about working with adjustment layers. Add layer masks to them and you gain a very powerful combination. This task is about using solid photo layers so that you get a better understanding of how layers and layer masks work.

In this task, you will put one photo on top of the other. This is no different than if you were to take two prints and put one print on top of the other. They show up as layers

in the Layers panel, and the top layer blocks the view of the bottom layer, just as if these pictures were sitting on top of each other on your desk.

Suppose you wanted the top photo to stay on top, yet allow some of the bottom picture to show up. With the photos on your desk, you could cut a hole in the top picture. That would allow the bottom picture to show through, but it would also damage the top picture.

① Open two photos from Organizer.

② Click and drag the top bar of the top photo to change its position on the interface so that you can see some of the second photo under it.

If you cannot separate the images, go to Preferences and then General (see task #13) so you can check Allow Floating Documents in Expert Mode.

③ Click the Move tool at the upper left corner of the Toolbox.

④ Press and hold Shift and then click and drag the top photo so that the cursor goes all the way over the bottom photo. It is very important to follow those directions exactly.

⑤ Release your mouse button and then the Shift key.

A The top photo is now on a layer over the bottom photo. If you did the steps exactly as described and your photos were the same size, they will also be exactly lined up.

6 Click the X at the top right of the first photo to close it in Windows or the red button at the top left of that photo on a Mac.

B Now you can clearly see the layers representing the two photos.

C You see only the top photo because it covers and blocks view of the bottom photo.

7 Click the Layer Mask icon at the top of the Layers panel.

52
DIFFICULTY LEVEL

TIPS

Important!
The exact steps mentioned here are very important. You must press and hold Shift first, click and drag the top photo so the cursor shows up on the bottom photo, and release the mouse button and then the Shift key. If you do anything else, you get an error message, or the photos do not line up correctly.

Important!
The Shift key is a constraint key with your computer. It modifies many things besides making letters capitals. In this task, you are using it to constrain the movement of one photograph onto another. If the two pictures are identical in size, the Shift key makes the move so that the top picture exactly lines up with the bottom.

Practice!
This cannot be overemphasized: You are simply not going to master layers and layer masks by reading this book and trying it a couple of times. Taking some time to master layers is worth it because once you do, you will find that your time in front of Photoshop Elements will be more efficient and effective.

There are many situations where you might want to put one picture on top of another, cut a hole in the top picture, yet keep that top picture undamaged. By adding a layer mask to the top photo, you can create a hole in that top photo to allow the bottom picture to show through. This is the same as if you cut a hole in the top print on your desk, except that you do it with the layer mask so that this hole is not permanent.

Remember that the layer mask affects only what happens to its layer. Black blocks the layer, whereas white allows the layer and its effects to appear. Black in the layer mask then allows you to cut a hole in the photo that represents that layer. If you do not like that hole, you can paint white over that area to fill it back in. This is a great advantage of layer masks — you can block or restore any part of a layer at will.

Ⓐ A white box appears in the layer and is the icon for the layer mask.

❶ Select the Paintbrush from the Toolbox.

❷ Click on the Brush button to choose a large soft-edged brush.

❸ Make the brush larger or smaller by using the Size slider or the bracket keys to the right of the letter P on your keyboard.

❹ Click the small white-over-black icon below the colors at the bottom of the Toolbox to reset foreground and background colors.

❺ Click the curved arrow between the foreground and background colors so that black is on top.

The top color is the foreground color and the color for your brush.

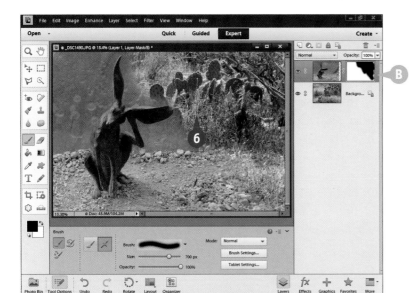

6 Paint over the photo where you want to remove the top photo.

The top photo disappears, blocked by the black you painted into the layer mask.

The soft edge between the pictures comes from the soft brush and the size of the brush.

B Black appears in the layer mask.

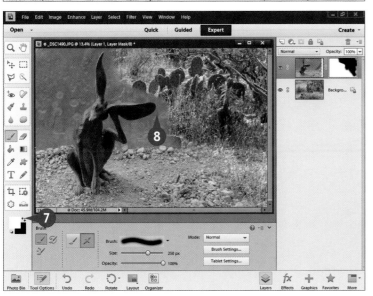

7 Click the curved arrow between the foreground and background colors so that white is on top.

8 Paint back parts of the top photo by painting white over the black.

TIPS

Important!
You must be in the layer mask to use it. That sounds obvious; however, it is easy to miss and end up on the photo itself. The difference between the photo on a layer and its layer mask being active is subtle. Usually the only indication that a layer mask is active is the subtle blue line around the active part. If strange things start happening to your picture, check your Layers panel to be sure that you are working in the layer mask.

Important!
Color on your photograph tells you that you are working on the photo instead of in the layer mask. When you are working in the layer mask, you should see no colors, just black or white appearing in the mask where you are painting your brush. If you do see colors, simply undo that brush stroke with Ctrl/⌘+Z, click the layer mask, and continue.

Try This!
When you are working with layer masks, you can make changes to your brush with your keyboard. Remember that you can make your brush larger or smaller simply by pressing the bracket keys to the right of the P key. You can also switch back and forth between the foreground and background colors, usually black and white, by pressing the X key.

REMOVE ADJUSTMENTS with black

Once you start working with layer masks, you will learn the real power of layers. It is very common to do early adjustments in a picture and run into a problem with the range of tones. For example, when adjusting most of the picture properly, you may find one small area gets overadjusted. If you try to adjust for that one spot, the rest of the picture does not get the proper adjustment.

A good example is seen here in this photo of a sunset in the Lake Mead National Recreation Area. As the bright

part of the sunset is adjusted for better color and tone, the bright clouds at top get too dark.

With the adjustment layer's layer mask, you can make the correct adjustment for the overall picture and ignore what happens with one small part. You simply use a black brush and paint over that problem part of the picture in the layer mask. That blocks the adjustment and gives you much more control over your picture.

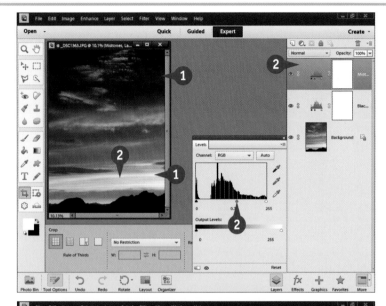

① Open a photo that has a contrast challenge with something very bright and something dark.

② Adjust the image to get the best out of the bright area.

③ Click the Paintbrush in the Toolbox.

④ If black is not the foreground color, click the curved arrow between the foreground and background colors so that black is on top.

⑤ Click Size in Tool Options and size your brush appropriate to the problem.

6 Paint black over the problem to block the adjustment.

A The layer mask icon indicates the painted area.

7 Change your brush size as needed to block or allow the adjustment in other areas.

TIPS

More Options!

You can change how strong the blocking effect of black is, or the effect of white, by changing the opacity of the brush. You make that change in Tool Options below the photograph. A number of other options are here for affecting how a brush works.

Remember This!

As you gain experience working on layer masks, you will discover that to get the best and most effective layer mask, you constantly have to change the size of your brush. That is normal. Do not try to keep using the same size brush. Remember the bracket keys to the right of the P key — the opening bracket ([) makes the brush smaller, and the closing bracket (]) makes it larger.

Important!

Once you start working with more than one adjustment layer, you have to be sure you are in the right layer and layer mask. As you make changes and move among layers, you can easily get confused and end up on the wrong layer or the wrong layer mask. To be sure, you can simply click the layer mask icon in the correct layer in the Layers panel. The correct layer is also highlighted in black.

ADD ADJUSTMENTS using black and then white

Sometimes you run into a photograph that simply needs an adjustment in one area but not in the rest of the image. You could try adjusting the whole picture and then block out everything in it, doing a lot of work with a black paintbrush. If there really is only a small area that needs to be adjusted, that truly can be a lot of work.

A better way is to first make the adjustment in an adjustment layer as best you can for the small area that needs the change. You ignore what happens in the rest of

the photograph. Then you block the entire adjustment by filling the entire layer mask with black. Next you take a white paintbrush and bring the adjustment back in only the areas where you want it. Essentially you are adding an adjustment to a very specific area without affecting the entire picture.

This image is from the wonderful visitor center at the Red Rock Canyon Conservation Area by Las Vegas, a place easy to get to and well worth the time spent there.

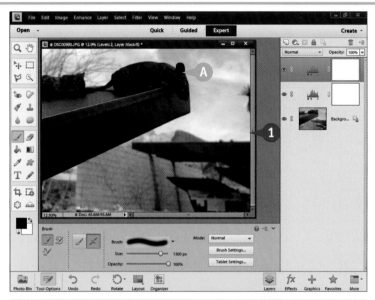

Identify the Problem

1 Open and adjust a photo that has a small area that needs adjustment compared to the rest of the picture.

A In this photo, the sky and background look good, but the wood rat sculpture is too dark and needs to better balance with the rest of the image.

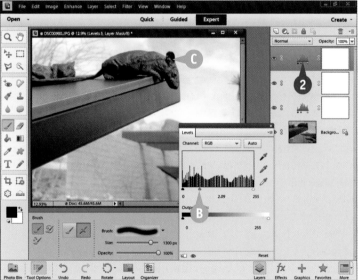

2 Add an adjustment layer to correct the problem area even though it makes the whole picture look wrong.

B A Levels adjustment layer was added to this photo with a strong brightening adjustment.

C The wood rat looks much better now, but the rest of the picture is washed out.

Add Black

1 Click Edit.

2 Select Fill Layer.

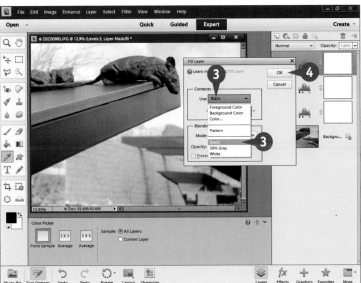

The Fill Layer dialog box appears.

3 Click the Use drop-down menu and select Black.

Leave the other options at their defaults.

4 Click OK.

TIPS

Try This!

All photographers must deal with the challenge of how we see the world compared to the way the camera does. Simply pointing a camera at a scene and taking the picture is no guarantee that the resulting photograph will have the right balance of tones. It can help to check your LCD playback to better see what the camera is capturing.

More Options!

You may be working on a picture and find that the layer mask gets confusing. You cannot tell what you have or have not done. To start with a clean slate, you can fill the layer mask with white by using the Fill Layer command from the Edit menu but choosing white instead of black.

Did You Know?

It can be confusing using layer masks because you can use the same brush and color, such as black, to do two different things, such as make a photo lighter or make it darker. Remember that painting on a layer mask has no effect on the adjustments themselves. It only turns them on or off. Black turns off the effect; white turns it back on. What actually happens depends on what the effect is.

A common problem in photographs is a lack of balance among the tones. You can see all the detail from bright to dark areas just fine, but the camera cannot. To bring that picture back to balance, you need to make some adjustments in Photoshop Elements.

This is exactly what is happening in this image. Although the shadowed redwood is naturally dark, the camera overemphasizes that darkness. It makes that part of the photo look like a black hole. By balancing brightnesses in a photo, you can help your photo better communicate.

This is where layer masks really shine. You can carefully choose exactly what areas of the picture are going to be affected by any individual adjustment. That can mean either blocking an overadjustment or allowing a small area of a very specific adjustment, as shown in this example. You will sometimes hear people say that this is "cheating." That comes from a lack of understanding of how photography really works. You should be able to control your picture to interpret it closer to what you really saw.

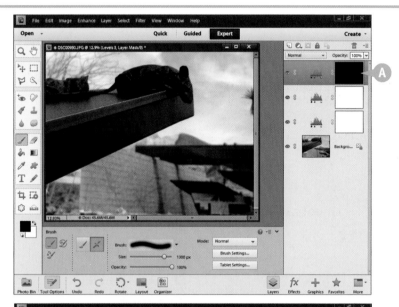

Ⓐ The photo still has the strong Levels adjustment layer, but the black in the layer mask blocks its effect.

The picture looks as if no adjustment has been made at all.

Work with White

① Select the Paintbrush.

② Change the foreground color to white.

③ Change your brush size to match the area that needs to be adjusted.

4 Paint the brush with the white foreground color over the area that needs to be changed.

The adjustment is now allowed, but only in that area.

#**54**

(continued)

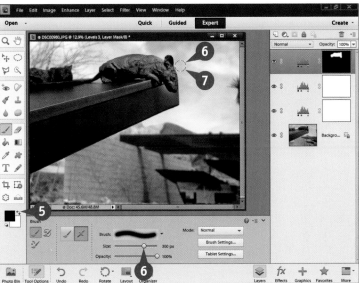

5 Change the foreground color to black.

6 Make the brush smaller.

7 Paint over problems along the edge between adjusted and unadjusted areas.

The black brush now blocks the adjustment again to fix the edge.

TIPS

Important!
Generally you want to use soft-edged brushes for the layer mask. Soft brushes enable you to better blend the adjusted and the unadjusted areas. Hard-edged brushes can cause problems by making your brush lines show up. Use them sparingly.

More Options!
Remember that you can change the opacity of the layer to affect how strongly the layer works with your photograph. If, for example, you darken bright areas but they look too dark, instead of readjusting the layer, you can simply reduce the opacity of the layer.

Important!
Edges are very important. One thing that often gives away a poorly adjusted image is the edge between an adjusted and unadjusted area. Pay close attention to what is happening along that edge. Use smaller brushes for a tight edge or larger brushes for a soft edge. And when you have a very tight edge, use a selection, even changing the feathering.

COMBINE LAYER MASKS with selections

Everything you learned about selections still applies when working with adjustment layers and layer masks. Selections are still very useful when working with layers in Photoshop Elements. Sometimes it is easier to simply paint an effect on or off the picture by using white or black, but other times your workflow is more efficient if you create a selection first. When you create a selection and then add an adjustment layer, a layer mask is automatically created for you based on that selection.

A selection limits an effect to one area and blocks the effect outside that area. That certainly sounds familiar. The same sort of thing happens with a layer mask because it limits an effect to an area controlled by white and blocks the effect where the mask is black. Making a selection and then adding an adjustment layer creates a layer mask with white as the selected area and black outside the selection. Selections can be very helpful when very specific areas need to be adjusted, such as creating dark edges for a photograph.

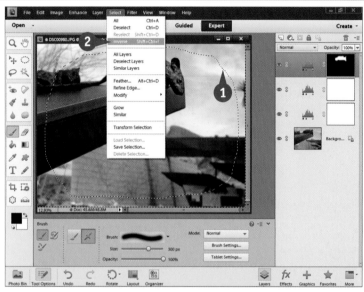

1 Make a selection around the subject, inside the outer edges of the photo.

2 Invert the selection by clicking Select and then Inverse.

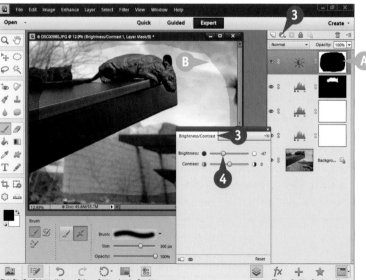

3 Open a Brightness/Contrast adjustment layer from the Adjustment Layer icon in the Layers panel.

Ⓐ A layer mask appears with white along the edges and black in the center.

4 Reduce Brightness enough to see the effect on the photo. Remember that you can always change this later.

Ⓑ The layer mask is controlling the effect, but the edge is very sharp and unattractive.

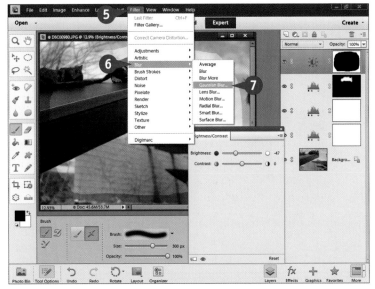

5 Click Filter.

6 Select Blur.

7 Select Gaussian Blur.

#55

DIFFICULTY LEVEL

The Gaussian Blur dialog box opens.

8 Click and drag the Radius slider to a high amount.

Depending on the photograph, this can be as low as 40 or as high as more than 200.

9 Click OK.

C A soft darkness is applied to the outer edges of the photo, emphasizing the subject. This is a traditional darkroom edge-darkening technique that gives more depth to the image.

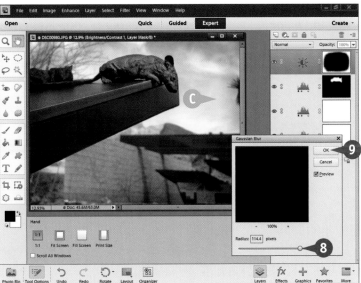

TIPS

Did You Know?

Using Gaussian Blur for blending edges has a lot of advantages over using feathering with selections. Feathering is applied using a specific number value, and then you click OK and look to see if the effect is what you want. With Gaussian Blur and a layer mask, you can change the Radius and watch the blending occur in real time.

More Options!

When you first open Gaussian Blur, the edge might not appear in the preview box. Simply move your cursor into the picture and click the edge. That immediately places the black-white edge inside the preview box so you can see what happens as Gaussian Blur is increased.

Important!

A great advantage of adjustment layers is the ability to change the adjustment. In this edge-darkening technique, for example, you can always double-click the Brightness/Contrast adjustment layer icon at any time and reopen the Adjustments panel. You can then change that edge darkness as desired.

BALANCE COLORS AND TONES *in a picture*

A common challenge photographers face is a picture not balanced visually to match the composition or the way that people really see a subject. If you look at a scene, for example, your eye balances out the brightness levels so that you can easily see and compare elements of that scene. The camera does no such thing. If the left side of a scene is brighter than the right, the camera shows it just that way, creating an imbalance in the tones of the picture compared to the way you see the scene. Colors can have a

similar problem when one color starts to dominate the picture because it is too saturated compared to the others.

Through the use of adjustment layers and layer masks, you can fix this imbalance and help your photographs communicate something much closer to what you originally saw when you took the picture.

In this picture, the mountains of Red Rock Canyon look great, but the bottom part of the photo is out of balance because it is too dark.

1 Click the Adjustment Layer icon to open a Brightness/Contrast adjustment layer to correct an imbalance in brightness.

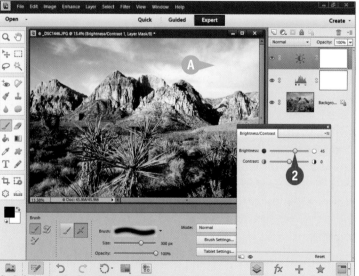

2 Adjust the sliders until the problem area looks better, such as the bottom part of the landscape in this photo.

A Ignore what happens in the rest of the photo because it will be overadjusted.

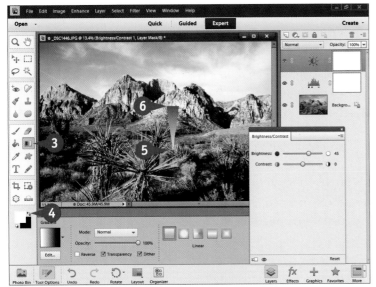

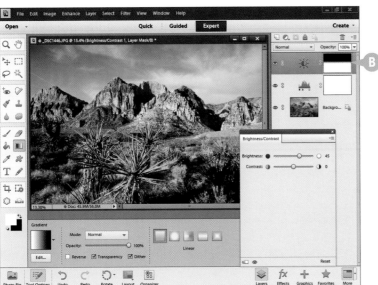

③ Click the Gradient tool in the Toolbox.

④ Click the curved arrow between the foreground and background colors so that white is on top.

⑤ Click your cursor first in the area where you want to keep your adjustment.

⑥ Drag your cursor into the area where you want to remove the adjustment.

Ⓑ The Gradient tool puts white in the layer mask up to the point you first click, black in the layer mask past the point you dragged to, and creates a blend between them.

The image now has its tonalities better blended.

#56
DIFFICULTY LEVEL

TIPS

Did You Know?
If you get the white and black parts of the Gradient tool mixed up, do not worry. That is actually a common challenge when first learning to use the Gradient tool. If you click and drag and the black and white show up in the wrong places, giving the opposite of what you wanted, simply do it again in the reverse direction.

More Options!
You may need to do multiple applications of the Gradient tool before the picture looks right. Sometimes the angle will be wrong, other times the gradient will be too short and too obvious, and other times the gradient will be too long and ineffective. Keep trying until your picture looks right.

Important!
Change the adjustment as needed after you use the Gradient tool. Sometimes you will guess wrong as to the correct amount of adjustment to properly balance the picture. When you apply the Gradient tool, the picture may look too dark or too light. Simply readjust that adjustment layer as needed.

As you look to balance a picture's tonalities, you often discover specific areas that are too dark — typically shadows that did not get the same light as the rest of the picture. Yet for the picture to really look right, for it to be interpreted closer to the way you saw a scene, these dark areas need to be increased in brightness.

This photo of paintbrush flowers against the sun shows exactly this challenge. The flowers are silhouetted against the bright sun, and the camera exposed correctly for it. However, the flowers are too dark and need to be brightened.

Once again the adjustment layer and its layer mask come to the rescue. You use a blending mode again, the Screen mode, to brighten the dark area, and then the layer mask to limit that change just to the area needed. Although this works very well, one thing you may notice occurring is an increase in noise in those dark areas. Revealing detail in dark areas sometimes means revealing the noise there as well.

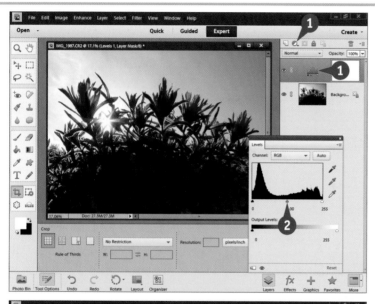

① Open a Levels adjustment layer by clicking the Adjustment Layer icon in the Layers panel.

② Make no adjustments.

③ Click the blending modes drop-down menu, which says Normal by default.

④ Select Screen.

The lightening effect of Screen is applied to the whole picture.

5 Adjust Levels further if needed.

6 Open the Fill Layer dialog box from the Edit menu.

7 Select Black in the Use drop-down menu in the Contents area.

8 Click OK.

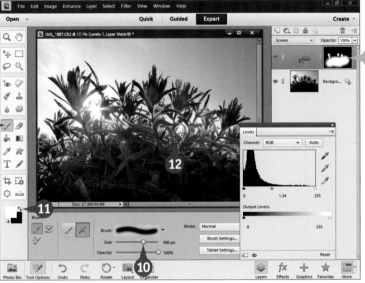

The lightening effect of Screen is blocked.

9 Click the Paintbrush in the Toolbox.

10 Choose a brush size appropriate to the area being adjusted.

11 Choose white for the foreground color.

12 Paint in the lightening effect.

A The layer mask icon indicates the painted area.

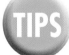

TIPS

Important!

Edges are critical when you are dealing with small areas of change in a photograph and using a layer mask. A sloppily painted edge is very obvious in the picture and distracts the viewer to the point of the truth of your picture coming into question. Sometimes blurring an edge with Gaussian Blur from the Filter and Blur menus helps.

Apply It!

Work your edges by going back and forth between white and black brushes. In addition, change the size of your brushes by using the bracket keys as you go. If you are really having trouble with an edge, try using a selection to control where the black and white go within your layer mask.

More Options!

You can actually see your layer mask in black and white over your photograph. Position your cursor over the layer mask icon in the layer you are working on. Press Alt/Option as you click the layer mask icon, and the layer mask appears where your picture is. Press Alt/Option and click again to get back to your picture.

DARKEN HIGHLIGHT DETAIL in specific areas

As you continue to balance a picture's tonalities, you often find too-bright areas. These may be highlight areas that received more light than your subject or something inherently brighter than the subject. When you expose properly for the subject, your photograph looks good where the subject is, but these bright areas look overexposed. Once again, for the picture to look right, such out-of-balance bright areas need to be balanced, this time brought down in tone.

In this image, the original exposure was good for the flowers, but that made the rocky hill at the left too bright.

The hillside needed darkening that would not affect the flowers.

You use an adjustment layer and its layer mask again, but this time using a Brightness/Contrast adjustment layer to darken the right area. The layer mask is used to limit that change just to the area needed. Luckily, no noise problems can come from darkening a bright area, but there are limits as to how much darkening you can do if the area is too overexposed.

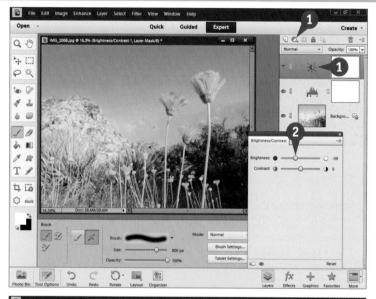

① Open a Brightness/Contrast adjustment layer by clicking the Adjustment Layer icon in the Layers panel.

② Make a brightness adjustment that darkens the overly bright area.

The darkening effect of the adjustment is applied to the whole picture.

③ Open the Fill Layer dialog box from the Edit menu.

④ Select Black in the Use drop-down menu in Contents.

⑤ Click OK.

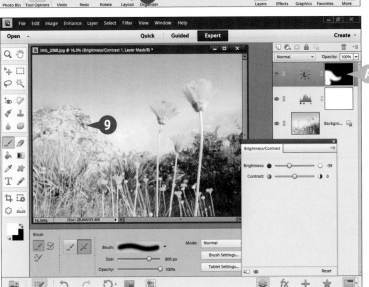

The darkening effect of the brightness adjustment is blocked so the whole image goes back to its original brightness.

6 Click the Paintbrush in the Toolbox.

7 Choose a brush size appropriate to the area being adjusted.

8 Choose white for the foreground color.

9 Paint in the darkening effect.

Ⓐ The layer mask icon indicates the painted area.

TIPS

Important!
Exposure is very important when dealing with bright and highlighted areas in a photograph. If a bright area is too washed out, no amount of work in Photoshop Elements will bring in any detail. When bright areas in a picture absolutely have to have detail, they must be captured when you take the picture.

Did You Know?
Sometimes when you make a correction to a specific area in the photograph, the whole photograph changes in its appearance, maybe looking too bright or too dark overall. You can simply go back to your midtones adjustment layer, reopen the adjustment, and make a correction.

More Options!
You do not have to limit your adjustments to simply fixing a bright area or a dark area. If your photograph needs help in both areas, use two different adjustment layers, one using Brightness/Contrast or set to Multiply and one set to Screen, and then use the layer masks appropriately to fix both places.

FLATTEN LAYERS when done

After working on your photo, you will come to the point where you are more or less done with it. You can save and store this photo as a Photoshop PSD file, and keep all of its layers. Sometimes, however, you may want a simpler file that you can quickly use for purposes other than adjusting it inside Photoshop Elements. The PSD file format and Photoshop layers are not generally recognized outside of Adobe programs, so even though you can save layers with a TIFF file, that does not do you much good.

At this point, a good idea is to flatten the image, merging the layers together into a simplified image file, and then save the picture in a new file, in the appropriate format. If you are going to use a photo for the web or e-mail, select a JPEG file. If you are preparing pictures for use in a brochure or other publication, you might decide to use a TIFF file. You can flatten an image using the Layer menu or through the Layers panel drop-down menu.

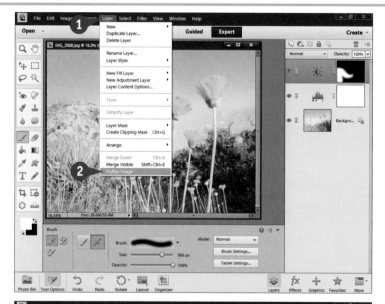

Use the Menu to Flatten

1 Click Layer.

2 Select Flatten Image.

All layers and their effects are now merged.

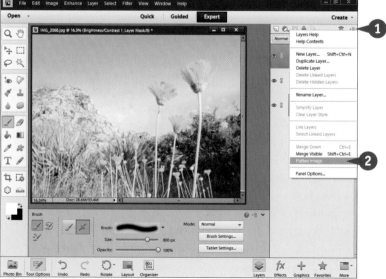

Use the Panel Menu to Flatten

1 Click the panel menu icon at the right of the Layers tab.

This icon is a set of horizontal lines and can be hard to see.

A drop-down menu appears.

2 Select Flatten Image.

(A) All layers and their effects are now merged.

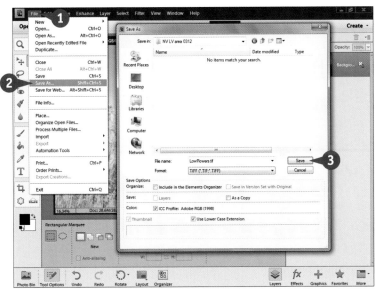

Save the Flattened Image

1 Click File.

2 Select Save As.

The Save As dialog box appears.

3 Choose the appropriate file format, change the filename and folder location if needed, and then click Save.

TIPS

Did You Know?

Some photographers save all their layered files forever, just in case they want to revise the pictures. Other photographers find that saving all these layered files can get unwieldy and unnecessary for their workflow. There is no arbitrary right or wrong to this. It depends entirely on how comfortable you are with your work.

Important!

Once your file is flattened and closed, you have no access to the original layers. If you flatten the file, you can always undo this in the History panel if the picture is still open. But if an image is flattened, saved, and closed, that opportunity is gone, and the layers are gone as well.

Try This!

You can combine all your layers and their effects into a single layer on top of the layer stack so that you have access to a "flattened file" and layers at the same time. Click the top layer and then press Ctrl+Shift+Alt+E or ⌘+Shift+Option+E. This merges the layers and then creates a new layer with that image on top of the layer stack.

Chapter 6

Solve Photo Problems

No matter what you do, no matter how expert you become as a photographer, your photos will have problems that you must fix, such as dust on the sensor, unwanted light flare, blank skies, and more. They are not anyone's fault, but can crop up in a picture due to many factors, and can keep that picture from being all that it can be. Regardless, you want them out of your picture.

Photoshop Elements includes some excellent tools to deal with problems in the picture after you have done your basic processing. Some of them do take some time and practice to master, however. Do not be discouraged if you try something like the Clone tool and your results are not perfect at first. With practice and experience, you can master any tool in Photoshop Elements.

Because Photoshop Elements allows you to fix problems in photos, this is not a reason to feel you do not have to worry about your photography because you can "fix it in Photoshop." That attitude can cause you unwanted problems. First, it can mean that you are missing things when you first take the picture that can help you get the best photo possible. Second, you will enjoy working with Photoshop Elements most after you have already taken the best possible picture with your camera. You do not want to have to fix problems in the picture that could have been avoided.

DIFFICULTY LEVEL

Cloning covers up a challenge in your photo by copying a small part of the photograph from a good area and then pasting that copy onto a new location over the problem. All you have to do is tell Photoshop Elements where you want the cloning to start from, how big of a copy you want to make, and where to place the copy.

You set a "clone-from" point by pressing Alt/Option as you click over the good part of the photo. You tell Photoshop Elements how big a copy you want to make by the size you choose for your brush. Finally, you click over your problem area, and the program knows where to place the little copy under the cloning point.

The Mesquite Flat Sand Dunes in Death Valley National Park make for wonderful subjects as the sun comes up. Their accessibility makes them easy to reach, but also makes it more likely other people will get into your photos. Cloning is one way to deal with that challenge.

This photo has a very obvious problem with the people showing up on the right.

1 Click the Zoom tool, or magnifier, at the top of the Toolbox.

2 Click and drag your cursor around the problem area to magnify it.

3 Click the New Layer icon in the Layers panel.

A This creates a new, empty layer.

4 Name the layer Clone Layer.

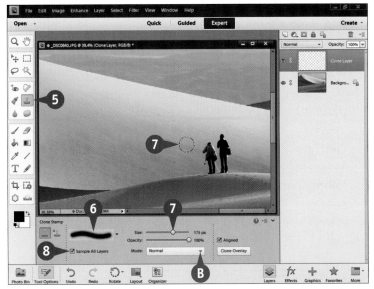

5 Click the Clone Stamp tool in the Toolbox.

6 Choose a soft-edged brush.

7 Size the tool appropriate to the problem.

B Leave Mode at Normal, Opacity 100%, and Aligned selected.

8 Select Sample All Layers.

9 Press Alt/Option as you click a problem-free area near your problem.

This sets the clone-from point.

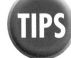

Did You Know?

For most cloning, you will use the Aligned option for the Clone Stamp tool. This keeps the clone-from and clone-to points at the same distance and angle from each other as you clone. If your clone-from area is very small, deselect Aligned so that the clone-from point always goes back to that area.

Try This!

If you run into trouble with the settings of any tool, including the Clone Stamp tool, you can quickly reset the tool back to its defaults. Click the small menu icon at the top right of the Tool Options panel. This gives you a menu with the reset option. Usually you can just select Reset Tool.

Try This!

Once you magnify the area where you are cloning, you may need to adjust the position of that area slightly. If you press the spacebar, the cursor changes to a Hand icon. Keep the spacebar pressed as you click and drag the picture to move it around. This works with any tool in Photoshop Elements.

Cloning takes practice. It also works best when you clone to a layer. By cloning to a layer you keep all this work separated from the photograph itself. You can then work on that layer without messing up the original picture. This frees you to really concentrate on the cloning because you do not have to worry about doing something wrong that cannot be fixed.

It is not unusual to find unexpected objects in your photograph simply because you did not see them when you pressed the shutter. Such problems can include

undesirable *lens flare* — the little light spots and circles near a bright light — or a misplaced piece of trash in the picture.

The Clone Stamp tool is a powerful way of covering up such problems. Click as you go for each clone spot instead of brushing continuously, reset your clone-from point whenever you see problems, and change your brush size as you go. By doing these things, your cloning looks more natural, without repeating patterns called *cloning artifacts*.

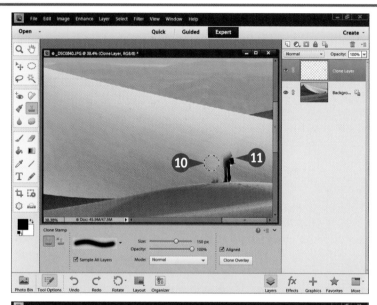

⑩ Click over the problem area.

The cursor shows the source of the clone as an overlay to help you find where to click.

Click multiple times to cover the problem.

Change your clone-from point to keep blending the clone work.

⑪ Continue clicking until the problem area is covered.

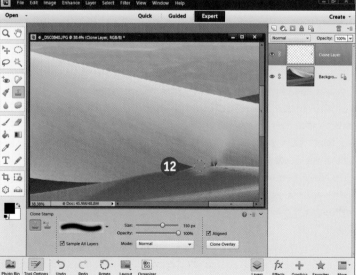

⑫ Clone over problems along an edge and do not worry about the edge at first.

Because you are on a layer, it does not matter if your cloning goes too far.

13 Click the Eraser tool.

14 Choose a small brush size.

15 Erase the problem part of the clone from the layer, such as an overlap of an edge.

If the edge is difficult to work with, try using a selection to limit where the Eraser tool works.

#60
(continued)

16 Look for problems in the image, such as unnatural bright areas, repeating patterns, or cloning artifacts that need to be removed.

17 Select a new clone-from point to clone back over the problem. You may need to change the cloning size, too.

18 Press Ctrl/⌘+0 to bring the picture back to full view.

Look over the image in full to be sure the cloning blends nicely.

TIPS

Try This!
If cloning starts to look messy, erase the work with the Eraser tool. Because you are working on a layer, you are erasing only something applied *over* the actual picture. You can always turn the visibility of the layer on and off to see this by clicking the eye icon at the left side of the layer.

Try This!
Use a layer mask instead of the Eraser tool on the cloning layer. Simply add a layer mask with the layer mask icon, then use a black brush to block the cloning from appearing. You can refine an edge of your cloning work by going back and forth between white and black brushes.

Did You Know?
Dust spots in the sky from sensor dust can be cleaned up using the Spot Healing Brush. This tool is in the group of tools just above the Eraser tool. With it, you simply click the dust spot, and Photoshop Elements copies something nearby over that spot and helps it blend. You can also use this tool with layers — select Sample All Layers in the Options bar.

Remove people from a scene with PHOTOMERGE SCENE CLEANER

You are at a really interesting historical site and want to photograph there, but people are constantly going through your composition. You try to wait, but they keep coming. You think that cloning might work, but the detail is so complex that you realize this will be a major challenge and probably will not work.

Sometimes you can wait until the person moves off, or a gap occurs in the flow of the crowd so that you get a picture without people. But often you cannot, especially if you are traveling with family who want to move on and see the other sights of the area.

The Photomerge Scene Cleaner in Photoshop Elements enables you to remove people from a scene. You have to shoot two or more pictures of that scene so that the people walking through it are not all in one place. Shoot from the same position, with the same exposure, and hold your camera as steady as possible so that the overall framing of your picture does not change much. This location is Rhyolite, a ghost town near Death Valley.

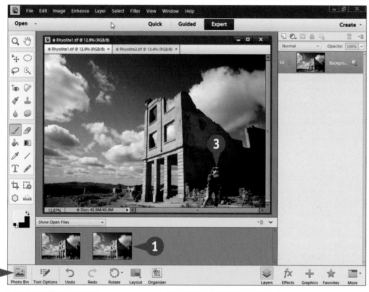

1 Open a series of photos of the scene you need to clean up.

2 Click Photo Bin so that they all appear in the Photo Bin.

3 Note where the problems are in the photos.

4 Click Enhance.

5 Select Photomerge.

6 Select Photomerge Scene Cleaner.

A message appears asking you to select the photos.

7 Click Open All.

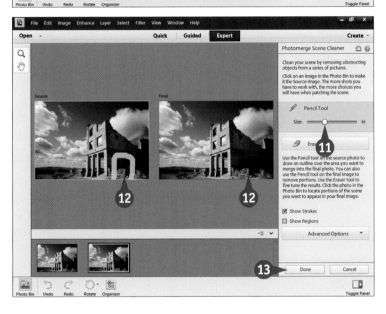

The Photomerge Scene Cleaner opens with your first image.

8 Double-click any image to make it your source.

A A how-to panel also appears.

9 Drag a different photo into the Final photo window.

10 Click the Pencil tool in the how-to panel.

11 Select a pencil size appropriate to the detail around the problem in the photograph.

12 Draw around a problem in the Final window that you want to replace from the Source frame.

A yellow line appears around the problem, then around the same area in the source as the photos are merged and the problem disappears.

13 Click Done when you are finished.

The photo opens as a new image into Expert with layers holding the work you did.

TIPS

Did You Know?

Photoshop Elements includes some pretty amazing alignment work in its Photomerge feature. To match everything in the Scene Cleaner, the picture elements within the scene must line up. The program analyzes the pictures and lines them up for you. It helps to keep the image frames lined up as best you can while you shoot.

Try This!

The Scene Cleaner may not work immediately the way you want it to. Undo your work, and then try drawing around a different part of the picture, drawing tighter to an area, using a thinner or thicker pencil, and drawing in both the Source and the Final images. You will get different results.

Try This!

Once you are done using the Scene Cleaner, you may discover that the photograph still has some imperfections. Instead of trying to do it all over again in the Scene Cleaner, it may be quicker and easier to use the Clone Stamp tool or the Content-Aware Spot Healing Brush to make small corrections as needed.

DIFFICULTY LEVEL

When you try to remove something that does not belong in the image, it can be challenging to make the correction match its surroundings. It can take a lot of work with the Clone Stamp tool or require just the right pair of pictures to use Photomerge Scene Cleaner.

The Content-Aware option for the Spot Healing Brush looks at what surrounds the problem, and then it covers up the problem by using the texture, color, and lines of the surroundings to try to better blend the patch. This

image of flowers in Death Valley has a bright rock distraction at the right side of the photo. All the detail around it would make it very difficult to clone out. The Content-Aware option for spot healing works very well here. If you try this tool and it does not give the desired results, try again for a different version.

The Spot Healing Brush itself simply blends a spot that you click into its surroundings. It does not look for things like texture and lines, so it cannot match them.

1 Examine the photo for small, unwanted parts that need to be corrected.

2 Click the Spot Healing Brush in the Toolbox.

3 Click Content Aware.

4 Select a brush appropriate to the size of the defect in the image. A hard-edged brush often works well for this tool regardless of the problem in the photo.

5 Resize the brush using the Size slider or bracket keys.

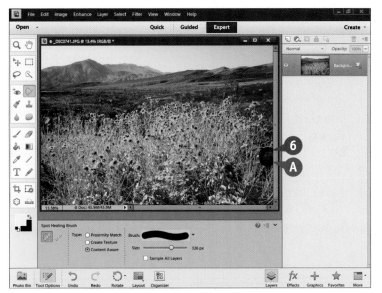

6 Brush over the problem.

A A dark area appears over the spot you have brushed.

B The Content-Aware Spot Healing Brush moves parts of the photo appropriately over the problem and then matches what it has done to the photo.

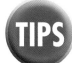

TIPS

Important!
Content-Aware cannot be used for everything. Sometimes cloning is better because you have very specific control over what is moved into a particular area. Content-Aware spot healing sometimes pulls in the wrong things to match the area you are working with. However, the tool is so good that it is often worth trying even if you end up undoing the change before using something else.

Try This!
If you try using the Content-Aware Spot Healing Brush and your correction does not completely match, do not immediately undo it. Try using the tool again over roughly the same area. The algorithms underlying this tool look for slightly new things each time you do this. You can also use the Clone Stamp tool to fix minor problems.

Did You Know?
The Content-Aware Spot Healing Brush has some very complex algorithms working inside Photoshop Elements to make it do its job. Because of this complexity, the brush can take a bit of time to complete its work. The larger the area that you try to work on, the longer this can take.

Fix problems due to LENS DISTORTION

Many photographers have discovered the benefits of large-range zooms that go from very wide angles to extreme telephoto focal lengths, such as 18-200mm or 28-300mm. These lenses offer a lot of focal-length options in one lens, making them ideal for travel as well as a convenient way to be prepared for any subject.

Such extreme focal-length changes in one lens, however, challenge lens manufacturers. Most of these lenses have something called *barrel distortion*, especially common when shot at wider focal lengths. This causes an outward

curving of straight lines near the top, bottom, or sides of the photograph.

The photo seen here from the Petrified Forest National Park shows what looks like bulging ground immediately in front of the camera. The ground is actually rather flat — the bulge is from lens distortion. You can correct this in Photoshop Elements in the Correct Camera Distortion filter, even though you are actually correcting lens distortion. You can apply this only to actual pixels of a photo, so this does not work on adjustment layers.

① Click Filter.

② Select Correct Camera Distortion.

The Correct Camera Distortion window opens.

③ Click the Remove Distortion slider and move it left or right to correct curved straight lines.

④ Use the grid to help you judge when the line is straight.

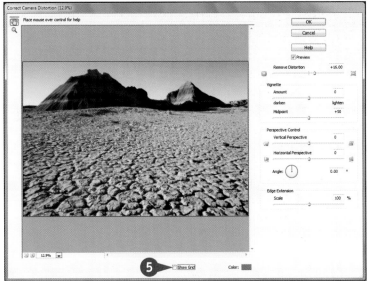

⑤ Select the Show Grid check box to turn off the grid so you can better see the image.

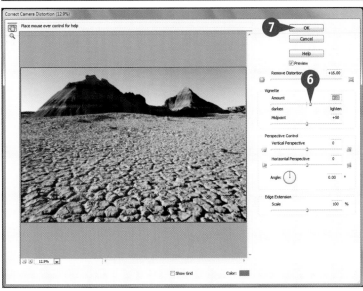

⑥ Use Vignette to correct dark outer edges that come from some wide-angle zooms. This control can also be used to add a nice traditional darkroom edge darkening if desired.

⑦ When you have corrected the photo, click OK.

The photo opens into Expert with your work displayed as a single layer.

TIPS

More Options!

Some photographers wait to fix the frame edges until the photo is back in the main Photoshop Elements work area. Sometimes this gives you more options for the final look of the image. In this case, set the Edge Extension slider to 0. Instead, use the Crop tool in Photoshop Elements to crop out the distorted edges of the final photo.

Try This!

After you have used your camera and its lens or lenses, you will learn what focal lengths create the most distortion. You can then try to avoid the problem when shooting by keeping strong horizontal or vertical lines away from the edges of the photograph. You can also disguise those edges by having something in the photo cut across them, such as a tree or a rock.

Did You Know?

You will frequently see the effects of barrel distortion on straight horizons, such as those found on ocean and big lake photographs. There will be no effect on a horizon in the middle of the image, but that is a boring way to compose a photo. The distortion becomes magnified the closer the horizon is to the top or bottom of the photo.

Buildings stand tall, but when you photograph them, they often look like they are falling over backward. This is because when you get close to a building and point your camera up to photograph it, the camera and lens accentuate perspective so that the building appears smaller at the top than at the bottom. This is especially common with wide-angle focal lengths. In the past, you had to use very expensive gear to correct this problem, which meant architectural photography was not as accessible for the average photographer. In many situations, a leaning building weakens the look of the building.

Correct Camera Distortion once again comes to the rescue. Although the filter is commonly used for buildings, you can also use it for trees, cliffs, and other tall objects. By straightening these objects, they gain a very majestic look in your photograph.

Here are ruins of a bank building in the ghost town of Rhyolite, Nevada, a mining town outside of Death Valley. Looking up with a wide-angle lens caused the lean of the structure in the photo.

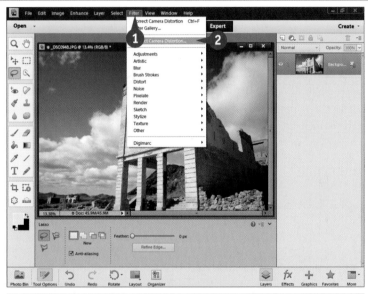

1 Click Filter.

2 Select Correct Camera Distortion.

The Correct Camera Distortion window opens.

3 Click the Vertical Perspective slider and move it to the left to vertically straighten a building.

4 Use the grid to help you determine when the building is straight.

5 Remove any lens distortion keeping the edges of the building from being straight.

6 Readjust the Vertical Perspective slider as needed.

#64

DIFFICULTY LEVEL

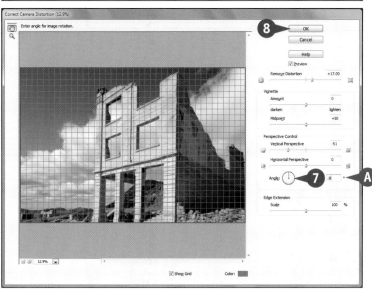

7 Correct any left or right lean with the Angle icon.

Ⓐ The Angle icon is very sensitive, so you may find it easier to type numbers in the angle degree box.

8 When you have corrected the photo, click OK.

The photo opens into the Editor with your work displayed as a single layer.

TIPS

Did You Know?

To control perspective in the past, such as correcting leaning buildings, photographers would use perspective control lenses that allowed them to move the lens to get a whole building into the scene instead of tilting the camera upward. A view camera offered the same control through shifting the whole front or back of the camera.

Try This!

As you adjust the perspective of your picture, you may find you lose certain parts of the image. Often you can do nothing about that. In that case, use your Crop tool creatively. Instead of trying to get everything into the picture, which cannot be done, crop your picture so that it looks interesting.

Try This!

When you tilt the camera up at a tall building, perspective always makes the building appear to fall backward. If you use a very wide-angle lens and get very close to the building, this can be a dramatic effect and not something you want to correct.

Remove dead space with RECOMPOSE

Sometimes people and objects do not cooperate when you photograph them. When you get extra space around your subject, you can use the Crop tool to remove pixels that do not belong in the picture. But what if those extra spaces are in between subjects?

Or what if you really like a particular composition, but it does not fit a particular proportion? This shot of cactus in the Alabama Hills landscape is framed in a 35mm format that does not fit 8 × 10, for example. Cropping to 8 × 10

would lose the look into the distance at the left, making the image look much flatter and less interesting.

The Recompose tool enables you to deal with such problems simply and easily. When you are using this tool, Photoshop Elements very smartly examines your picture to find important objects in it. Then as you change the size of the picture, Photoshop Elements keeps the important objects at the same size while carving out dead space in between them. The results can be quite remarkable.

1 Select the Recompose tool to the right of the Crop tool in the Toolbox.

2 Click the + brush at the left in Tool Options.

3 Use the Size slider to create an appropriate sized brush.

4 Paint over areas you want to protect so Photoshop Elements protects them as you change the size of the photo. Protected areas are green and are locked down so they do not change.

5 Use the + eraser to remove parts of the green protected area.

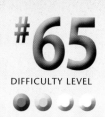

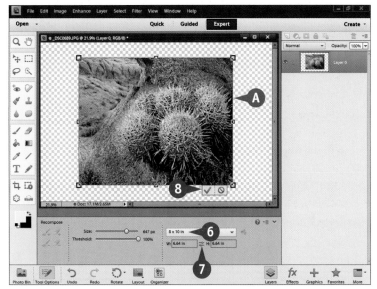

6 Click on the restrictions box and choose 8 × 10 in.

7 Double-click the blue arrows between the dimensions to make the box orient the correct way.

A A preview of the recomposed image appears.

8 Click the green check mark icon when you are done.

Photoshop Elements processes the recomposition to make this change work.

B The recomposed image appears.

C The image appears as a layer.

TIPS

Caution!

Be careful of altering reality. Bringing two people closer together who are naturally close so that they better fit a certain crop does not alter the basic relationships among the pictorial elements in the image. You can change the image so much that the photograph becomes a lie. Simply tightening up a photo does not alter reality as long as the basic relationships stay the same. Change as much as you want if you are after a fantasy image; label it as such.

Be Patient!

This is an extremely processor-intensive feature of Photoshop Elements. If your original file has any size to it at all, the actual recomposing work the program does can take a long time. It examines every pixel in your image and makes decisions on how to deal with them. Older computers can take a very long time for this processing to occur.

Make an OUT-OF-FOCUS BACKGROUND

A good background in a photo can really showcase your subject. But for a variety of reasons, sometimes the background does not let your subject stand out as well as you would like it to.

One way of improving backgrounds is to make them out of focus. Sometimes you can do this when you are taking the picture, but you can also blur the background behind your subject in Photoshop Elements. The latter action can give you more control over your background, although

making it look right can be a challenge. Although you can use selections to confine a blur to the background, you will find you get faster and better-looking results when you use layers.

This image was shot in the Crystal Forest part of Petrified Forest National Park. The logs were once trees, but now are solid rock. Although the overall shot looks okay, a more dramatic image is possible by blurring the background and keeping the foreground rock in focus.

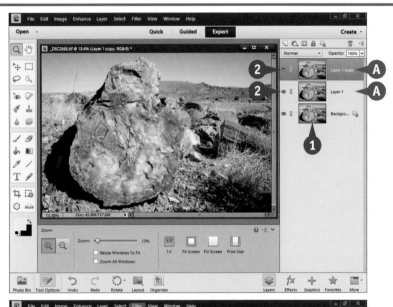

① Flatten your photo if needed.

② Press Ctrl/⌘+J twice to duplicate your layer twice.

Ⓐ Duplicate layers appear over your original.

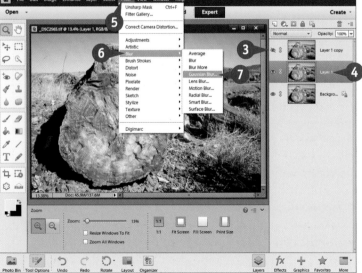

③ Click the top layer's eye icon to turn it off.

④ Click the middle layer to select it.

⑤ Click Filter.

⑥ Select Blur.

⑦ Select Gaussian Blur.

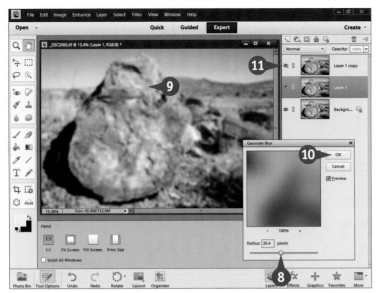

The Gaussian Blur dialog box appears.

8 Click and drag the Radius slider until the background looks out of focus.

9 Ignore what is happening to the subject.

10 Click OK.

11 Click the top layer's eye icon to turn the layer back on.

12 Click the top layer to select it.

13 Click the Layer Mask icon to add a layer mask.

14 Select a good-sized brush based on the area of the background, and change the size as you go.

15 Select black for the foreground color.

16 Paint with the black brush to block the sharp parts of the top photo layer so the underlying blurred parts show through.

B Black brush strokes appear in the Layer Mask icon.

If you go too far, change the foreground color to white and paint back the lost items.

TIPS

Caution!
Be careful of the amount of blur used. Too much blur and the photo looks surreal. Also, watch the edges as you use the layer mask. Change your brush size and hardness as you go around important edges on your subject. You may also need a selection to protect an important edge.

Try This!
If you want to keep your layers, you can use the merge and copy layers technique. You need a flattened "photo," but a flattened layer representing that photo will do. Select the top layer and then press Ctrl+Shift+Alt+E in Windows or ⌘+Shift+Option+E on a Mac to create a merged-flattened layer above it that can be used for this task.

Try This!
You can also make a selection around your subject, invert it, feather it appropriately, and press Delete or Backspace to reveal the background. On some photos, this provides better results than the layer mask technique, especially if the subject has a lot of intricate edge detail. On other photos, making a selection just takes more time, and the layer mask technique is more efficient.

Color is important for most photographs. Color is not, however, arbitrary and constant. Any color is influenced by other colors around it, dark or bright areas near it, people's feelings about it, and how a particular sensor and camera deal with it.

When you have a distracting color within the image area, it can detract from your picture. This probably happens most commonly with bright colors such as red, yellow, and orange. Bright colors draw the viewer's eye away from other parts of the picture. This is especially true if the

subject does not have bright colors that can compete with the distracting one. In this image of a boiler in an old power plant in Redondo Beach, California, a bright red-orange sign takes away from the mood of the scene.

Any color can be a problem, too, when it is bright and saturated and draws attention away from the focus of the photo. Toning down or even removing problem colors can be an important adjustment for your photograph — you want to direct the viewer to the right things in it.

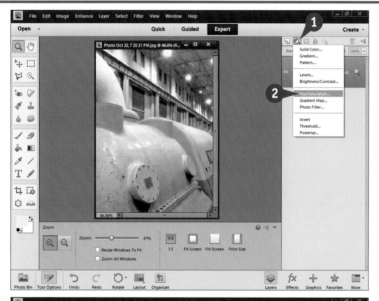

1 Click the Adjustment Layer icon in the Layers panel.

2 Select Hue/Saturation.

A A Hue/Saturation adjustment layer is added to the picture, and an adjustment panel opens.

3 Click the color drop-down menu arrow and select the color that most closely matches the color you want to change in your photograph.

4 Click the first eyedropper.

5 Position your cursor over that color in the picture and click to refine the Hue/Saturation adjustment limits.

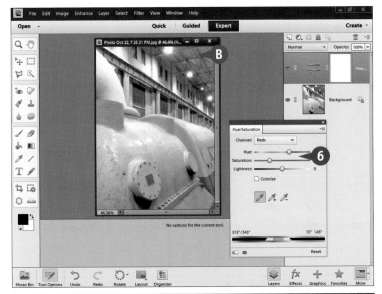

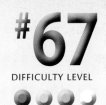

⑥ Adjust the Hue, Saturation, and Lightness sliders until the color becomes less dominant in the picture.

Usually, the Saturation slider provides the greatest change, but try them all.

Ⓑ In this photo, reducing the saturation of the red-orange sign has dulled the colors in the ceiling.

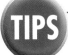

⑦ Press Ctrl/⌘+I to invert the white layer mask to black.

⑧ Click the Paintbrush.

⑨ Change the foreground color to white.

⑩ Paint white over the problem color area.

This enables you to limit the color adjustment to only one part of the picture.

Ⓒ White brush strokes appear in the layer mask icon.

TIPS

Did You Know?

You can change the layer mask between black and white in a couple of ways. One is to press Ctrl/⌘+I to invert a color mask from white to black or black to white. Another is to click the Edit menu and then select Fill Layer to completely fill the layer mask with black or white, which replaces any work done in the layer mask. The layer mask has to be selected and active for any of this to work.

Try This!

Use this technique to tone down a color in the background of your photograph that cannot be removed any other way. You may find that you cannot crop that color out nor can you blur it without adversely affecting the rest of the picture. Yet, by simply toning it down, you make it less dominant.

Try This!

If several colors are giving you problems, use a separate adjustment layer for each one. Although you can do more than one color with a single adjustment layer, that can be confusing. Using single layers for each color makes it easy to go to the exact layer needed for any adjustment. Name your layers by the color affected.

Improve BLANK SKIES

During the day, skies are bright. Typically, they are much brighter than anything on the ground. If you try to photograph the sky so that it has good color, you usually end up with a landscape that is too dark. If you expose to get good detail in the landscape, the sky becomes blank, or white. Another problem occurs when photographing on days with a hazy sky. The sky often looks blank in the photograph then, as well.

The backlit willows and rocks in this image in Alabama Hills cannot be exposed to hold detail in the rocks and sky at the same time, so the sky is washed out.

You could select the sky and simply fill it with a blue. This usually does not look very good, even to the point of looking quite artificial. Skies are not a consistent shade of blue. They get darker higher in the sky and lighter closer to the horizon. You need to duplicate this when fixing a blank sky so that it looks right.

1 Click the Magic Wand selection tool.

2 Click the sky to select it.

 Shift+click multiple times to get all the sky.

3 Invert the selection so that the landscape is selected by using Inverse from the Select menu.

4 Click Refine Edge.

The Refine Edge dialog box appears.

5 Choose the black or red overlay in View to better show the edges of your selection.

6 Use the magnifier if needed.

7 Adjust the Smooth, Feather, and Contract/Shift Edge sliders until the edges along the sky look good.

8 Click OK.

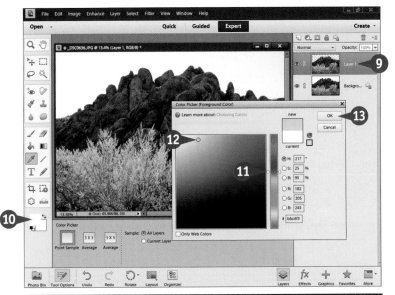

9. Press Ctrl/⌘+J to copy the landscape to a new layer.

10. Click the foreground color to open the Color Picker (Foreground Color) dialog box.

11. Click the center color bar to pick a good sky-blue color.

12. Click in the big color box to refine your color selection.

13. Click OK.

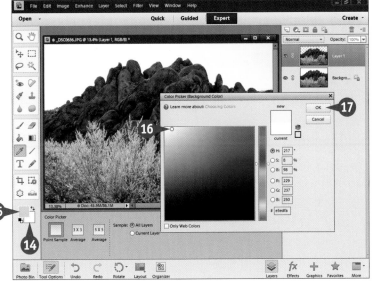

14. Click the background color to get the Color Picker (Background Color) dialog box.

15. Click the foreground color box to get the same color.

16. Click in the big color box to get a color lighter than the foreground color.

17. Click OK.

#**68**

DIFFICULTY LEVEL

TIPS

Did You Know?

Being able to add an overlay in Refine Edge that clearly shows what edges will look like based on the selection is a great benefit, and this dialog box gives you multiple options. Use the magnifier in the Refine Edge dialog box to enlarge the image to better see what is happening on the edge. The hand icon allows you to move the enlarged photo around.

Try This!

When you deal with skies that the subject breaks up — trees in the background and other pictorial objects — you may find it helpful to use the Magic Wand selection tool with Contiguous unselected. This enables the program to look for the sky throughout the picture even if it is not directly connected to the area that you click on.

Did You Know?

The Color Picker that appears when you click the foreground or background color enables you to choose all sorts of colors. The central color bar is for selecting hue, and the large box enables you to select the brightness of a color from left to right and the saturation from top to bottom.

Placing the selected landscape in a separate layer enables you to change and tweak the sky on a different layer as much as you want without affecting the landscape. Plus, the edge of the landscape covers the sky so you have fewer edge problems. In addition, it enables you to tone down the intensity of the fixed colors by simply modifying the opacity of the layer. You can also change the color of the sky by using Hue/Saturation on the layer.

Finally, a separate layer is very important because it enables you to add noise to the fixed sky. All photographs have some sort of noise at some level. When Photoshop Elements adds color, it adds it in a pure form, without any noise whatsoever. This can make the sky look unnatural.

By adding color to the blank sky of this photograph, the picture gains a little bit more of a feeling of reality. This makes the image closer to what you see instead of being limited by the sensor of the camera.

18 Click the bottom layer or Background.

19 Add a blank layer by clicking the New Layer icon.

20 Click the Gradient tool.

21 Click high in the sky to start the gradient.

22 Drag your cursor down to the bottom of the sky and release to end the gradient.

A new sky appears; it will often be too intense.

Try this multiple times until the gradient looks reasonable.

23 Adjust the opacity of the sky layer until the sky looks natural.

24 Click the Zoom tool and then click the photo to enlarge a small section of sky.

25 Click the Hand icon to move the photo around to better see the sky.

26 Click Filter, select Noise, and then select Add Noise.

The Add Noise dialog box opens.

27 Select Gaussian.

28 Add a small amount of noise so the sky is a closer match to the original photo.

29 Click OK.

TIPS

Caution!

Be sure you are in the right layer when you add the sky. You do not want to add the sky to the original image or to any other layer that you might be using. This will cause you problems, although if you accidentally put the sky in the wrong place, you can undo it using the History panel.

Try This!

Often you will find that it takes several tries with the Gradient tool to get a good-looking gradient for the sky. You may find that one time the sky looks crooked, another time it does not seem to match the way the rest of the scene looks, and another time the blend is too high or too low. Keep trying the tool until the sky looks good.

More Options!

The Gradient tool has a number of options in the Tool Options panel. Most photographers use this tool at its default settings. However, you can choose some other interesting gradients in Tool Options. You might like experimenting with them for special-effect purposes. Use the Reset Tool menu at the top right to get back to the defaults.

Control the focus with TILT-SHIFT EFFECTS

Photographs look their best when the image is clearly structured for the viewer. You want the viewer to be able to understand what your picture is about or at least understand your interpretation of the scene. Composition, filters, depth of field, and other shooting techniques are used to help define and structure the picture so that it affects the viewer.

A trendy effect photographers have been using for this purpose is a unique use of sharpness. By using special lenses called tilt-shift lenses, they create a small area of sharpness within the picture to define exactly what they want the viewer to look at. You can do something similar in Photoshop Elements. You create a blur over most of the picture that blends nicely to a sharp area. By choosing this sharp area carefully, you create a strong way of communicating your focus to your viewer.

The control wheels at the old power plant make an interesting photo, but by controlling focus with a lens blur effect, a new and more dramatic image appears.

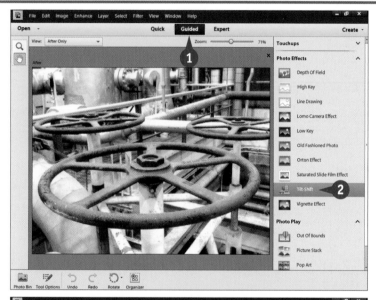

1 Click Guided.

2 Select Tilt-Shift.

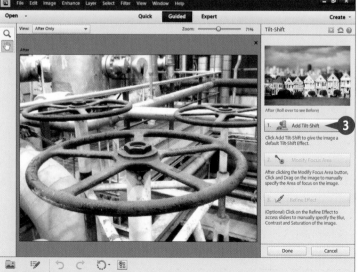

The Tilt-Shift panel appears.

3 Click Add Tilt-Shift.

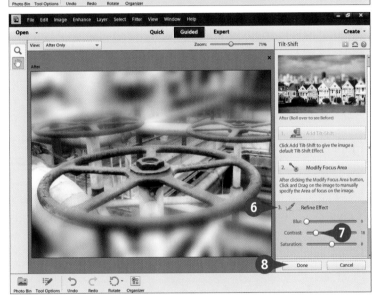

A The image changes to a scene with both sharp and blurred areas, with a blend between them.

4 Click Modify Focus Area.

5 Click and drag on the image to place your sharp area. Where you click is the center of the sharpness, and the distance you drag affects how large an area it is.

6 Click Refine Effect to access control sliders.

7 Try the Blur, Contrast, and Saturation sliders to see if they help your photo.

8 Click Done.

TIPS

Try This!

This can be a fun way to work with an image. Try all sorts of places for the center of the sharp area, and definitely try dragging your cursor from there in different directions. Vertical or diagonal bands of sharpness can create unique and striking images. Keep trying things until you get something you like.

Did You Know?

Sometimes this effect is called the toy effect. If you photograph a street scene from above, for example, and put a band of sharpness through the street where the people are, the buildings will be blurred. This looks like something you would get from photographing a close-up of toys.

Did You Know?

Clicking Done, then Expert, takes you back to the usual mode for Photoshop Elements. There you will see that this Tilt-Shift effect has created new layers that you can now access. By using layer masks, you can further refine the effect in very specific places in the image.

How often have you taken a picture of friends or family, and you have liked the subject but not the background? This happens all the time. Sometimes the liveliest photos that really give an interesting interpretation of the person are captured informally, even spur of the moment, with a point-and-shoot camera. In these situations, you rarely have the chance to choose a great background for your subject.

You can change the background in Photoshop Elements. You can create everything from a very simple background

to something with rich texture and color. You can even put your subject in front of a totally different real-world background. The technique is the same for both types of backgrounds. Changing backgrounds lets you practice your selection skills and your use of layers. The possibilities are endless and can keep you up late at night trying them!

The image seen here is a quick portrait of a woman and her son. The background could be much better, but is what can be expected from a snapshot.

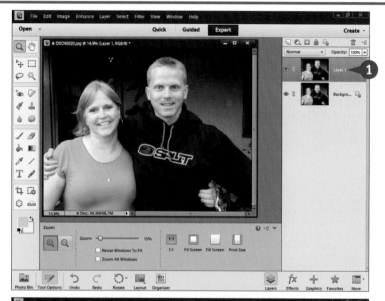

① Copy your photograph to a new layer by pressing Ctrl/⌘+J.

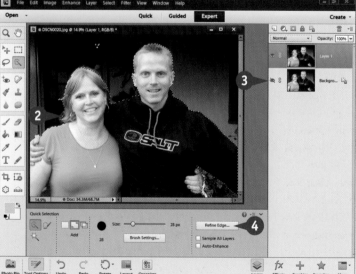

② Make a selection around your subject using whatever selection tools work best.

③ Turn off the bottom layer or background by clicking its eye icon.

Sometimes you get the best results by selecting the background and inverting the selection, which was done here.

④ Click Refine Edge.

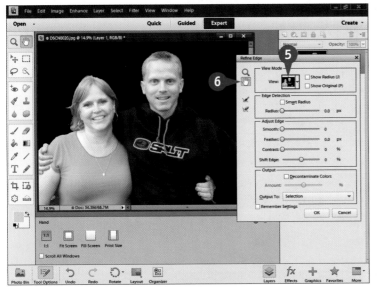

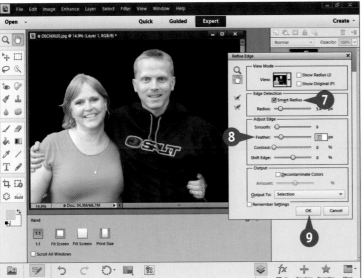

The Refine Edge dialog box opens.

5 Click the black or red overlay in View that better displays the edge.

6 Use the Zoom and Hand tools as needed to magnify the image and move it around so you can better see the edge.

The Zoom tool zooms in by default. Pressing and holding Alt/Option plus the Zoom tool zooms out.

7 Try Smart Radius to see if the edge improves.

8 Adjust the Smooth, Feather, and Contrast/Shift Edge sliders to refine the edge of the selection.

9 Click OK.

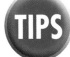

TIPS

Important!

Watch those edges as you go around your subject. The edge really has a big impact on how well the background works with your subject, and the selection gets you started. Select your subject using whatever selection tools work best for you and the subject. Add to and subtract from that selection by pressing Shift and Alt/Option.

Did You Know?

The overlay that appears when you use the View mode in Refine Edge helps you see changes in the selection edge. If you use the red overlay, the red is where nothing is selected; you clearly see the selected area that has no red. This edge shows blending, feathering, and so on, which is not visible with the normal selection edge.

Did You Know?

Selections work well with layer masks. Think of a selection as a precursor to a layer mask. Anything selected is "allowed" and therefore is white in the layer mask. Anything not selected is "blocked" and therefore is black in the layer mask. Selections can help create a layer mask, and then the layer mask can make the selection easily modifiable.

(continued)

So what can you put as a new background for your subject? Bright colors work great with young people. Muted colors work well with gentle portraits. White and gray create a more formal, elegant look, whereas black is dramatic. Textures give dimension to a background, and Photoshop Elements offers a lot of them if you experiment with the filters in the Filter menu.

You can open a totally different photograph and use it for a background. An easy way to do this is to make a new layer in that photo by pressing Ctrl/⌘+J, and then select the Move tool at the upper left of the Toolbox. Click the layer and drag it to the photograph of your subject that needs a new background. Be sure that your cursor has gone completely over the edges of the photograph and then release the mouse button. This picture is dropped onto your picture, over the active layer. Move it up and down in the layer stack as needed. Blur it so that it looks more natural.

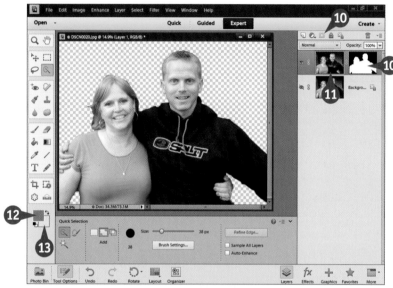

⑩ Click the Layer Mask icon to add a layer mask to the top layer.

A checkerboard pattern indicates the area has no pixels to display and nothing can appear there when the bottom layer is turned off.

⑪ Click on the photo icon in the layer.

⑫ Pick an interesting foreground color by clicking it and using the Color Picker (Foreground Color) dialog box.

⑬ Pick an interesting background color by clicking it and using the Color Picker (Background Color) dialog box.

Foreground and background colors are now available for use.

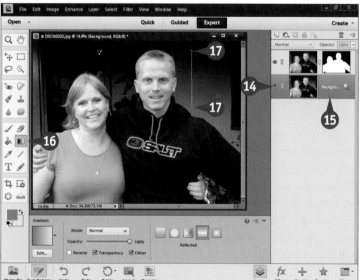

⑭ Click the eye icon for the bottom layer to make it active.

⑮ Click the bottom layer to select it.

⑯ Select the Gradient tool from the Toolbox.

⑰ Click in the upper part of the photo and drag down past the middle and release the mouse button to create a gradient.

Because the bottom layer is active and selected, the gradient occurs there. Try different blends by changing your start and end points.

A A new background appears behind the subject. The Gradient tool gives the background some dimension.

B Problems with edges show up now.

18 Click the layer mask.

19 Click the Paintbrush and pick a small, soft-edged brush.

20 Change the foreground color to black.

21 Paint black along the problem edges to make them blend better.

22 Click Brush Settings if needed to change the brush hardness to better work an edge.

TIPS

Important!

Watch your edges. They can make or break this type of work in Photoshop Elements. Your selection was only the start of working that edge. Once you have a layer mask, you can refine that edge as much as you want by simply using small black or white brush tools to block or allow parts of the edge.

Try This!

Once you start putting backgrounds behind your subject, be aware of sharpness. Normally you want your subject to be sharp and the background to be less sharp. Because the background is new, you can blur it as much as you want with Gaussian Blur. Usually you should have at least a slight blur on that new background.

Try This!

Freely experiment with backgrounds. You can discover all sorts of backgrounds by using different colors and different images, and then just trying a lot of filters in the Filter menu. You can even copy your original picture below your subject and apply filters to that layer just for the effect.

Size and Sharpen Photos

Whenever you want to use a digital image for something, you always have to size it. If you think about it, even when using film, you had to make a print sized specifically for the need or use of the photograph. With film, you simply put the negative into an enlarger and make the picture bigger or smaller as needed. With digital images, you now put the image into a "digital enlarger" that smartly changes the size of the photo. It is a little harder than using an enlarger for film because you have to be very specific in how you create a size for the image. Things like resolution and physical size must be treated separately.

In general, do all your processing work on a photograph using a master Photoshop, or PSD (Photoshop Document), file, and then save that master file for any future resizing purposes. Create a new file for every major change in size of picture you need. Do not resize your master file because you cannot get back the original file from the saved file.

Some photographers resize an image for every small change in size that they need. This is rarely needed. You do not find a lot of quality difference changing from an 8-x-10-inch photo to a 5-x-7-inch photo, for example. But you do see a difference if you try to use an 8-x-10-inch photo for a 2-x-3-inch wallet-size image or vice versa.

DIFFICULTY LEVEL

Photoshop Elements puts the key photo-sizing controls in one place: Image Size, under Resize in the Image menu. To use the image-sizing options effectively, it helps to understand how Photoshop Elements structures the resizing of an image. You can make a picture bigger or smaller by either changing how many pixels are in a picture or changing the spacing of the pixels in an image file.

The program uses some rather complex algorithms to make an image file bigger or smaller in pixels, yet retain the best possible quality for the picture. You have to tell

Photoshop Elements how to handle your particular picture, which is what the options in Image Size enable you to do. The right choices are fairly straightforward; however, some options can create problems if you are not careful. This should not deter you, but you do need to pay attention to what you are doing.

The photos seen in this chapter come from old mines in Death Valley. This place of extreme temperatures was literally a hotbed of mining about 100 years ago.

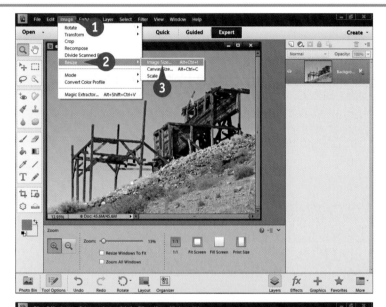

1 Click Image.

2 Select Resize.

3 Select Image Size.

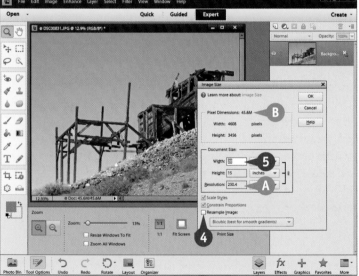

The Image Size dialog box opens.

4 Be sure Resample Image is unselected.

5 Type either the Width or Height, and the other dimension appears automatically.

A Resolution changes because at this point you are only moving pixels closer together or farther apart.

B Pixel Dimensions do not change because there are no new pixels.

6 Select Resample Image.

This tells the program to add or subtract pixels to change an image size.

7 Type a Resolution.

8 Type a new width or height.

C Pixel dimensions change because new pixels will be created.

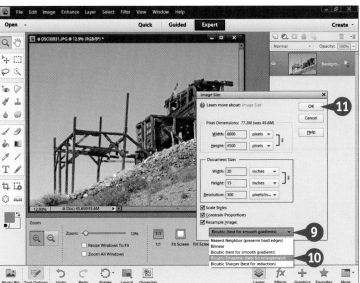

9 Click the drop-down menu below Resample Image.

10 Select Bicubic Smoother if your photograph will be enlarged; that is, Pixel Dimensions increase.

Select Bicubic Sharper if your photograph will be reduced in size.

11 Click OK to resize the picture.

TIPS

Did You Know?

Image sizing is not designed to give you a specific proportional size such as 8 × 10 inches or 11 × 14 inches. It is designed to make your overall picture larger or smaller. If you want a very specific size, you need to use the Image Size dialog box to get a correct height or width, and then use the Crop tool to get the final size.

Caution!

In general, you should always leave the Constrain Proportions box checked. This means your picture resizes according to the original proportions of the photograph. If this box is unchecked, you get mildly to wildly distorted photographs from your resizing.

Did You Know?

When you enlarge an image size and pixels are created, the differences between those pixels must be smoothed out so your photo has maximum quality. That is why you use Bicubic Smoother. When you reduce the size of an image, detail is thrown out, but you want to retain the sharpest detail. That is why you use Bicubic Sharper.

Size photos FOR PRINTING

Inkjet printers do a fantastic job creating superb photo quality for your prints. But to get the optimum quality, the image file must be sized properly for a given print output size. You do not get the best results if you simply print any and all image sizes from one master file that has a specific size and resolution. In fact, print image quality can decline from both too little or too much resolution.

Resolution is a very important part of image sizing for a print. You need to create an image with a printing resolution. All inkjet printers create a high-quality print using resolutions between 200 and 360 ppi (pixels per inch), though quality images are possible only if you are using printing paper designed for photographs. If you can resize your image without resampling the picture and stay within this range, you can use your master image file for printing. You do not need to make and save new copies of this image until you start resampling the picture.

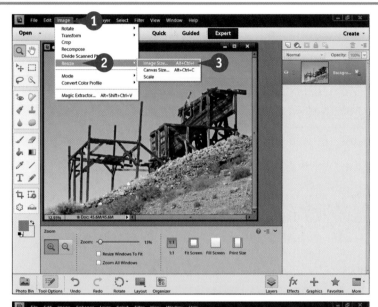

1. Click Image.
2. Select Resize.
3. Select Image Size.

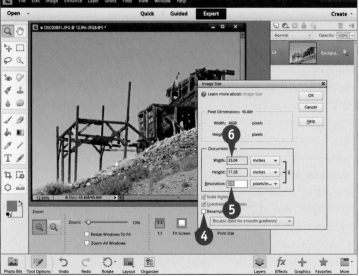

The Image Size dialog box opens.

4. Be sure Resample Image is unselected.
5. Type **200** for Resolution.
6. Note the width and height because this is the maximum size for printing without resampling.

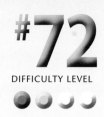

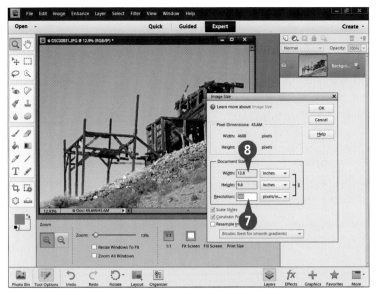

⑦ Type **360** for Resolution.

⑧ Note the width and height because this is the minimum size for printing without resampling.

You now know how big or small you can print without increasing or decreasing the number of pixels.

⑨ Select Resample Image when you want to change the size of your picture beyond the range represented by 200 to 360 ppi.

⑩ Type **200** ppi for bigger pictures and **300** ppi for smaller pictures.

⑪ Type a desired width or height for your photo.

⑫ Choose Bicubic Smoother if your photograph will be enlarged, that is, Pixel Dimensions increase.

Choose Bicubic Sharper if your photograph will be reduced in size.

⑬ Click OK to resize the picture.

TIPS

Important!

The resolution of an image is not the same thing as the resolution of a printer. Image resolution refers to the way pixels create tones and details in a photo. Printer resolution has to do with how the printer puts down ink droplets on the paper. They mean very different things.

Did You Know?

Pixels per inch, or ppi, is a standard way of measuring the density of pixels in a picture, which is also a measure of resolution. Pixels alone are not enough information. To understand resolution, you must have pixels combined with inches or another linear measurement, which is an indication of how many pixels fit in a linear dimension.

Did You Know?

The type of paper used for printing affects the ppi needed in the original image. Matte finishes can handle lower resolutions quite nicely, whereas glossy papers tend to require higher resolutions. Do your own tests and see how resolution affects the look of an image on the papers that you use.

Size photos FOR E-MAIL

Sharing photos via e-mail is a great way to get your pictures in front of friends, family, and others. You can, for example, take pictures of your kids playing soccer in the afternoon, and then send copies of those pictures to the grandparents that night. That is a lot easier than making prints and trying to mail them.

However, a common problem with e-mail pictures occurs when people simply download the image files from the camera and send them attached to an e-mail. The high-megapixel cameras of today produce huge files for

e-mailing, even when using JPEG. This can cause problems for the recipient of the e-mail. Files this size can take too long for recipients to download or even crash their e-mail software, especially when multiple photos are attached. Most recipients of such pictures have no need for such large image files.

You can avoid this problem by sizing your pictures properly for e-mail purposes. It is possible to e-mail images from the Share option in Organizer, but this gives you fewer options.

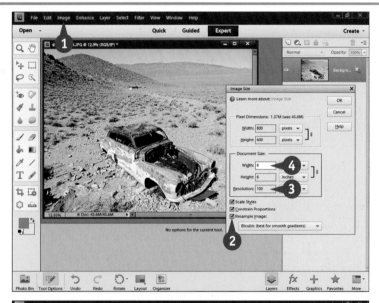

1. Click Image, Resize, and then choose Image Size.

 The Image Size dialog box opens.

2. Select Resample Image.

3. Type **100** for Resolution.

4. Type **8** for the longest side, whether it is width or height.

 This creates a good, small image file for standard e-mailing purposes.

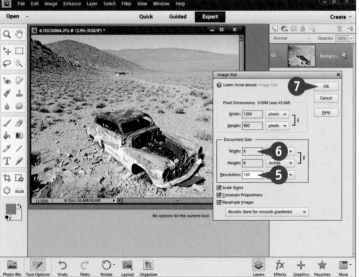

5. Type **150** for Resolution.

6. Type **8** for the longest side, whether it is width or height.

 This creates a small image file that can be both e-mailed and printed at moderate quality.

7. Click OK.

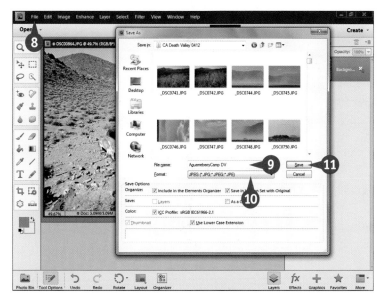

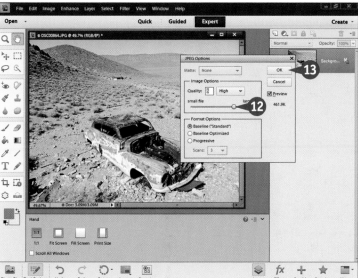

#73
DIFFICULTY LEVEL

Your image now appears smaller in size in Editor.

Make it fill the workspace again by pressing Ctrl/⌘+0.

⑧ Click File and select Save As.

The Save As dialog box appears.

⑨ Give the file a name.

⑩ Select JPEG for the file format.

⑪ Click Save.

The JPEG Options dialog box appears.

⑫ Click and drag the Quality slider to a moderate JPEG Quality setting between 6 and 9.

⑬ Click OK to resize the picture.

TIPS

Did You Know?
A resolution of 100 ppi is easy to remember and works fine for displaying pictures that have been sent by e-mail. Few monitors display at 72 ppi anymore, which used to be the recommended resolution for e-mail.

Did You Know?
For optimum printing quality, you should generally choose a resolution of at least 200 ppi. However, 150 ppi gives an acceptable, photo-quality print while at the same time enabling you to have a significantly smaller image size for e-mailing.

More Options!
When you save an image as a new JPEG file, a dialog box with options for JPEG settings appears. As you change the Quality setting, you see a number appear below the Preview check box. This number is the size of your image based on the quality setting you selected. For e-mail, quality numbers between 6 and 9 are common and work fine. Look for a setting that provides a final file size less than 300KB (the number appears below the Preview check box).

Sharpen photos with UNSHARP MASK

Photoshop Elements has excellent sharpening capabilities, but it can only be used to sharpen something with pixels. You must sharpen a flattened file saved for a specific purpose or use a technique that creates a pixel-based layer for sharpening. If you have sharpened in the Camera Raw part of Photoshop Elements, you do not need to sharpen again.

Sharpening in Photoshop Elements is designed to get the optimum amount of sharpness from your original image based on a sharp picture to begin with. It does not help blurred or out-of-focus pictures.

For a variety of reasons, images coming from a digital sensor are not optimally sharp. Most cameras apply some sharpening to a JPEG file as it is processed inside the camera. No sharpening is applied to a RAW file. Yet, no matter what image comes into Photoshop Elements, it usually needs some degree of sharpening. The name Unsharp Mask comes from a traditional process used to sharpen photos for printing plates in the commercial printing industry. It does not refer to making unsharp pictures sharp.

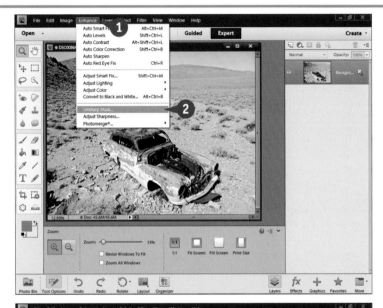

1 Click Enhance.

2 Select Unsharp Mask.

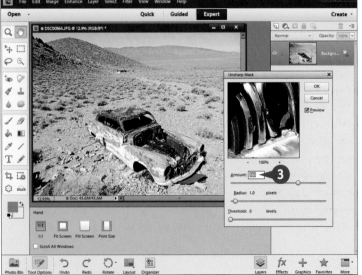

The Unsharp Mask dialog box opens.

3 Type a number between 130 and 180 for Amount.

Amount is the intensity of the sharpening.

Different subjects need levels of sharpening appropriate to their look.

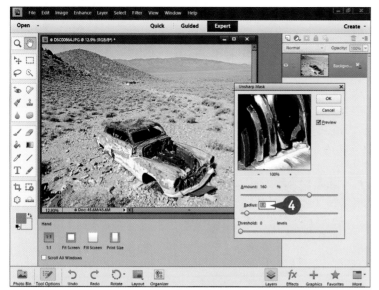

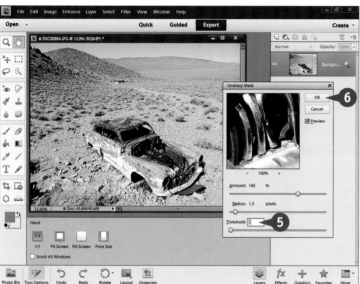

4 Type a number between 1.0 and 1.5 for Radius.

Radius affects how sharpness is enhanced around an edge.

Be careful of overdoing this control — watch for unnatural halos of brightness around contrasting edges.

5 Type a number between 3 and 6 for Threshold.

Threshold affects how small details such as noise are sharpened.

Set this higher for images showing more noise, and lower for those showing less.

6 Click OK to sharpen the picture.

TIPS

Caution!
Be wary of using high Threshold numbers. Threshold is very useful in minimizing the impact of sharpening on noise and other image detail problems called *artifacts*. But it can also affect small important details. Keep your Threshold setting below 6 when you can, and go up to only a maximum of 12.

More Options!
The Preview in the Unsharp Mask dialog box can be very helpful. Click part of the picture to show its detail in the preview. Click the preview picture on and off to see how sharpening is being applied. Click the preview picture and drag to move its position around so it displays key sharp parts of the image.

More Options!
Change your sharpening based on the subject. Landscapes and architecture typically do well with higher sharpening numbers for Amount and Radius. Photos of people, especially close-ups of faces, usually need less sharpening, even as low as 100 for Amount and less than 1 for Radius.

Sharpen photos with ADJUST SHARPNESS

Adjust Sharpness uses advanced algorithms for sharpening to get the maximum detail possible from a photograph. This is the same control as Smart Sharpen in Photoshop. You might wonder why you would not use this method to sharpen photos all the time. The reason is because of noise and Threshold.

Adjust Sharpness does not have a Threshold control. This means if you have noise in your picture, that noise is likely to be sharpened just as much as anything else in the picture. Luckily, today's digital cameras do keep noise to a minimum. You find more noise in small cameras with small sensors and high megapixels. You also find more noise with higher ISO settings. If noise shows up too much from Adjust Sharpness, go back to Unsharp Mask.

Adjust Sharpness works well for highly detailed pictures, such as landscapes and architecture, but when you need more gentle sharpening, such as with people, you may find Unsharp Mask works better. Getting the most detail of someone's facial pores may not be the most flattering thing to do.

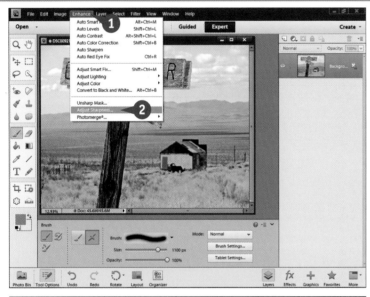

① Click Enhance.

② Select Adjust Sharpness.

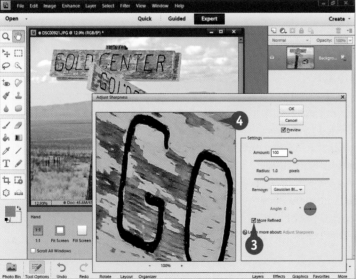

The Adjust Sharpness dialog box opens.

③ Select More Refined.

④ Click and drag the Preview until you find a good place to check sharpness.

Alternatively, click your cursor on something that should be sharp in the photo itself.

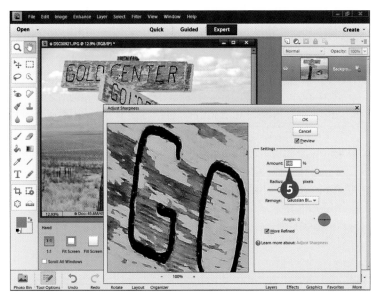

5 Type a number between 100 and 160 for Amount.

Amount acts slightly different from Amount in Unsharp Mask.

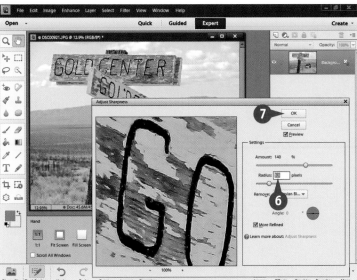

6 Type a number between 1.0 and 1.5 for Radius.

Radius also acts slightly different from Radius in Unsharp Mask.

7 Click OK to sharpen the picture.

TIPS

Important!
Because noise can become more obvious in Adjust Sharpness, looking for it is important. Enlarge the picture in the Preview by clicking the plus button underneath the Preview. Check areas such as dark parts of an image that have been brightened and the sky. They usually show noise before other areas.

More Options!
Remove instructs Adjust Sharpness how to handle sharpness. Click it, and a drop-down menu appears. Sometimes sharpening pictures that have motion blur is easier by selecting Motion Blur. And sometimes you can get sharper pictures with an out-of-focus subject by selecting Lens Blur.

More Options!
If you read anything about Photoshop and Photoshop Elements, you will find a variety of formulas for Unsharp Mask and Adjust Sharpness. Generally, they all work and can be worth a try. Every photographer uses different formulas because sharpness truly depends on the subject and on the personal tastes of the photographer.

SHARPEN PHOTOS when you have layers

The sharpening features of Photoshop Elements must have pixels to work on. This presents a challenge when you are working with layers because first, you need to have pixels in a layer to sharpen it, and second, even if you do have pixels in a layer, you can sharpen only one layer at a time. Once you have finished working on a photograph using layers, you normally sharpen the whole picture, including everything that adjustment layers might do to it. This is one reason why sharpening is one of the last things you

do in Photoshop Elements. If you are sizing a photo for a particular use, such as a print or an e-mail, you then sharpen at that size.

It is possible to sharpen a master file that still has layers. You must create a special layer on top of all your other layers that merges those layers together into one pixel layer. You then sharpen this layer. You can later go back and adjust anything underneath that layer, although you must create a new sharpened layer if you do.

① Click the top layer.

② Press Ctrl+Shift+Alt+E in Windows or ⌘+Shift+Option+E on a Mac.

You are pressing the modifier keys plus E.

Ⓐ A new layer formed from a copy of the merged layers appears at the top of the layer stack.

③ Rename this layer Sharpened Layer.

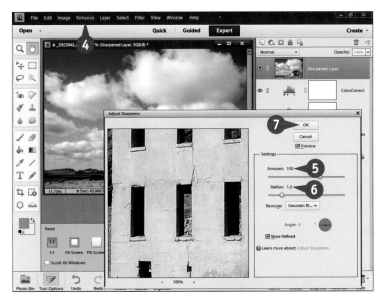

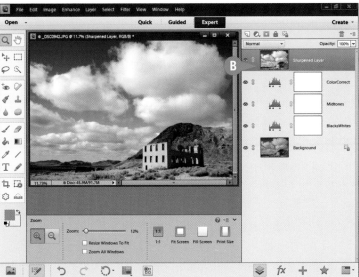

④ Click Enhance, and then select Adjust Sharpness.

The Adjust Sharpness dialog box opens.

⑤ Type a number between 100 and 150 for Amount.

⑥ Type a number between 1.0 and 1.5 for Radius.

⑦ Click OK.

76
DIFFICULTY LEVEL

Ⓑ Photoshop Elements sharpens the layer named Sharpened Layer but nothing else in the layer stack.

TIPS

Caution!
Beware of oversharpening. Although you can increase the Amount and Radius to make a blurry picture look sort of sharp or make sharpness look intense, this can also damage your photo in a lot of ways. It makes tonalities look harsh, and you lose fine tones and colors in the picture.

Did You Know?
Unsharp Mask can be very useful when you are sharpening the layer created from merged layers in a many-layered file. When a lot of adjustment layers are applied to a photograph, especially a JPEG picture, you may find noise and other image artifacts begin to appear. You can minimize them using a Threshold setting, which does not exist in Adjust Sharpness.

Did You Know?
The Merge and Make New Layer command, Ctrl+Shift+Alt+E in Windows or ⌘+Shift+Option+E on a Mac, is a fairly well-known command, but it does not show up in any menus. You have to know it exists and what it does to use it. This command is the same in both Photoshop and Photoshop Elements. Be very careful that you click the top layer before using the command.

If you have a photograph with a close-up of a flower, and that flower is sharp whereas the background is out of focus, you really only need to sharpen the flower. If you have a portrait with an out-of-focus background, the face needs to be sharp, but not the background.

In fact, there are good reasons that you should not try sharpening out-of-focus areas at all. A big reason is noise. Noise tends to show up more in out-of-focus areas and does not need to be sharpened. Another reason is that

odd little details can be sharpened in the out-of-focus area, degrading the visual quality of the area. If you restrict your sharpness to only the areas that need to be sharp, you will not have these problems.

This image of a small barrel cactus in Death Valley uses limited depth of field to focus on the cactus. Sharpening just the cactus helps emphasize it in the photograph without sharpening things that should not look sharp.

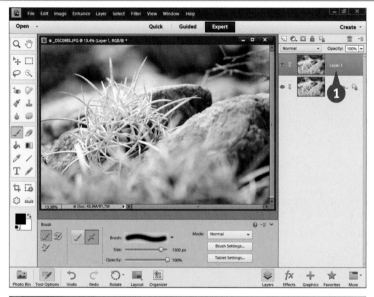

① Press Ctrl/⌘+J to duplicate your photo to a new layer.

Alternatively, click the top layer of a layered file, and then press Ctrl+Shift+Alt+E or ⌘+Shift+Option+E.

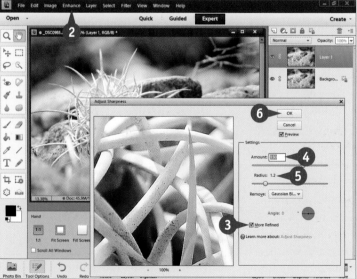

② Click Enhance, and then select Adjust Sharpness.

The Adjust Sharpness dialog box opens.

③ Click More Refined.

④ Type a number between 100 and 150 for Amount.

⑤ Type a number between 1.0 and 1.5 for Radius.

⑥ Click OK.

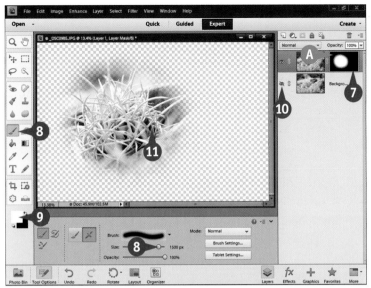

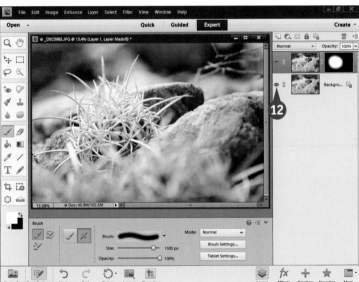

⑦ Press Alt/Option as you click the layer mask icon. This creates a black layer mask, which blocks the sharpened layer.

⑧ Select a large, soft-edged brush.

⑨ Choose white for the foreground color.

⑩ Click the eye icon for the bottom layer, Background, to turn it off.

⑪ Paint white over the parts of the picture that need to be sharpened.

Ⓐ The layer mask icon indicates the sharpened area.

By turning off the bottom layer, you can more easily see what you are affecting.

⑫ Click the eye icon for the bottom layer, Background, to turn it back on.

The top layer is now a sharpened layer, but only where the original picture was sharp.

TIPS

Caution!

If you are shooting JPEG, be very wary of oversharpening your photo. Many cameras already apply a high amount of sharpening on their JPEG files, especially lower-priced cameras. Watch out for gentle, pleasant tonalities changing and becoming harsh and unpleasant.

Did You Know?

You typically do sharpening at the end, or at least toward the end, of your image processing workflow in Photoshop Elements. The reason is that sharpening affects things like noise and other details that can be changed as you process the image. Sharpening too early can cause problems with these things.

Attention!

Think about your subject as you sharpen your photograph. Sharpening is not a one-size-fits-all adjustment. Some subjects look great with high sharpness, such as rocky landscapes. Others look better with lower amounts of sharpness, such as people's faces.

Go Beyond the Basics

Digital photography gives you some wonderful opportunities to go beyond the basics of standard photography. Not all that long ago, color was the special type of photography, and black-and-white was rather ordinary. At that time, black-and-white was commonly seen in every publication. In fact, it was considered the "cheap" part of a magazine, for example. Today, color is the most common way that pictures are printed in books and magazines. And of course, it is always easy to upload and display color on the Internet. Black-and-white photography has become something unique today. It has become a very special way of dealing with pictures, giving images a special look in contrast to very common color photos. In addition, black-and-white gives you multiple ways to deal with a subject.

This chapter includes some other fun things you can do with digital photography and Photoshop Elements. One thing you can do is take multiple images of a single subject to create a panoramic photograph. This type of photograph is created from a series of images. The width or height of the scene is too great for your lens to include when you are shooting, so you make up for it by taking pictures across the scene. Alternatively, you may like the format of a panoramic image, but want a photograph that is bigger than possible from simply cropping a panoramic format from a single image. Photoshop Elements supports the multi-image panoramas quite well.

DIFFICULTY LEVEL

Convert color photos to BLACK-AND-WHITE

With many digital cameras, you can set the camera to take a black-and-white photograph. The advantage to this is that you can see exactly what you get from a scene when it is turned into black-and-white. The disadvantage is that the black-and-white image is locked into a JPEG file and cannot be changed.

Any black-and-white photo is created by changing the colors of the world into tones of black-and-white. When you convert a color image to black-and-white in Photoshop Elements, you have a lot of control over how the colors change. This can be an extremely important factor in your work because sometimes colors that stand out in a color image blend together when first turned into black-and-white equivalents.

This early-morning image of a rock outcropping in the Santa Monica Mountains near Los Angeles, California, can be interpreted in black-and-white in many ways, both good and bad. The challenge is to create a black-and-white photo that appears as lively and interesting in black-and-white.

① Process the color image as you normally would.

② Click Convert to Black and White.

The Convert to Black and White dialog box opens.

③ Compare the color and black-and-white images to see how well the default interpretation of the scene works.

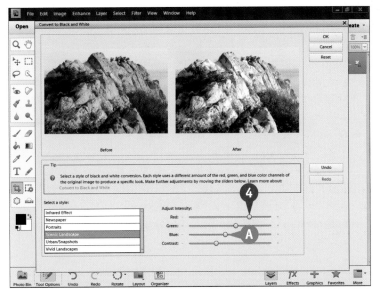

④ Modify the look of the black-and-white image by changing the brightness of gray tones by adjusting the intensity of colors.

Colors are not arbitrarily one gray or another. They change dramatically as you adjust these controls.

Ⓐ If you adjust one control, you will have to adjust another in the opposite direction to keep "exposure" consistent.

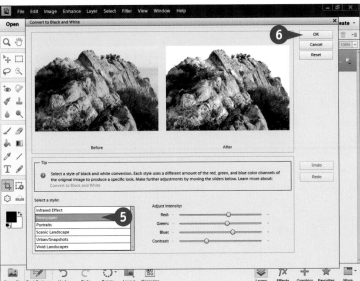

⑤ Click different styles, or interpretations, of conversions for some automated translations of colors into shades of gray and see how they work with your photo.

⑥ Click OK.

Photoshop Elements converts the photo to black-and-white.

TIPS

Important!

The default black-and-white conversion of your image by Photoshop Elements should be seen purely as a starting point. Sometimes it will look fine, but most of the time you will need to at least adjust the color sliders to refine how colors are changed into tones of gray.

Did You Know?

Making strong adjustments to a picture while converting it to a black-and-white image can cause some undesirable effects. Watch out for noise appearing in areas that have had an extreme change. Also beware of breaks in the tonality, which look like steps of tones, in smooth-toned areas such as skies.

Did You Know?

RAW files always come into Camera Raw in Photoshop Elements as color images even if you shot them as black-and-white in the camera. One advantage to RAW for black-and-white is you can use a 16-bit file. This allows for stronger tonal adjustments without breaks in smooth-toned areas.

Adjust your photos in BLACK-AND-WHITE

The tonalities and gradations of grays are what bring a black-and-white image to life. This is why these tonalities and gradations are very important. The first way to get them is when you make the conversion from color to black-and-white. Do not be satisfied with simply changing the picture to black-and-white. Be sure that such a conversion does well with changing colors to certain shades of gray. For some photos, this is all you have to do.

Often, however, you need to do more using the controls that have been discussed in the rest of this book. Because

a good, strong black is very important to a good-looking black-and-white image, it can be very helpful to reexamine the blacks in your photograph. You may want to set them to a higher point within the range of dark grays for a dramatic effect. Midtones are also very important, so you may want to use Color Curves to see various effects. All black-and-white images are interpretations of the world because humans do not see the world this way.

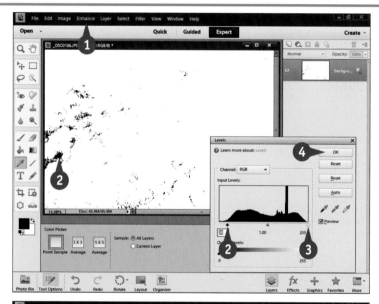

① Click Enhance, select Adjust Lighting, and then select Levels.

The Levels dialog box opens.

② Press Alt/Option as you move the black slider toward the right until you like how your blacks look.

③ Do the same to check whites by using the whites slider.

④ Click OK.

You can also make the adjustments seen here using adjustment layers. See Chapter 5.

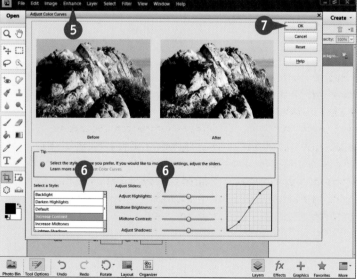

⑤ Click Enhance, select Adjust Color, and then select Adjust Color Curves.

The Adjust Color Curves dialog box appears.

⑥ Adjust the styles, plus the shadows, midtones, and highlights, until you like the overall brightness of the picture and how the tonalities look.

⑦ Click OK.

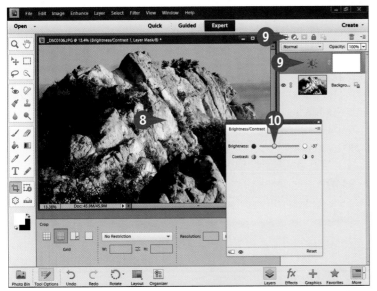

8 Examine your photo for tonal imbalances or areas that should be lighter or darker.

9 Click the Adjustment Layer icon and select Brightness/Contrast to add that as an adjustment layer.

10 Adjust the Brightness slider to brighten or darken the picture's problem area, as appropriate.

11 Press Ctrl/⌘+I to invert the layer mask to black and block the darkening effect.

12 Use a soft white paintbrush to brush in the darkening where needed in the picture.

TIPS

Important!

Grayscale and Remove Color in the Enhance menu are two additional black-and-white adjustments in Photoshop Elements. They are very limited and not recommended for most black-and-white conversions because they change color to black-and-white tones in one, and only one, way. You cannot change this.

Did You Know?

You sometimes hear black-and-white images called grayscale. *Grayscale* is a term that simply refers to the way an image deals with color, in this case a scale of gray tones. The term tends to be used more by computer people than photographers.

Did You Know?

Another term for black-and-white is *monochrome*. Although somewhat trendy, monochrome actually refers to any image based on one color. Monochrome is not limited to gray and can include red, blue, or any other color as that one color.

Create TONED IMAGES

One of the classic ways photographers worked in the traditional darkroom with black-and-white images was to *tone* them. This meant adding a slight color to a black-and-white image. It was rare, for example, for photographers like Ansel Adams to leave a print totally neutral in color. The most common toning color was a warm tone called *sepia tone*. Another common toning color was a slight blue for a cool effect. Either color often added a richer tonality and color effect for the print.

You have a whole range of possibilities here, from using just a hint of color for subtle effects, to more strongly

colored images that serve a special purpose. One advantage of a toned image is that it usually prints well on any inkjet printer. A pure black-and-white photo often prints with an undesirable tone, so choosing your own tone makes your image better looking.

Photographers sometimes create dramatic posters using a strongly colored black-and-white image. For this sort of effect, they create dramatic black areas and white areas in the photograph that go beyond a simple black-and-white conversion.

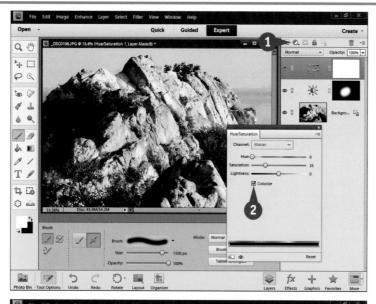

1 Click the Adjustment Layer icon and select Hue/Saturation.

2 Select Colorize.

The image now has a color and is a monochrome image based on that color.

A For a sepia-toned image, use a number between 35 and 50 points for Hue to get a warm tone you like.

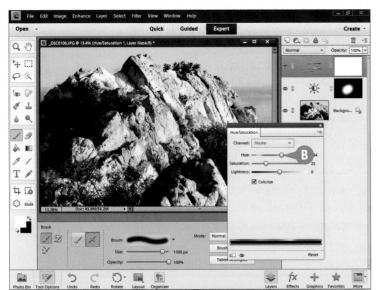

B For a cool-toned image, use a number between 180 and 210 points for Hue.

#80
DIFFICULTY LEVEL

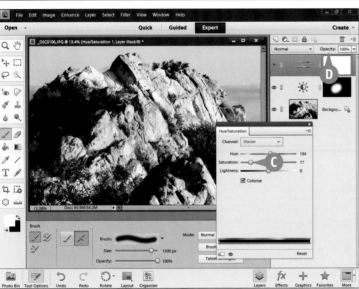

C In Saturation, use a lower number for a less intense color or a higher number for a more intense color.

D Use the layer Opacity to reduce the effect of the color as needed.

TIPS

More Options!

As you make a color image into a black-and-white photo, you may find it helpful to save different versions of your pictures. An easy way to do this is to select Duplicate in the File menu. This option creates an immediate copy with a new name, saved to the same folder as your original. Now make the changes to the copy.

Try This!

You can modify the toning effect using layer blending modes. Click the blending modes menu, which displays Normal at first, and then try the blending modes grouped under Overlay. Some of them can be pretty extreme, but all of them can create interesting effects with your photograph.

More Options!

Have fun with toning colors. There is no right or wrong, only what you like or dislike. Although most black-and-white photographs probably do not look their best with extreme colors, it can be fun to try unexpected colors to create unique images that elicit attention for special purposes.

Photographers typically think of filters as something that screws to the front of a lens and changes the way your camera captures the scene, such as a polarizing filter or a star filter. Photoshop Elements has a whole set of adjustments, also called filters, that change the way an image looks.

You have a large range of filter possibilities in the Filter menu, so large that it can seem a bit overwhelming. Luckily, Photoshop Elements presents them in their own window after you select any one of them, and in that

window, you can freely go from one filter to another to see what it does.

A challenge you will face is that these filters are extremely processor-intensive, meaning they make your computer work hard to apply them. This can mean that large files take a lot of time to process, making experimenting with filters a chore. One answer to this is to resize your photo as shown in Chapter 7 to a small size just to use for experimentation.

1 Click Filter.

2 Select Texture.

3 Select Mosaic Tiles.

This particular filter is a good one to start looking at because its effects are quickly evident, and any changes you make will be easily seen.

The Filters window opens with Mosaic Tiles.

4 Click the + button at the bottom left of the preview image to enlarge the image enough to clearly see the effects of the filter.

Click the – button to reduce the size of the preview image.

The image appears larger in the preview.

5 Click and drag the filter control sliders to see how they affect your image.

6 Click another filter category such as Artistic.

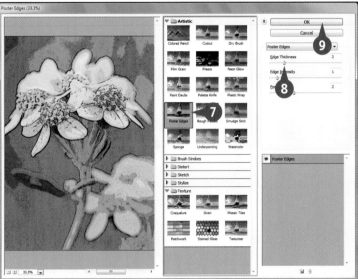

7 Click Poster Edges, another filter that displays its effects in an obvious way.

8 Experiment with the filter control sliders. Nothing is permanent until you click OK.

9 Click OK when done.

 TIPS

More Options!

You may find it helpful to copy your original image to a layer before applying filters. This allows you to freely experiment and compare results by applying different filters to different layers. In addition, you can combine the original unaffected image with filtered layers by using a layer mask or a blending mode.

Try This!

As you experiment with filters, you may find that the adjustments get so mixed up that you are not sure what the original application of the filter looked like. Press and hold Alt (Windows) or Option (Mac) and the Cancel button changes to Reset. Click it to reset the Filters window.

More Options!

Filters can be applied in an additive way so that they affect each other. You start by applying a filter to your image. Then at the bottom right side of the Filter window, you will see two icons: a new page and a trash can. Click the new page icon to add a new filter layer on top of your original, then select that new filter to apply. Click the trash can icon to remove a filter layer.

Create a GRAPHIC NOVEL LOOK

Graphic novels have become extremely popular in recent years. They range from superhero comics to serious discussions of world events, and everything in between. Now you can apply a graphic novel look to your photographs. Although this can be applied to any photograph, the look probably does best with people.

The silly image of the young man seen here is perfect for the graphic novel look. When you first try this filter, do not be alarmed at the results. They might not be close to what you consider good! Adobe engineers have no way of

knowing what every image will look like when this filter is applied to it, so they pick a generic, middle-of-the-road look that works well for some images and terrible for others. You simply have to try the adjustment sliders until you get something you like.

This filter can be a wonderful tool to play with as you work with multiple images. You can create interesting essays and even photo stories that truly reflect the idea of a graphic novel.

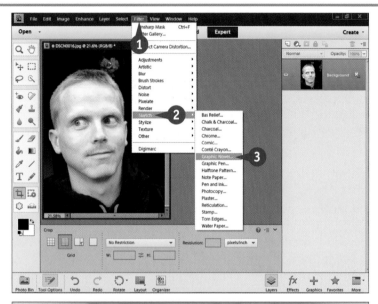

1 Click Filter.

2 Select Sketch.

3 Select Graphic Novel.

The Graphic Novel window opens

A The Painted Gray preset is the default. This looks like a stylized black-and-white photograph and can be used for that purpose.

4 Click Hard Edges.

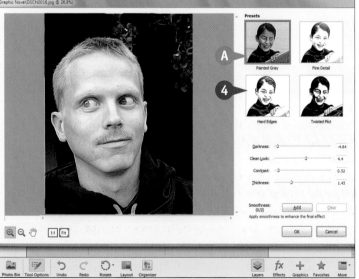

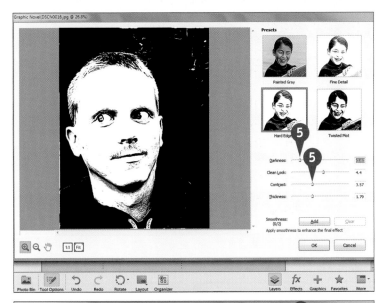

The Hard Edges processed image appears. This is a dramatic change and often is too stark to use.

5 Click and drag the Darkness and Contrast sliders to change the look.

You usually must adjust two or more sliders and keep changing them as you use them in order to get a good look.

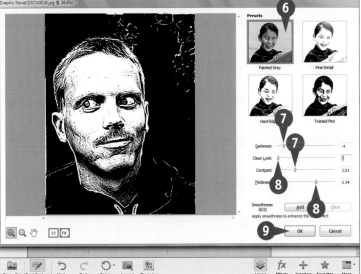

6 Click back on Painted Gray.

7 Experiment again with Darkness and Contrast.

8 Try the Thickness slider, then the Clean Look slider to affect the grunginess of the image.

9 Click OK when done.

 TIPS

Try This!

A very interesting image can be made by using layers. Copy the original image to a layer and apply the Graphic Novel filter to it. Add a layer mask. Then remove parts of the Graphic Novel layer to reveal the original image for a lively combination of reality and graphic novel looks.

Try This!

The look of the Graphic Novel filter changes considerably depending on the original image. It is true that you can gain new and sometimes better effects by adjusting the original to gain more or less tonality, especially in the midtones. Unfortunately, you have to just try this and see what happens because you cannot pretest results as you go.

More Options!

You can get some color effects with the Graphic Novel filter if you apply the filter to a layer copy of your original image. Your in-color original is then underneath the filtered layer. Click the layer blending modes at the top left of the Layers panel (it says Normal by default) and select Screen. This gives a color effect. Try other blending modes, too.

USE THE SMART BRUSH **for creative effects**

A fun black-and-white effect is to create a photograph in both black-and-white and color. A good example of this shows the subject in color, and the background in black-and-white. Color in a black-and-white photo could also include a very small part of the picture, such as a red ladybird beetle on some lupine flowers as shown here. A very interesting black-and-white image results when most of the picture is black-and-white, but the insect retains its color.

You can create special effects like this with layers: Copy a photo to a layer, apply a unique effect to the top layer, and then in that layer, use a layer mask to control where to reveal the original image underneath. You can do this more simply by literally painting the effect onto your picture using the Smart Brush. The Smart Brush adds an adjustment layer to your photograph, and then uses the Quick Selection tool with the layer mask to smartly place the adjustment where you brush.

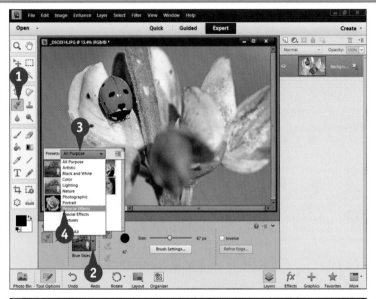

① Click the Smart Brush in the Toolbox.

② Click the Smart Brush effects icon.

③ Click the Smart Brush drop-down menu.

④ Select Reverse Effects.

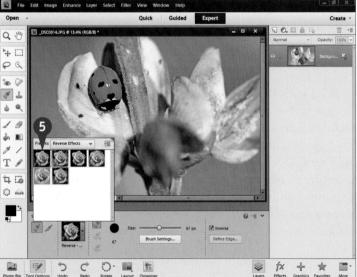

⑤ Click Reverse – black and white.

The effect name appears on your monitor, but you will not see it here because of the screen resolution needed to display images properly in these tasks.

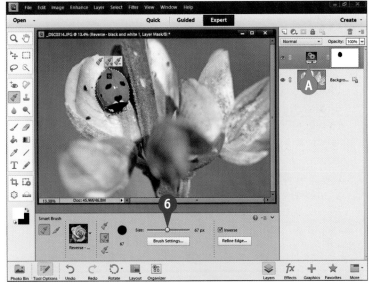

6 Select an appropriate brush size for your photograph.

7 Begin painting on the part of the picture where you want the effect to occur.

A A special adjustment layer is added to your photograph.

B Photoshop Elements smartly finds similar areas to use for your effect.

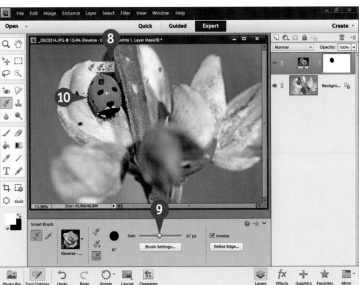

Sometimes the tool selects too much and applies the effect where you do not want it.

8 Change the effect brush to an effect removal brush by clicking the - brush icon.

9 Adjust the brush size to fit the area that you want to change.

10 Click in that area.

It often works better to click in areas to remove an effect and then brush over the area.

TIPS

Important!

Unless your background is very simple, you will find you must change brush sizes as you use the Smart Brush. A large brush works well at first, but then begins to capture too much of a photograph. When this happens, switch to a smaller brush. Remember to use the [and] keys to quickly change your brush size.

Try This!

Because everything you do with a Smart Brush uses an adjustment layer plus a layer mask, changes to your picture are not permanent. This means you can freely experiment with the Smart Brush effects. If you do not like the way the effect is working, simply drag the layer to the trash can icon to delete it.

More Options!

You can use the Smart Brush to make a lot of interesting adjustments to your picture. They all work the same way in that an effect is applied to your picture in specific areas as you paint over the image. Explore the complete list of Smart Brush choices and you may find a few that will probably work with your types of pictures.

Create pop art effects with GUIDED EDIT

Special effects used to be something only expert users in Photoshop could do. They certainly did not seem to be possible for the average photographer with Photoshop Elements and without a lot of time to learn how to create those effects. The folks putting together Photoshop Elements recognized this challenge and included special effects in Guided Edit. This makes it very easy to try some cool effects with your photo without spending a lot of time learning all the intricate details needed for those effects.

Guided Edit includes a whole group of cool effects that include a unique depth-of-field effect, an old-fashioned photo effect, an out-of-bounds effect, and a reflection effect. All these can be done without a lot of time or effort. In this task, you learn to create pop-art-styled photographs. Guided Edit truly does guide you through creating these effects so that all you really have to know are the basics of opening and adjusting your photo. It does help to understand layers because these effects do create and use layers.

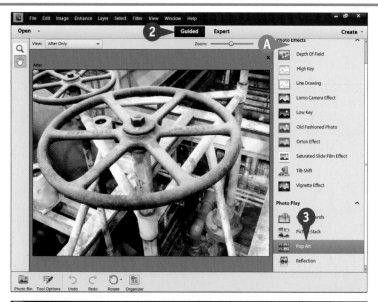

① Open your photo in Editor and do basic adjustments to it.

② Click Guided.

Ⓐ The Guided Edits panel opens.

③ Click Pop Art under Photo Play.

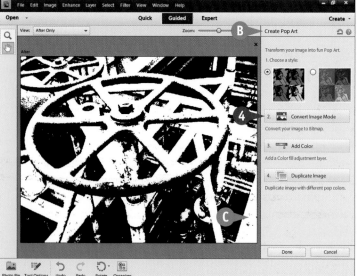

Ⓑ The Create Pop Art panel appears.

④ Click Convert Image Mode.

Ⓒ The photo changes to pure black and white.

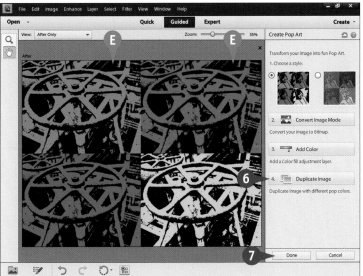

5 Click Add Color.

D Color is added to the image.

6 Click Duplicate Image.

E The image is duplicated with different colors.

7 Click Done.

TIPS

Did You Know?

As you work on the Pop Art effect, layers are created for your image. If you go to the Expert mode after clicking Done, you will find four layers with the colored images. You can change the color of any one by clicking the layer and adjusting Hue in Hue/Saturation.

Important!

This effect can be a lot of fun, but it can also be frustrating if you do not have the right photo. Two things can make it easier for you to apply this effect. First, you need a photo with very strong brightness contrasts that separate it from its surroundings. Second, it helps to have the background either much darker or much lighter than the subject.

More Options!

One cool effect you might want to try in Guided Edit is Depth of Field in Lens Effects. The name might be misleading because it is not about getting more depth of field, but about creating interesting limited focus effects in an image. This can produce dramatic-looking photos with the subject being in focus and other areas out of focus.

ADD TEXT to a page

You add text to a photo for many reasons. You may want to identify the photo as yours with your name at the bottom, or you may want to identify the photo for future use. You may also want to create a poster from your photo or even a postcard or birthday card.

Photoshop Elements makes using text a lot like working with text in a word processing program. You can quickly select a font, change its size, and decide whether it is centered or oriented to the left or right sides.

Once you create text, you can move it around the photo, quickly change its color, resize it, and more. You should think a bit about text you are adding to a photo. You want to be sure it complements the image and does not become a big distraction. The size, color, and font have a lot to do with how well text looks with a photo, but these choices depend on what the subject matter of your photo is and its intended use.

1 Click the Type tool in the Toolbox.

2 Select a font, its style, a color, and a size. All these can be changed later, but you need something to start.

3 Click the photo where you want the text to start.

A A Text layer appears in the Layers panel.

4 Type your text.

5 Move your cursor away from the text so it turns into a multi-arrow icon, and then click and drag your text to a better location.

B The text appears in the layer name. When you have much text, only the first part of the text appears.

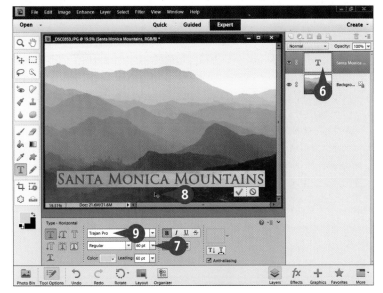

6 Double-click the T icon in the Text layer to select your text.

7 Click the font size box to change the size of your text to better fit the image.

8 Click and drag outside of the text to reposition it.

9 Change other aspects of the type as needed.

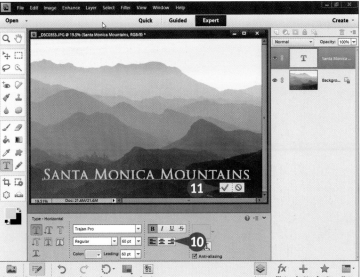

10 Click to choose a new alignment for your text.

11 Click the green check mark to finish the Text layer.

TIPS

Try This!

You can select any part of your text for modification. Double-click the T icon in the Text layer to get started. With the whole text selected, you can go into it and select parts just as you would select any text with a word processor. Once selected, the text can be changed in many ways without affecting other parts of the text.

Important!

Use different layers if you need to place text in different and specific places around your photo. Varying your placement of text is difficult when it is in a single text box on a single layer. By putting your text on separate layers, you can move it around separately as well, giving you a lot of flexibility. Any time your text is not selected or active in the text box, you can click anywhere with the Text tool to get a new layer.

More Options!

Text spacing is easy to change. Make sure your text is selected and highlighted, and then click the Leading box. A menu of numbers appears. You can choose any number there to change the spacing between lines of text on a single text layer.

Photograph a scene to GET MORE EXPOSURE DETAIL

Photographers see subjects whereas the camera sees and emphasizes the light and contrast in a scene. This can cause a problem for photographers when they try to photograph something that they see perfectly well, but the camera cannot.

The camera simply cannot give an exposure that equals what the eyes see. That is very true for this image of a scene in San Diego's Balboa Park. No one exposure can capture the full tonal range between the blue sky in the background and the shadowed building detail in the foreground.

The answer to that is to use more than one exposure. Shoot an image with an exposure that makes the bright areas look their best and not overexposed. Then shoot an image with an exposure that makes dark areas look good even if the bright areas are overexposed. Finally, shoot one or more photos in between these two exposures. Photoshop Elements then puts these exposures together in one shot that shows the entire range of tones and colors.

1 First, take a picture that exposes for the brightest areas in your scene — in this case, so the sky has good color. It does not matter if the dark areas look very dark.

2 Take a second photo with an exposure that favors the dark part of the scene even if the bright areas look too bright.

3 Take at least one more exposure in between the first and the second.

You can put these multiple images together into a final shot in Photoshop Elements.

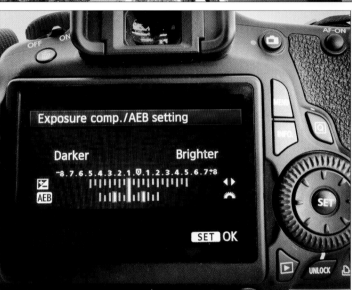

A simple way to do this whole process is by adjusting auto exposure compensation, or AEB, if your camera has it.

4 Set up AEB on your camera to cover the range of exposure needed to capture the bright areas, dark areas, and in-between correctly.

 TIPS

Try This!

Use the playback capability of your digital camera when doing this technique. Play back both the darkest and lightest photographs on your LCD that you have taken to be sure that you have one that adequately captures the bright areas and another that adequately captures the dark areas.

Important!

A tripod can be critical when you are taking multiple exposures of a scene in order to get more exposure detail. Photoshop Elements can, to a degree, line up images not shot on a tripod, but this can take time and does not always work.

More Options!

HDR or *high dynamic range* photography is becoming increasingly popular. With Photoshop Elements, you have a simplified form of HDR photography as seen here. With HDR photography, you take three or more exposures of the same scene so that you have a whole range of exposures showing off everything from the dark parts of the scene to the very brightest parts of the scene. You then bring these images into the computer and process them into one final photo.

MERGE PHOTOS **for more photo detail**

Once you have taken your multiple exposures of a scene, you need to combine those images into one final photo that is closer to what you saw. Photoshop Elements does this in its Photomerge Exposure feature. The best way to learn how to use this feature is to shoot at least three exposures of a scene as described in the previous task and then try to merge them.

Photomerge Exposure uses the technology of high dynamic range or HDR photography, although you do not have the ability to actually see or work with a true HDR file. That HDR file is used by the program to create this adjustment, but it is a hidden file that you have no access to. Some photographers use HDR with other software to create fanciful imagery, and so a lot of photographers think that is what HDR is all about. HDR also allows you to create normal-looking images that capture more detail in a scene. Photoshop Elements only gives you the ability to produce natural images that show off the real world as we see it.

① Open your series of photos into Photoshop Elements.

② Click the Photo Bin icon to open it and reveal your photos there.

③ Select all images by Ctrl/⌘+clicking them in the Project Bin.

④ Click Enhance.

⑤ Select Photomerge.

⑥ Choose Photomerge Exposure.

The Photomerge Exposure screen opens with Automatic as the default.

⑦ Check to see how well your images are blending.

⑧ Click and use the Zoom tool (magnifier) to enlarge details as needed to better check highlights and shadows.

⑨ Use the Hand tool to click and drag the magnified image to key areas.

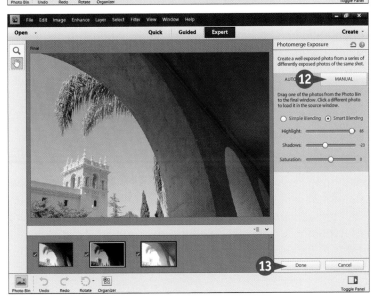

10 Refine the blend of images with the sliders on the right side of the screen.

11 Click the Reset Panel icon if the overall adjustments start looking bad.

12 Click Manual if you see problems with the blending, especially if the scene elements do not line up.

13 Click Done when the image looks good.

TIPS

Did You Know?
Why not simply use Shadows/Highlights to adjust the dark and bright areas of one image? You gain a couple of things by merging multiple exposures as seen in this task. First, less noise. Simply brightening a dark area often increases noise in that area and reduces image quality. Second, better color. Your sensor records the best color in the middle of its range, so by exposing your colors in that range, you get better color than if they are under- or overexposed.

Did You Know?
Processing the images to create the final image can take some time. Do not be surprised to find that when you select Photomerge Exposure and click Done that your computer has to work a while before anything appears. Photoshop Elements examines the photos pixel by pixel, aligning them and then comparing how brightness levels change before putting all of this together into an image that can appear on your screen.

Try This!
Adjust your photos for optimum color and contrast before using Photomerge Exposure. This enables you to be sure that your highlights do indeed look their best in the highlight-exposed image, and the shadow tonality and color look their best in the darker-exposed photo.

Photograph a scene for a PANORAMIC IMAGE

The panoramic image is like a wide-screen movie — physically, it is very wide compared to its height. You can crop a photograph to give it a panoramic look, but in that case the size your picture can be has limits because it is restricted by both the maximum size of the image file and by your widest angle focal length.

You create a multi-image panoramic photo by shooting two or more overlapping images across a scene, and then merging them together in the computer. This type of

panoramic shot gives you a very large image because your original image file size is actually quite a bit smaller than the final photo. This means you can make very large prints without any loss in quality. In addition, you can shoot a wider view of the scene than is possible otherwise, including a full 360-degree photograph.

The location seen here is from the Red Rock Canyon Conservation Area outside of Las Vegas; the photo was taken in the early morning.

Before taking your panoramic photo, find a scene with distinctive photo elements from the left to right.

1 Find a beginning.

2 Include an interesting middle.

3 Finish with an end.

Set up your tripod.

4 Level the top of the tripod below the tripod head.

5 Level the camera.

6 Set your camera to Manual exposure.

7 Set one exposure for the scene to be used for all images.

8 Shoot a series of pictures across the scene.

9 Overlap the pictures by 30 to 50 percent so that they can blend well in Photoshop Elements.

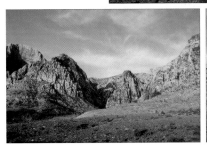

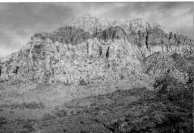

TIPS

Try This!

You can do verticals in a panoramic format, as well. This creates a tall, narrow image. The process is the same except that you shoot a series of images that overlap from top to bottom instead of left to right. This can be a great way to photograph a waterfall, for example.

Important!

Manual exposure, including setting a specific white balance, is very important when you are shooting panoramic images. If you shoot your camera on automatic, you get variations of exposure and color among the series of photos you take across the scene. This variation makes the photos much more difficult to blend together.

More Options!

You can do several things to level your tripod and camera. A simple, compact level from the hardware store can help get you started. You can also get a level that fits into your camera's flash hot shoe. Many cameras now include a digital level that can be displayed on the LCD.

Now that you have shot your photos, you are ready to merge them in Photoshop Elements. Photomerge for Photoshop Elements includes several ways you can merge multiple photos, from working with different exposures to cleaning up scenes to the powerful Photomerge Panorama. Photomerge includes a number of possibilities for your panoramic images.

The basics are simple. You tell Photoshop Elements which pictures to work with. These are photos you shot using the techniques from task #88. The Red Rock Canyon photos

come together as one long image in this task, a shot much wider than any wide-angle lens could capture.

Photoshop Elements examines your set of pictures, comparing the overlapping areas, and aligns the images. This is why getting a good overlap with your photographs as you take them is so important. The program lines up the images so the overlapped areas match, which is why leveling your camera is important; otherwise, the matched individual pictures line up crookedly. Finally, Photoshop Elements puts these pictures together as a panoramic image.

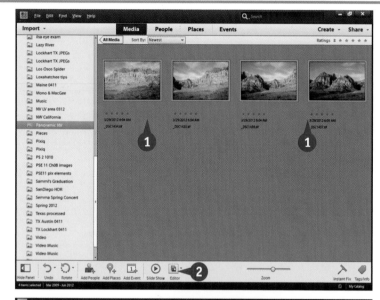

Open Photos

1. Select your set of panoramic images in Organizer.

2. Click Editor.

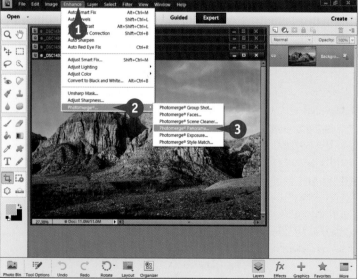

The group of photos opens in Editor.

Merge Photos

1. Click Enhance.

2. Select Photomerge.

3. Select Photomerge Panorama.

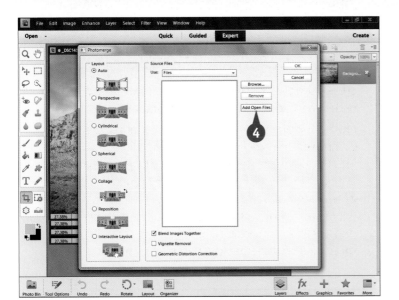

The Photomerge dialog
box opens.

4 Click Add Open Files.

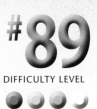

A The filenames show up in the
Source Files box.

5 Select Reposition in the Layout
area.

6 Click OK.

TIPS

Try This!

Sometimes you will find that
individual pieces of your
panoramic image do not blend
together as well as you would like.
Because Photoshop Elements puts
the individual pictures for a
panoramic into layers, you can
adjust individual pictures to make
them better match the rest. Simply
select that area's layer and work
on the picture there directly.

Try This!

When is the best time to process
individual panoramic images?
Before or after putting them into
the panorama? The answer is not
simple. Sometimes working on
individual pictures before
combining them is easier. Other
times working with the individual
photos in layers is better because
it gives you a lot of flexibility.

More Options!

When you open Photomerge
Panorama, you can choose either
Folders or Files in the Use drop-
down menu. Some photographers
merge a lot of images into one. To
keep track of them all, they often
find it easier to put each panorama
group into its own folder. That way
they can go directly to the folder
when they are in Photomerge
Panorama.

Photoshop Elements does most of the work for a panoramic for you, and it does it very well indeed. The program offers several different options for putting together your panoramic image. A common look for a panoramic is to use the Reposition option, which is the one used here. This simply lines up the pictures where they overlap and blends them together in a straightforward manner.

The Perspective option puts the pictures together with perspective effects. If you are photographing so that parts of your picture are in front and directly to the sides of you, this option may line things up better. The Cylindrical option maps the image onto imaginary cylinders, which sometimes helps things line up better in really wide panoramic shots. The Spherical option maps the images to the inside of a sphere. This option is similar to Perspective, but gives some curved perspective lines. Collage is a funky option that allows for some changing of sizes and angles to the shots. The Interactive Layout option lets you do it all yourself.

A panoramic image is created based on your group of photos. Depending on the speed of your computer and size of the original files, this can take some time.

Ⓐ Each photo is placed into a layer with an automatic layer mask to help blend it with the others.

The Clean Edges dialog box appears. This uses the same technology as Content Aware for the Spot Healing Brush to fill in the gaps along the edges.

❼ Click Yes.

❽ Click Photo Bin.

❾ Select the original images, but not the panoramic photo in the Photo Bin.

❿ Right-click any of those images. All computers allow a right-click mouse, and Adobe products are strongly oriented toward context-sensitive menus that come from right-clicking.

⓫ Choose Close in the menu that appears.

The original images close.

12 Use the Zoom tool as needed to magnify the image to better see and work on problems.

13 Look both at the top and bottom to check for poorly filled areas, and on the photo itself to check where the overlap occurs between pictures to see if any problems need to be fixed.

14 Press Ctrl/⌘+0 to see the whole image displayed again.

15 Click the Crop tool in the Toolbox.

16 Click and drag your cursor to create a crop box over the image.

If the image wants to snap to the edge, press Ctrl/Control as you drag.

17 Press Enter or click the green check mark icon.

18 Use the Clone Stamp tool on a new layer to fix problems.

TIPS

Important!
Today's Photoshop Elements uses some very advanced processing algorithms to line up and merge the different photos into a final panoramic photo. You will often find you get excellent results right from the start. If you see any problems, however, you still have the layers to work with. You can go back and use a black or white paintbrush in the layer masks to better blend problem layers.

Try This!
Sometimes it is hard to see how the edges overlap in the Photomerge output. It can help a lot if you click layers on and off. This helps you to better see edges and what they are doing in your image. You will often find problems with, as well as opportunities for, your image when you do this.

Important!
When your panoramic image is basically complete, you can continue to adjust tonalities and colors. At this point, however, turn off the top panoramic layer and adjust the underlying layers with adjustment layers. An adjustment layer above the top photo in your panoramic image now adjusts the entire panorama. You can limit adjustments to certain layers by grouping an adjustment layer to that layer.

Unique looks for a photo can be challenging to accomplish because they can take a lot of work in the program. However, Photoshop Elements enables you to quickly get creative looks through something called *styles*. You start processing an image in Photoshop Elements, and then you use Photomerge Style Match. Some images with distinctive styles are included to get you started. Even though some images are black-and-white, you can apply them to color photos.

You can also import your own photos to use for style matching. You might, for example, have spent a lot of time on an image and you really like the final results. You would like to duplicate that same result in other photos without going through all the work you did on the first photo. You can click the green plus button in the Style Match work area and follow the directions to add your own image.

The photo seen here is from Death Valley National Park, California. The style chosen gives it a more dramatic, desert-intensive look.

1 Click Enhance.

2 Select Photomerge.

3 Choose Photomerge Style Match.

Ⓐ The Photomerge Style Match panel opens with a Style Bin holding images.

4 Click an image from the Style Bin.

5 Drag the image to the Style Image opening at the left.

Your original photo on the right is changed to match the style of the photo at the left.

6 Adjust Intensity to affect how boldly the style is matched.

7 Change Clarity to affect the softness or hardness of the image.

8 Adjust Details to affect how intensely details show up.

#90

DIFFICULTY LEVEL

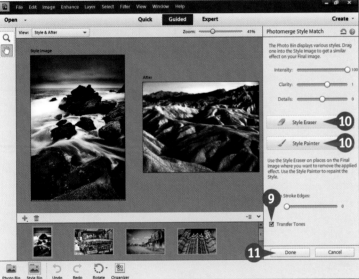

9 Click Transfer Tones to make a color image match the black-and-white tones of the style image.

10 Use the Style Eraser and Style Painter tools to change where the style is applied to your photo.

11 Click Done.

TIPS

Try This!

Play around with the extremes of the Clarity and Intensity sliders. They do similar things though the results are not identical. Moving both left gives an almost painterly look to the image. Clarity left and Painter right give a very stylized look to your image. Both right give an extreme contrast that is very bold but may look harsh for many images.

Important!

Style Match requires intensive processing on the part of your computer as it compares the two images. Do not be surprised if this processing takes a little time. Even changing the options sliders can put your computer into thinking mode as it works through the algorithms to make this change.

More Options!

The Style Eraser and Style Painter tools are brush controls; you can change them the same as any brush in Photoshop Elements. The easiest way to change the size of these brushes is to use the bracket keys ([and]) to the right of the P key on your keyboard. You can also quickly set a brush by right-clicking the photo to get a brush menu.

Software Plug-ins Make Work Easier

Plug-ins are powerful programs that work within Photoshop Elements to make your work easier, faster, and more effective. They are sometimes referred to as Photoshop plug-ins, but they usually work in Photoshop Elements, too. They can also let you do things that would otherwise be quite difficult to do in Photoshop Elements alone. In a sense, these programs smartly automate certain controls and adjustments to make your time spent with the computer more efficient. Spending more time at the computer than you have to makes no sense when there are photos to be taken!

One of the big benefits of using a plug-in within Photoshop Elements is that it can expand your efficiency and the power of the program. Many

photographers discover that by using a few plug-ins, they can easily create work equal to that of more sophisticated photographers using Photoshop. And they can do this at a fraction of the cost of buying Photoshop!

In this chapter, you learn about a variety of plug-ins that offer a range of features for Photoshop Elements users. Few photographers will need or even want all of them. A great thing about these plug-ins is that you can always try any of them for free by downloading trial versions from the manufacturers' websites. This way you can decide how valuable a given plug-in might be for you at no cost.

DIFFICULTY LEVEL

USE VIVEZA for quick creative adjustments

Nik Software (www.niksoftware.com) is a company that specializes in plug-ins for photographers, plug-ins that really seem to speak to photographers' needs. Did you think that layer masks were difficult to learn? Viveza 2 offers a unique, easy-to-use approach that uses a control point on the photograph instead of layer masks. This control point looks for similar tones, colors, and textures within a defined circle. Then as you make adjustments to that control point, such as brightness or contrast, Viveza 2 makes those adjustments to only the parts of the picture it

sees as similar. For example, if you put a control point in the sky, adjustments affect the sky but not the clouds around it, and this is without you having to do anything other than click in the picture and start making adjustments.

In addition, Viveza 2 includes a unique Nik Software control that no other companies have, called Structure. It affects the details of midtones by changing only their contrast in a way that really can make landscape and travel photographs come alive.

Note: Plug-ins must be installed and Photoshop Elements restarted before they show up in the program.

1 Click Filter.

2 Select Nik Software.

3 Select Viveza 2.

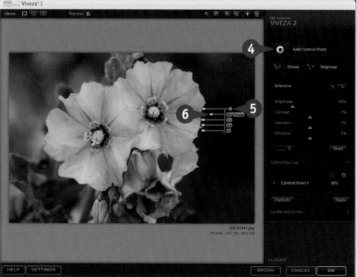

The Viveza 2 plug-in interface appears.

4 Click the Add Control Point icon.

5 Click something in the photo that needs to be adjusted, such as the out-of-focus foliage in the background of this photo.

6 Adjust this area by adjusting the sliders that appear by the control point.

The background foliage is darkened here, but only the foliage.

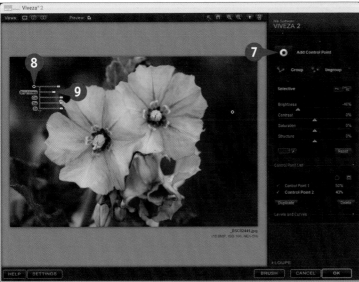

#91

DIFFICULTY LEVEL

7 Click the Add Control Point icon.

8 Click another part of the photo that needs to be adjusted, such as the background on the left.

9 Adjust this new area by adjusting the sliders that appear by the control point.

10 Click the unmarked slider coming from the control point. This affects the area of coverage.

11 Adjust the area of coverage as needed. Viveza 2 is not looking at everything within that area, only things that match the location of the control point.

12 Click OK.

TIPS

Did You Know?

The adjustments for Viveza 2 can be added at the control point or by using the sliders in the right panel. If you click off of a control point, you can use these sliders globally to adjust the entire photo. If you then click back on a control point, the sliders become selective and act only with that point.

Did You Know?

The Structure control is a very powerful part of Viveza 2. It affects the contrast of midtones in a very natural way and gives them a sense of presence. They almost seem to become dimensional, as if they were present right before you. This can be very effective with landscapes and buildings.

Important!

Most plug-ins must have pixels to work with. This means they need to work on a flattened image file or on a layer made up of pixels. You can apply a plug-in to a layered file by adding a single layer created from all of your layers using the keyboard command Ctrl+Shift+Alt+E in Windows or ⌘+Shift+Option+E on a Mac.

One thing Nik Software Color Efex Pro does for you is make your work more efficient. You can apply many of the adjustments and effects in this plug-in using Photoshop Elements, but Color Efex Pro enables you to make these adjustments faster, more easily, and more efficiently. In addition, the plug-in offers preview images that give you an idea of how a photo will look with an adjustment before you even apply it.

Color Efex Pro is a plug-in with a large range of ways to adjust your photographs. There are more than 50 effects,

including ones to change the brightness balance of certain colors, add a graduated neutral density filter effect, and get more richness from foliage. Very creative effects are also included, such as effects that mimic the look of infrared film, create a glamour glow look, and make a pastel image from your original.

In this image of the petrified forest, harsh light gives dimension to the scene, but also makes it hard to see all the details. Color Efex Detail Extractor pulls out that detail simply and effectively.

1 Click Filter.

2 Select Nik Software.

3 Select Color Efex Pro 4.

The Color Efex Pro plug-in interface appears.

4 Select Detail Extractor from the left side.

A The effect appears in the center window.

5 Click the preview icon that appears when your cursor hovers over the filter name.

6 Click an effect preview thumbnail to add those settings to the image.

7 Refine your adjustments with the sliders in the right panel.

8 Click Add Filter.

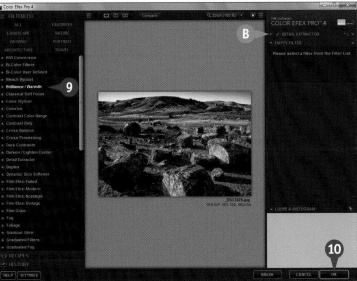

B The effect is connected to the image as a layer. Technically, nothing is applied to the image until you click OK.

9 Click another effect to further refine your photo.

10 Click OK.

TIPS

Important!

Do your basic image processing before you use a plug-in. You want to be sure that your blacks are set properly, the midtones look good, and the colors are corrected before you start making major changes to the photograph. Start with a good photograph before using the processing power of a plug-in.

Did You Know?

Color Efex Pro also includes the capability to define a specific color for a graduated filter effect. This can be very helpful in matching sky color or to create a late-afternoon mood by darkening all the sky except the light coming from near the horizon. The combination of Viveza 2 and Color Efex Pro adds a lot of power to Photoshop Elements.

Check It Out!

You can learn more about Color Efex Pro and other software plug-ins from Nik Software by going to its website, www.niksoftware.com. The site has trial versions to download as well as a complete listing of all the features in its programs. Plus, you can see some great examples and tutorials of how the software can be put to work.

Noise can be a problem with digital photos. Noise often shows up when an underexposed image is brightened to normal levels in Photoshop Elements. Other times it shows up when a high ISO setting is used because of low light levels or because you need a fast shutter speed. Although Photoshop Elements includes some very basic noise reduction controls, they do not work very well when you have the challenge of strong noise in a picture.

For optimum noise reduction, you need a dedicated noise reduction software program. Nik Software's Dfine is a

plug-in that works to control noise without hurting other details in the photograph. Dfine also enables you to specifically define areas based on color to determine how much noise reduction you do. This gives you more control over how details are affected.

The image seen here was shot with a compact digital camera on a dark, cloudy day. The conditions were such that a high ISO was needed for a sharp picture. This image was shot at ISO 1600 and has a lot of noise.

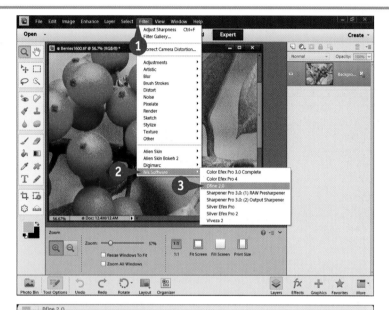

① Click Filter.

② Select Nik Software.

③ Select Dfine 2.0.

The image has been magnified here to show the noise, although you can also magnify the image in Dfine.

Dfine appears.

Ⓐ By default, noise is automatically measured at specific areas in the photo.

Ⓑ Based on those measurements, noise is reduced over the whole picture.

④ Position your cursor over the image to display the before and after noise reduction in the Loupe.

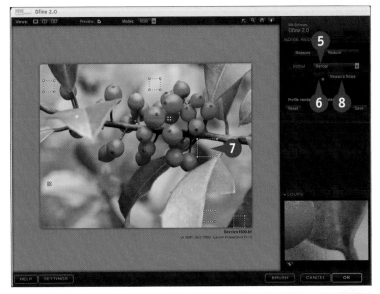

5 Click the Method drop-down menu if more noise reduction is needed and choose Manual.

6 Click the add rectangle button below Manual.

7 Draw a rectangle over an area with a noise problem.

8 Click Measure Noise.

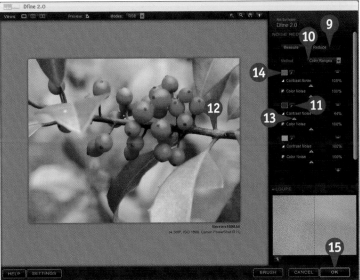

9 Click Reduce.

10 Click the Method drop-down menu and select Color Ranges.

11 Click an eyedropper next to a color.

12 Click a color in the photograph that you want to affect.

13 Adjust the slider to change how much noise reduction is done for that color.

14 Repeat steps 11 to 13 for other important colors.

15 Click OK.

TIPS

Important!

Use the Loupe to monitor small detail and see how the noise reduction affects it. Noise is essentially small detail. Dfine does a good job of controlling noise without hurting small detail, but sometimes it has trouble telling the difference. Reduce the amount of noise reduction when this happens.

Did You Know?

It can help to take some of the noise reduction off blacks and very dark parts of the picture. These areas often create a certain structure for sharpness, and a slight bit of noise in them can actually help. As long as these areas remain dark in your processing, noise will probably not be a problem.

More Options!

Nik Software includes a number of views of how your picture is being affected. On the left in the upper toolbar, you will see Views with several icons. The first shows you the picture as it changes. The others may show before and after images, plus split views showing before and after in the same picture.

Get dramatic black-and-white WITH SILVER EFEX PRO

Black-and-white photography is an art and craft, not simply a matter of changing a color picture to grayscale or monochrome. It is about how different brightness values and colors in a photograph are changed to tones of gray. You can, of course, create a fine black-and-white image in Photoshop Elements, as shown in Chapter 8.

But for the photographer who really wants to get the most out of black-and-white, Nik Software Silver Efex Pro 2 offers a superb amount of flexibility and control. The plug-in uses the same type of interface as other Nik Software

programs. Silver Efex Pro adds controls that make it easier to look at how a color picture changes to black-and-white. Preset effects are shown as small sample images to make your options easier to choose. Just click what you want. In addition, a range of controls enable you to make adjustments as needed.

The photo seen here shows Joshua trees in Death Valley. The picture is okay in color but becomes very dramatic in black-and-white.

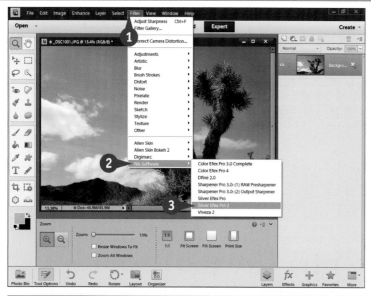

① Click Filter.

② Select Nik Software.

③ Select Silver Efex Pro 2.

Silver Efex Pro appears.

Ⓐ The adjustment that appears in the center pane is the default adjustment, Neutral.

④ Examine the sample image thumbnails at the left side to see what looks good with your photo.

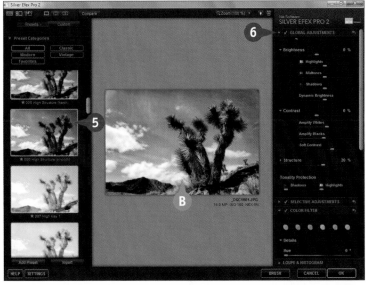

5 Click the desired change, High Structure (smooth) in this example.

B The center photo shows the adjustment.

6 Revise this adjustment using the sliders in the Global Adjustments panel.

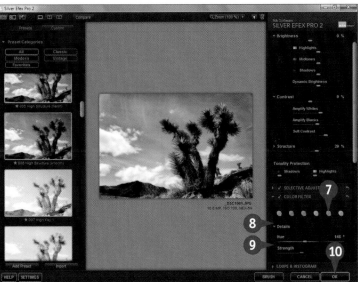

7 Click different color filters to change how colors translate to black, white, and shades of gray.

8 Click the Details drop-down menu arrow.

9 Change the Hue and Strength sliders to adjust the effect.

10 Click OK.

Did You Know?

The Structure control in Silver Efex Pro is an adjustment that affects the finer gradations of tonalities. The control is similar to the Contrast control, and definitely affects contrast, but is more refined. Structure looks at and adjusts small changes in tonalities for more or less drama in the details of a picture. You can choose to affect only certain tonalities with Structure as well.

Did You Know?

Control points allow you to make very specific changes to your photograph without ever having to deal with layers or layer masks. In Silver Efex Pro 2, you can selectively control the tonality and structure of an object or area, or you can add color back to a specific part of your image. This really helps you define parts of a photograph.

More Options!

Silver Efex Pro 2 includes a Finishing Adjustments section that enables you to darken image edges and add borders for a very refined look to your photo. Many photographers enjoy giving a black-and-white image a slight color toning effect, and you can do this simply and easily here as well.

Digital photography is great, but sometimes you want to get something from your images that goes a little bit beyond the typical photograph. You can do this in Photoshop Elements by using some of the filters, but that does not always give satisfactory results without a lot of experimentation.

Alien Skin Snap Art 3 takes your photograph and applies virtual paint strokes over it to create something that has the look of a painting or even a sketch. There are ten basic looks from color pencil to comics to watercolor. Once you

choose a look, the program offers you a lot of options to change how that look is applied to your photograph. You can adjust things like the colors used, the type of canvas, the lighting, and more.

The program builds the effect stroke by stroke so that it truly does look like the effect is hand applied. You really do have to experiment with this program because it is very hard to predict how a given photograph will react to the changes Snap Art 3 makes.

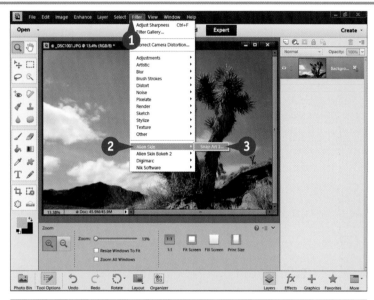

1 Click Filter.

2 Select Alien Skin.

3 Select Snap Art 3.

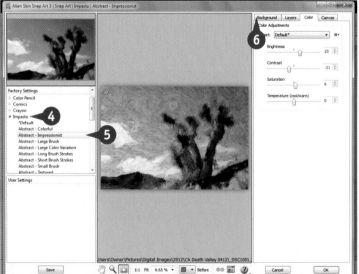

Snap Art opens.

4 Click any art title that sounds interesting to open its options.

5 Select an option to work with.

6 Click Background.

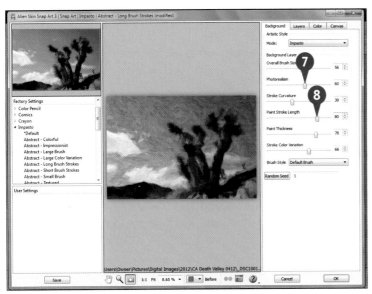

7 Try varying any of the Background controls, such as Photorealism.

8 Change Paint Stroke Length.

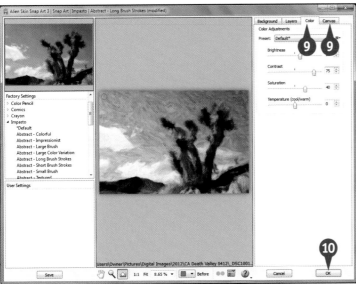

9 Click the Color and Canvas tabs and play with the settings there.

10 Click OK.

TIPS

Did You Know?

One thing that makes it difficult to evaluate results of Snap Art is that the effects look very different depending on whether you are using the image small or large. If you are making a little postcard-sized image, the effects must be stronger for them to be visible. For larger prints, you can often use more subtle adjustments, such as shorter brushstrokes.

Did You Know?

Sometimes using "creative" effects like those from Snap Art 3 can be challenging if you have not decided where to go with the effects. Alien Skin's website, www.alienskin.com, includes both examples and case studies of photographs using Snap Art 3 so you can get some ideas of what might be possible with different sorts of subjects.

Check It Out!

If you really get into special effects, you might want to check out Alien Skin's Eye Candy plug-in. This unique plug-in does everything from creating realistic texture, even out of nothing except tone, to generating realistic fire effects to making smoke, rust, and icicles.

Chapter 10

Get Photos out of Photoshop Elements

A fun part of digital photography is sharing those images — and there are so many ways to share! So, after you have done all your work on your pictures in Photoshop Elements, get them out of the computer so that people can view your pictures, share your experiences, and learn about your passions.

The world of digital photography offers diverse ways to share pictures with others. Printing, of course, is a very traditional and popular way to look at a photograph. Displaying your prints on the wall is a great way to share your experiences with others. Printing often causes problems for photographers when prints just do not come out right. Partly the problem occurs because what you

see on the monitor appears with a glowing screen, and prints are on solid paper with pigments — two very different media. But creating excellent prints is possible, and Photoshop Elements gives you the tools to do that.

You can even print calendars using pictures and add special frame effects to them. And today, many photographers are enjoying printing photo books that can be proudly displayed on the living room coffee table. Such books make vacations come to life and photographs from a trip much more accessible than ever before. Photoshop Elements makes it a lot of fun to use these and other ways of sharing images!

DIFFICULTY LEVEL

CALIBRATE your monitor

Calibrating your monitor is important. A calibrated monitor gives you a predictable and consistent environment for working on images that will be used for everything from prints to e-mail. Monitor calibration is done using a special sensor that fits on your monitor screen and reads colors and tones from calibration software. This is an easy thing to do. The task shown here includes a number of steps, but this is due to the calibration software manufacturer wanting to simplify each

step to a core adjustment rather than putting multiple adjustments on a page that might then be confusing.

You will likely find a free calibration program on your computer. That is better than nothing but not the best way to calibrate your monitor. You need to be able to combine software and hardware that reads colors very precisely, which is much different than how the human eye looks at colors. Datacolor Spyder and X-Rite i-1 calibration systems are good options and include both software and hardware.

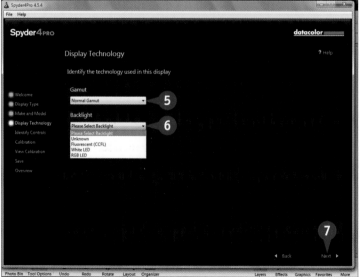

The calibration shown here uses Datacolor Spyder4. Every program is different, though the basic steps are the same.

A welcome screen and checklist appears when you first open the calibration software. Click next for the Display Type window to open.

1. Choose a display type. Most photographers now use LCD monitors.

2. Click Next to go to the Make and Model window.

3. Include the make and model of your monitor.

4. Click Next.

 The Display Technology window opens.

5. Choose a Gamut. Normal Gamut is good for most purposes.

6. Select the way backlight is handled for your LCD monitor. Select Unknown if you do not know.

7. Click Next.

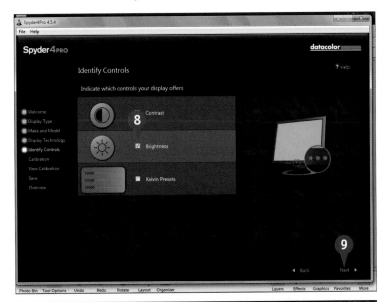

The Indentify Controls window opens.

8 Choose whatever controls are available for adjusting your monitor brightness, contrast, and color.

9 Click Next.

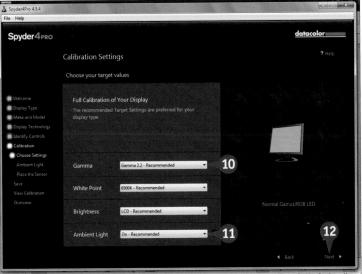

The Calibration Settings window opens.

10 Choose the Gamma, White Point, and Brightness settings. You can simply stick with the recommended settings that show up by default.

11 Select an Ambient Light setting. You can go with recommended or turn this off. This measures the light in the room where you are working with your computer.

12 Click Next.

TIPS

Important!
Laptop monitors are notoriously difficult to calibrate properly. For one thing, their appearance can change dramatically as you shift your head position relative to the screen, making any calibration less useful. In addition, they simply are not built in the same way as standard computer monitors.

Did You Know?
Many photographers working with a laptop will add a second, larger monitor for photographic work when they are not traveling. This larger monitor plugs into the display port of your computer and can be made to mirror the display on your laptop. This type of monitor makes your work easier to see and is more readily calibrated, too.

Did You Know?
The ambient light of your computer room, that is, the light all around you, has a strong effect on how you perceive colors and tones on your monitor. If you can work on Photoshop Elements in a room that can have its light consistently controlled, your adjustments will be more consistent, too.

A misconception about monitor calibration is that when a monitor has been calibrated, it then matches other monitors. That is not possible. Monitor calibration can work only within the limitations of the technology of the monitor. Just as different models of television monitors make a movie played on them look slightly different, different models of computer monitors have varied ability to display a range of tones and colors.

What monitor calibration does is give you a predictable set of colors and tones on your monitor that help you make more accurate and reliable adjustments to your images. This can be especially important with prints. If a monitor is way off, your prints will never give you expected results.

Less expensive monitor calibration systems do work well for most photographers. You do not have to spend a lot of money on calibration. Because you will not calibrate constantly, you might even be able to share your calibration system with friends at a camera club, for example.

The Measuring Ambient Light window opens.

⑬ Place the measuring device on its stand near the computer.

⑭ Click Next to measure the ambient light.

An ambient light analysis appears and you can choose to accept the new, suggested settings for this light.

⑮ Click Next.

A window appears showing you where to place the sensor device on your monitor screen.

⑯ Place your device on the screen.

⑰ Click Next.

The software begins sending colors to the monitor for the sensing device to read. You see what the monitor is sending to the device here.

18 Click Finish when the calibrating is done.

19 Remove the sensor.

20 Name and save the new monitor profile that has been created.

21 Select a reminder time for the software to let you know when to calibrate again.

22 Click next to see the before and after versions of the calibration.

TIPS

Important!

The reason that software-only programs do not work very well for monitor calibration is because of the way our eyes adapt to different light. You can know this immediately if you think how something looks largely the same whether it is in sunlight or indoor tungsten light, even though the color of light is dramatically different.

Did You Know?

How often should you calibrate? Today's LCD monitors are remarkably stable and do not need frequent calibration, though how often you calibrate depends on how much they are on. If a monitor is on infrequently, its display will not change much. If a monitor is on all the time, you may need to recalibrate at least monthly.

Did You Know?

High-end calibration systems go through more sophisticated analysis of colors and tones. They measure a great number of specific colors to see how they display on a monitor. For certain types of precision work, this can be important, but most photographers really do not need this level of precision for calibration.

PRINT your photos

There is no question that photos are used in many different ways today. It seems like iPhones and iPads are everywhere, and people are using them to look at and share photos. Is the printed image going away? Not at all. Inkjet printers all do a terrific job printing photos, their prices are quite low, and paper and ink continue to be sold in large quantities.

And there is something more. People love looking at prints, holding prints, sharing prints, putting them into frames and up on the wall, and so on. Prints are

important. And photographers are making them bigger and bigger.

This book cannot make you a master printer, but this task gives you some ideas on how you can make better prints with your own inkjet printer. Photo-quality inkjet printers are available today from budget units to expensive pro-level printers. Be sure to pick a true photo-quality paper for your printing, too. The right paper can make a big difference in the final look of your prints.

1. Start by sizing and sharpening the photo as discussed in Chapter 7.

2. Set image resolution to 240 at the image size you want to print.

3. Click File.

4. Select Print.

The Print window opens.

5. Click the Select Printer drop-down menu if you have more than one printer and select the printer to use from the menu.

6. Click Change Settings in the Printer Settings section.

A. Important: The Print Quality displayed in dpi refers to the printer, not the image ppi.

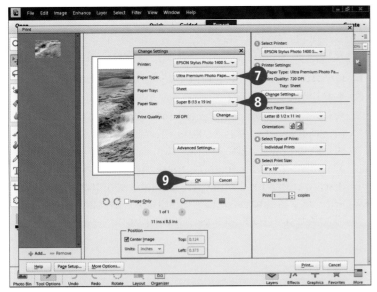

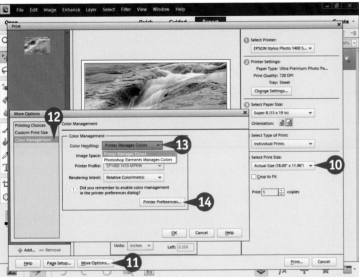

DIFFICULTY LEVEL

The Change Settings dialog box appears.

⑦ Choose the correct paper type based on what you are using.

⑧ Choose the paper size that you are using.

⑨ Click OK.

⑩ Click the Select Print Size drop-down menu to set a size for the image on the paper.

⑪ Click More Options.

The More Options dialog box opens.

⑫ Click Color Management.

⑬ Click the Color Handling drop-down menu to choose Printer Manages Colors or Photoshop Elements Manages Colors.

Canon and Hewlett-Packard, as well as lower-priced Epson printers, often do well with Printer Manages Colors.

Higher-end Epson printers usually do best with Photoshop Elements Manages Colors.

⑭ If you chose Printer Manages Colors in step 13, click Printer Preferences now.

TIPS

Important!
Photoshop Elements resizes your image to a printing resolution of 240 ppi when you set up your image to print. This may not give you the size you want, so it is best to resize the image to the proper dimensions at this resolution using the Image Resize control first. The numbers given for printing resolution in Chapter 7 still apply to printing an image outside of Photoshop Elements.

Did You Know?
When the printer manages color, it takes the color information from Photoshop Elements and refines it based on the paper used and the color settings of the printer driver. When Photoshop Elements manages color, a very specific interpretation of color is sent to the printer based on paper profiles.

Did You Know?
Printer profiles are specific translations of color and tonality for printing based on testing specific papers with specific printers. They are also called *paper profiles*. A special image of colors is printed on paper, and then the colors are read and interpreted by colorimeters to define a profile.

You often hear photographers say that their goal is to make a print that matches the monitor. Your goal should be to make a good *print*. No one will care if it matches the monitor or not. Viewers care only about the print in front of them.

This is a different mindset than many digital photographers work with. It means that you have to take your print away from the monitor and really look at it as a print. Do you like the image that you see? Does it have the appropriate brightness and balance of tonalities for the size of the print? Are there colorcasts that show up too strongly in a print but looked okay on the monitor? What you are looking for is a print that you can be proud to put up on the wall.

It can even help to take the print to the place where you plan to display it. Prints look different in different light. A print that looks fine in one location may look wrong in another.

15 If you chose Photoshop Elements Manages Colors in step 12, click the Printer Profile drop-down menu.

A profile menu appears.

16 Select the profile that fits your printer and paper.

17 Click Printer Preferences, which is visible when the Printer Profile menu closes.

Important: Macs put the printer driver into the operating system, so you will not see Printer Preferences here. You set the same things when you get to the Print window that opens when you select Print on the Mac.

The printer driver's Properties dialog box appears.

Very important: Not all printers use this organization of Properties, but all the settings must be chosen.

The Properties dialog box sets most of the settings, but confirm them and set additional settings here.

18 Select the correct printing quality option.

19 Confirm the paper type.

20 Confirm the paper size.

21 Click Advanced.

Important: *The following settings appear in different places for various printer models and Macs or PCs, so you may have to look for them.*

22 If you chose Printer Manages Colors in step 13, leave Color Controls selected in the Color Management section.

23 If you chose Photoshop Elements Manages Colors in step 13, select ICM and Off (No Color Adjustment), or Off (No Color Management) in some printer drivers, in the Color Management section.

24 Click OK.

25 Click OK to close the More Options dialog box.

26 Choose a number of prints to make.

27 Click Crop to Fit if you want the photo itself to fit a specific paper size.

28 Click Print.

Important: On a Mac, you will now have to set the options noted in steps 18 to 23.

Try This!

Photographers using traditional darkrooms almost always consider their first print a work print. They examine this print carefully to decide what else is needed to make the print better. Many photographers consider a work print a good idea for digital printing as well.

Did You Know?

Although you can use the Select Print Size drop-down menu to scale a picture to fit a certain size of paper, use this sparingly. It works if you are making only a small change in size. For optimum quality, you need to size the picture with the specific resizing algorithms used with Image Resize in Photoshop Elements itself.

Did You Know?

Printer resolution and image resolution are two different things. *Printer resolution* is set by the printer driver and affects how ink droplets are put on the paper. *Image resolution* is set by Photoshop Elements and is based on the pixels in the photograph. They deal with separate qualities for printing.

PRINT a calendar

Calendars are a traditional use of photography. They used to be possible only with commercial printing, unless you wanted to make something by pasting photos onto preprinted monthly calendar pages.

Digital printing makes calendars possible for any photographer. A calendar of your photos can make a terrific Christmas or other holiday present. Friends and relatives love personal gifts.

Calendars are also great as part of a business. You can put together images of your product line, or maybe just pretty photos that encourage customers to keep your calendar with your contact information up all year.

When putting together a calendar, it helps to choose photos based on some sort of theme. This can be as simple and direct as seasons or grandkids, or it can be deep and nuanced such as love or freedom. The point is to organize your photos in some way that makes sense to have them as a group. Create an album in Organizer to help so you can click and drag photos into and out of it as you decide on photos for your calendar.

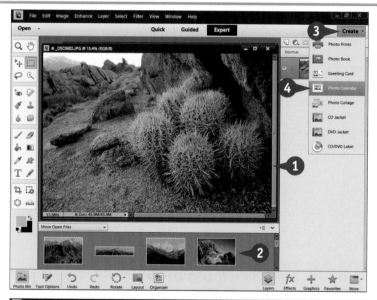

① Open 12 images into Editor.

You can click and drag photos to order them in the Photo Bin to fit a sequence in the year.

② Select all images by clicking the first one in the Project Bin and then Shift+clicking the last.

③ Click Create.

④ Select Photo Calendar.

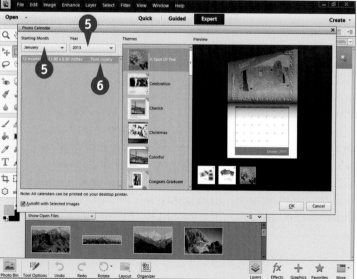

The Photo Calendar dialog box opens.

⑤ Choose a month and year.

⑥ Select where to have your calendar printed.

Print Locally is your printer. If other options appear, they will include Internet printing services.

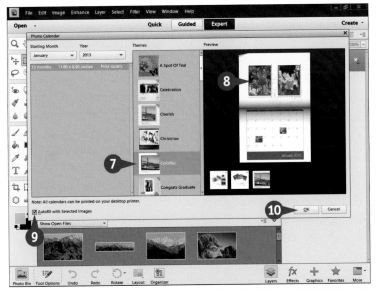

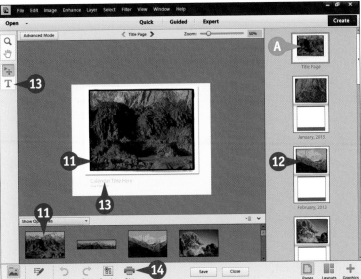

7 Choose a design theme for your calendar.

You need a connection with the Internet because Photoshop Elements has to download the chosen theme.

8 Check what it looks like in the preview.

9 Be sure Autofill with Selected Images is checked.

10 Click OK.

A The calendar pages appear in the right panel with your photos.

11 Click and drag a photo from the Project Bin to the photo in the center calendar page layout to change a photo.

12 Check to be sure you like all the calendar pages with photos in the panel on the right.

13 To change text on the cover, double-click the words and the Text tool opens.

If that does not work, click the Move tool and then choose Auto Select Layer in Tool Options, before clicking the text.

14 Click Print.

TIPS

Try This!

Your calendar prints with a cover page. Consider what might be a good photo for that page and be sure you have moved that photo from the Project Bin to the cover page. Usually you want the cover page to duplicate one of your favorite photos inside your calendar.

Try This!

If you do not like certain aspects of the calendar design, you can change them. Click the Layout icon to change what the calendar design looks like. You can also use the Advanced Mode button to open the Toolbox so that you can use any of those tools to adjust your calendar.

Did You Know?

You can save your calendar whether you print it or not by clicking Save. This lets you save the complete calendar in one file. You can return to the calendar at a later time to reprint it or make changes. This is saved in a special Photo Project Format (PSE) unique to Photoshop Elements.

PRINT a photo book

Digital printing also makes photo books possible for any photographer. This is a terrific way to create a memory book of a vacation or for a life event such as an important birthday or anniversary.

Many pro photographers use photo books now as part of their businesses, but any photographer can use them to display a range of special photography. In addition, a business can put together a special catalog of a product line, or maybe just a pretty photo book that reminds customers of you.

Books can be small or large, thin or thick. You can create a book with lots of pages and print them from your inkjet printer. However, that can stress the processor and make it hard to do any other work; you may have to do it in sections. Create an album in Organizer to help keep track of photos for your book. Once the album is created, you can click and drag photos into and out of it as you decide on photos for your book.

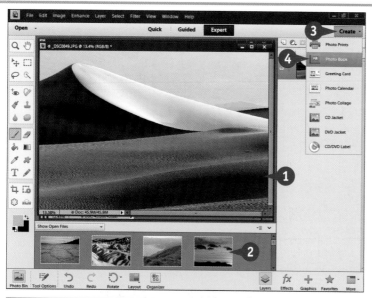

① Open a series of images into Editor.

② Select all images by clicking the first one in the Project Bin and then Shift+clicking the last.

③ Click Create.

④ Select Photo Book.

The Photo Book dialog box opens.

⑤ Choose a size for your book in the section where you will have your book printed.

Print Locally is your printer. Shutterfly is an Internet printing service.

6 Choose a design theme for your book.

7 Check what it looks like in the preview.

8 Type a number of pages for your book.

9 Be sure Autofill with Selected Images is checked.

10 Click OK.

The book pages appear in the right panel with your photos.

11 Click and drag a photo from the Project Bin to the photo in the center book page layout to change a photo.

12 Click the Text tool to add text.

To change text, double-click the words and the Text tool opens.

13 Check to be sure you like all the book pages with photos in the panel on the right.

14 Click the Pages icon to display individual pages or groups of pages.

15 Change layouts by clicking the Layout icon.

16 Click Print to print, or click Save to save.

TIPS

Try This!

There is a Switch to Advanced Mode button for both photo calendars and photo books. This allows you to access the Layers panel along with the Create panel. All the design of a book or calendar is done using layers. You can go into the layers in Advanced Mode to alter very specific parts of the design of your project.

Did You Know?

Books generally need enough pages to come together effectively as a book. A good minimum is 20 pages. That might mean you would need 20 photos or quite a bit more depending on how many photos you are using per page. Do not cram a lot of photos on every page because that will make your book hard to understand by a viewer.

Did You Know?

If you do not have enough photos for the book, you have some options. First, you can change the layouts of the pages in the Layouts panel to have fewer photos per page. Second, you can add photos by going to File and Open. When you do that, the project disappears. That is not a problem. Click the project in the Project Bin to get it back and to add the new photos.

The edge of your photograph can be very important in a print. That is, after all, the place where the photograph connects with its surroundings. Borders can accentuate the photograph itself and keep the viewer's eye on the image.

You can apply some very interesting border effects to the edges of your picture in Photoshop Elements by using layers. This task helps you better use and understand layers as well as create some good borders for your photos. In this task, you see how to apply a ragged-edged border

very simply by having two layers. You can create similar effects using different colors and different brush types. By adding a layer, you are essentially creating something that acts like a clear piece of plastic over your photograph. You can then paint or affect that plastic in any way without changing the original photograph.

Watch how edges interact with your photograph. One problem a lot of photographers run into is that they pick a color for a border that competes with the colors in the photograph.

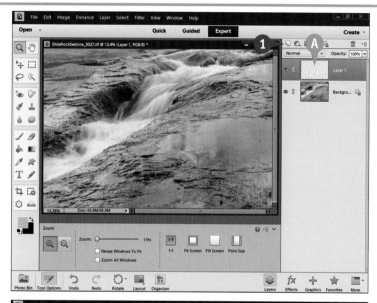

1 Click the New Layer icon at the top of the Layers panel.

A A blank layer appears over your image.

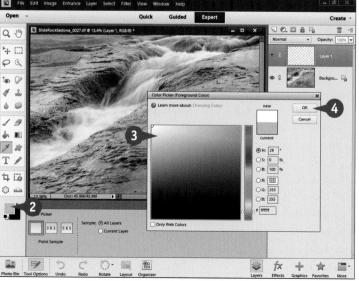

2 Click the foreground color.

The Color Picker appears.

3 Click the pure white at the top left of the color box.

4 Click OK.

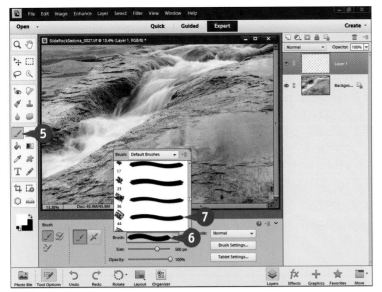

5 Select the Paintbrush from the Toolbox.

6 Click the Brush in Tool Options to get a menu of brushes.

7 Scroll down the brushes until you find an interesting shape that has some edges to it and click to select it.

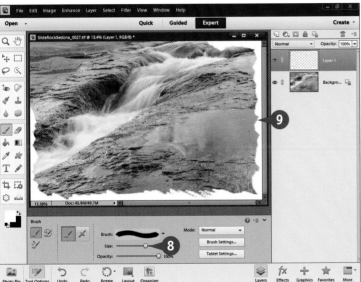

8 Choose a brush size big enough to create an interesting effect along the edge of your photograph.

9 Paint in a jagged way all around the edge of your photograph. Try both brushing over the edge and clicking to "dab" white into the photo.

The photograph's border now has a painted look.

TIPS

Try This!

If you do not like how your border is working, that is no problem because you are using a layer. You can erase what you do not like with the Eraser tool and then paint over the problem. You can also add a layer mask to the layer. Then you can adjust what the border looks like by painting black into that layer mask to block the layer or white to allow that layer. See Chapter 5 for several tasks about layer masks.

More Options!

Because you are creating this effect on a layer separate from your photo, you can create some interesting effects by using the filters available from the Filter menu. There are all sorts of filters that do attractive things to a solid tone such as what you are painting around your photograph. You have to experiment.

Check It Out!

If you like interesting frame and edge effects, check out PhotoFrame from onOne Software (www.ononesoftware.com). This plug-in includes hundreds of frames that were developed by professional photographers but are now available for anyone to use. This plug-in works in Photoshop Elements.

Make a GREETING CARD

Greeting cards are a wonderful way to use your photography and make someone happy that you sent them a card. You can totally personalize it in Photoshop Elements, from the photos used to the text chosen, plus you can save it with layers to reuse later by changing the text.

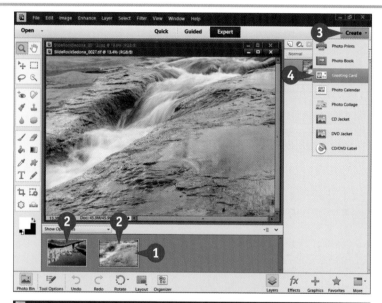

1. Open at least two images into Editor. Photoshop Elements greeting card templates use at least two photos.

2. Select all images by clicking the first one in the Project Bin and then Shift+clicking the last.

3. Click Create.

4. Select Greeting Card.

The Greeting Card dialog box opens.

5. Choose a size for your card in the section where you will have your card printed.

Print Locally is your printer. Shutterfly is an Internet printing service.

6 Choose a design theme for your card.

7 Check what it looks like in the preview.

8 Be sure Autofill with Selected Images is checked.

9 Click OK.

10 To change text on the card, double-click the words and the Text tool opens.

11 Change things like font, font size, and font color just like you would in a word processor.

You can go larger than the maximum listed font size of 72. Simply select the number in the font size box and type a larger number.

12 Change layout using the Layouts icon.

13 Click Print to print, or click Save to save.

TIPS

Try This!

If you want text to go over a photo, choose the Text tool and add text wherever you want it. Be careful that the text and photo do not compete with each other so that the text cannot be read. Look for blank areas, such as sky, that shows off the text nicely without causing problems for the rest of the photo.

Did You Know?

You can get specially prepared card stock for greeting cards that is designed for inkjet printing of photos. This comes in standard sizes that work well for cards and fit standard envelopes. Most office supply stores have this paper in their photo paper section and properly sized envelopes in the envelope section.

Did You Know?

Glossy paper can be a problem for greeting cards because it does not fold very well. It tends to either crack unattractively along the bend or not hold a fold well. Matte finish photo papers work better for cards, although some special greeting card papers do come in glossy with pre-scored places to fold them.

Index

Index

Index

Index

Index

There's a Visual book
for every learning level...

Simplified®

The place to start if you're new to computers. Full color.

- Computers
- Creating Web Pages
- Digital Photography
- Internet
- Mac OS
- Office
- Windows

Teach Yourself VISUALLY™

Get beginning to intermediate-level training in a variety of topics. Full color.

- Access
- Computers
- Digital Photography
- Dreamweaver
- Excel
- Flash
- HTML
- iLife
- iPhoto
- Mac OS
- Office
- Photoshop
- Photoshop Elements
- PowerPoint
- Windows
- Wireless Networking
- Word
- iPad
- iPhone
- WordPress
- Muse

Top 100 Simplified® Tips & Tricks

Tips and techniques to take your skills beyond the basics. Full color.

- Digital Photography
- eBay
- Excel
- Google
- Internet
- Mac OS
- Office
- Photoshop
- Photoshop Elements
- PowerPoint
- Windows

...all designed for visual learners—just like you!

Master VISUALLY®

Your complete visual reference. Two-color interior.

- 3ds Max
- Creating Web Pages
- Dreamweaver and Flash
- Excel
- Excel VBA Programming
- iPod and iTunes
- Mac OS
- Office
- Optimizing PC Performance
- Photoshop Elements
- QuickBooks
- Quicken
- Windows
- Windows Mobile
- Windows Server

Visual Blueprint™

Where to go for professional-level programming instruction. Two-color interior.

- Ajax
- ASP.NET 2.0
- Excel Data Analysis
- Excel Pivot Tables
- Excel Programming
- HTML
- JavaScript
- Mambo
- PHP & MySQL
- SEO
- Ubuntu Linux
- Vista Sidebar
- Visual Basic
- XML

e **Available in print and e-book formats.**

31901051737080

For a complete listing of Visual books, go to wiley.com/go/visual